Art:
Explained

100 Masterpieces and What They Mean

LAURENCE KING

First published in Great Britain in 2022 by Laurence King Publishing
an imprint of The Orion Publishing Group Ltd
Carmelite House, 50 Victoria Embankment
London EC4Y 0DZ

An Hachette UK Company

10 9 8 7 6 5 4 3 2 1

A CIP catalogue record for this book is
available from the British Library.

ISBN 978-0-85782-897-2

Designed by John Round Design
Printed in Malaysia by Vivar Printing Sdn. Bhd.

**BOOK
CHAIN
PROJECT**

www.laurenceking.com
www.orionbooks.co.uk

Art:
Explained

100 Masterpieces and What They Mean

Susie Hodge

Laurence King Publishing

Contents

Introduction

Art has become an essential part of human existence, and creativity is one of the traits that define us as human and distinguish us from all other animals. In every society, art has formed part of a complex structure of beliefs, traditions and customs, but has also been a vehicle for creative, individual expression.

The first art we know of was produced more than 30,000 years ago, and over the thousands of years since, countless artworks have been produced, demonstrating the scope of human creative endeavour. Yet, despite this incalculable amount of creativity, every single work of art is different from all others; no two are the same. Even art that is created as a copy of another work is always different from the original. There might be variations in the colours or materials used, or in the application of materials and techniques, even if the same artist is producing the copy as produced the original. Similarly, art is rarely perceived in the same way by two people; our viewpoints nearly always differ, even if only slightly, based on background and personal experience. What one person considers beautiful, another might believe to be ugly; a work of art might strike someone as witty or humorous, while someone else will see it as dull or annoying; and while some people find certain artworks shocking, others might view the same as intriguing. Art has the power to inspire particular feelings, and some works even change our viewpoint or opinions, directly affecting our thinking or beliefs.

Changing or affirming outlooks was the purpose of much early art, since a great deal of it was created specifically to shape and support a community's social conduct and beliefs. The artists worked to strict formats, spending years training, learning rules of technique, method and materials, and following established subjects, themes, styles and design systems. However, even in such inflexible conditions, individuality and originality abounded. As time passed the structure of many societies changed, and art became more personal and varied. Artists allowed their own ideas and styles to come to the fore, and individuality became more apparent and more highly valued.

The earliest art was often perceived as having powerful magical or spiritual properties. Later art was often educational or instructional, and then some art was created to adorn surroundings or uplift viewers. Even later art became an observation or commentary on its society. While it remained an essential component of its community, it became ever more expressive. Whereas from the earliest times contemporaries of many artists could easily 'read' the visual language of the art, much recent art has been less easy to decipher, even by the societies from which it comes.

From prehistoric cave paintings and carvings, to Renaissance frescoes and statues, to twenty-first-century installations and performances, art has provided unique ideas, fresh insight and new perspective, often encouraging the viewer to reconsider aspects of his or her own society that need to be addressed, whether obvious or obscure. Many artists evaluate or reflect on their own political, economic and social systems. They may highlight the failings or prejudices they perceive in their communities, or express their own or universal views, provoking a re-examination of or debate about accepted thinking on certain topics.

Some artists leave such philosophy aside. Instead, they document history, dramatize events, elaborate on myth and religion, capture

likenesses in portraits or landscapes, depict their own ideals, dreams and memories, pass on traditions and stories, demonstrate technical expertise, experiment with a particular medium, or celebrate the physical world and the world of the mind.

Across all these purposes, cultures and traditions, every work of art is created for a reason, and every artist's interpretation is individual. Even traditional stories are depicted in myriad ways by artists of different periods and nationalities. Techniques are frequently adapted and personalized, and new methods and ideas invented. Why an individual artist creates a particular work of art in a certain way is always a fascinating mix of their background, experience, situation, history, influences and surroundings.

These unique elements culminate in a vast range of reactions and outcomes, and that is why this book explores 100 extremely different works of art. Some are easily recognized, others are less well known, but all are explored, uncovering where, why, when and how they were made. All are remarkable works of art, from some of the earliest ever discovered to those created recently, and the book analyzes many of the meanings and purposes behind them, considering such things as the artists' backgrounds, experiences and beliefs, the reasons for the use of particular materials, aspects of the societies surrounding those artists, and what they hoped to achieve. If you have ever looked at a work of art and thought 'What's the big idea?', this book will provide answers. It investigates individual interpretations of certain themes, as well as such things as the demands or requests of difficult patrons, inspiration and influence that affected the artists, and personal issues and broader political, social and economic concerns that may have had an impact.

Whether art was made centuries ago, within civilizations we know little about, or created relatively recently, and whatever the aims of each artist or the reasons for their work, most seek to make an impression on and elicit a reaction from the viewer. For example, in 1882 Vincent van Gogh wrote: 'I want to touch people with my art. I want them to say "he feels deeply, he feels tenderly."' In 1889 Auguste Rodin said: 'The main thing is to be moved, to love, to hope, to tremble, to live,' and Eugène Delacroix wrote in 1824: 'What moves those of genius, what inspires their work[,] is not new ideas, but their obsession with the idea that what has already been said is still not enough.' Finally, and perhaps most succinctly, in 1939 Georgia O'Keeffe said: 'I made you take time to look at what I saw.'

Art can be annoying, aggravating, uplifting or nostalgic, exciting, amusing and much more. Most of all, it is frequently intriguing, enthralling and even comforting. The world would be a drearier place without it. The reasons behind what we see after an artist has completed a work of art and shown it to the world are frequently fascinating and compelling, and this book will help you to understand and enjoy art even more.

Venus of Willendorf
promises pregnancy

Some of the earliest art was believed by its contemporaries to have magical abilities, and was linked to superstition and belief in higher powers. This implies that these early cultures also believed that humans, especially artists, could have a powerful effect on the world. However, because much of such work was prehistoric – produced before the invention of written language – there is no proof of its meaning or of the artists' methods or purposes. All analysis can therefore be only conjecture, based on what can be seen, where it was found, the materials and any marks left by the artist.

In 1908 a small limestone statuette of a woman was found in Willendorf, Austria, one of three discovered in the same area. Dating from the Upper Palaeolithic period, during the period of Gravettian art, the tiny figure is tinted with red ochre. It has no hands or feet, a head with no facial features but what appears to be a braid or cap, large breasts, belly and hips, and exposed genitalia. Because some essential elements of the human form are missing while others that are essential to female reproduction are exaggerated, it is likely that the figure was made as a fertility amulet or icon, although some scholars have suggested that it might instead have been a goddess effigy or mother figure. Some have even proposed that it was a child's toy.

It is not apparent what tools were used to carve the figure, but the fact that it is made of limestone that is not found in Willendorf suggests that it was made elsewhere. More than 100 similar figurines produced at approximately the same time across Europe and Asia have been found, meaning that they were probably created to be portable and owned by individuals who either carried or wore them. This idea is supported by the fact that the artists who created the statuette led a nomadic life. Although not all these statuettes are as plump as this, they have all been retrospectively named Venus figurines after the Roman goddess of love, who was central to ancient Roman worship, although of course the figures were created long before the Romans.

This figure was named *Venus of Willendorf*. At the time she was created, it is unlikely that real women were as well fed as her rounded body shape suggests, so she is likely to have been both an embodiment of and talisman for female sexuality or fertility and a celebration of corpulence, implying an abundance of food when food was difficult to come by. However, this would not explain why several of the other statuettes are far slimmer, nor why they all appear to represent women.

Artists unknown
Venus of Willendorf, limestone with ochre colouring, c.24,000–22,000 BCE

'Some of the earliest art was believed by its contemporaries to have **magical abilities**, and was linked to **superstition** and belief in **higher powers**.'

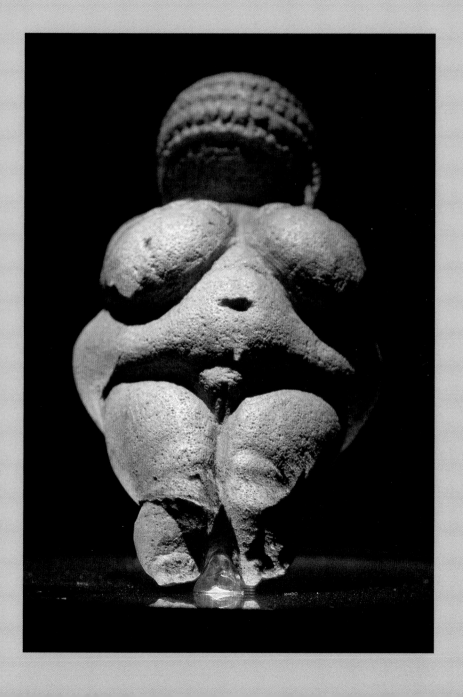

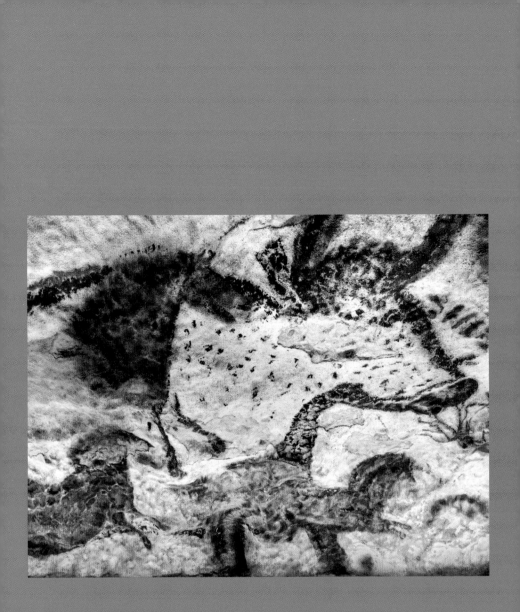

'As with all prehistoric art, the **purpose** of these paintings
remains a **mystery**, although **theories abound**.'

Hall of Bulls
ritualizes hunting

Some of the oldest art in the world has been found on cave walls and ceilings in the Franco-Cantabrian regions of southern France and northern Spain. Much of it was produced between about 25,000 and 12,000 years ago, in the Palaeolithic era. It includes an astonishing range of paintings, drawings, engravings, prints, reliefs and sculpture. Although there are a large number of abstract marks and hand stencils, most of the art represents large wild animals.

In 1940 more cave art (also called parietal art) was discovered at Lascaux in the Dordogne region of southwestern France. Dating from c.17,000–c.15,000 BCE, there are almost 600 paintings in the interconnecting caves, including images of horses, deer, aurochs, ibex, bison, bulls and felines. Considering the artists had only rudimentary tools and materials, and worked in near darkness, much of the art is remarkably naturalistic. On the limestone walls of the vast main chamber – called the Hall of Bulls – among other animals, galloping wild horses in profile are followed by arrows.

Before they painted on the walls, cave artists scraped and cleaned them. Then they attempted to render texture and tone, to make the animals appear three-dimensional, to suggest movement and interaction, and some used the natural contours of the cave walls to create the effect of solidity. Several of the animals were overlapped to make them seem to be moving together. Some of the images were drawn with contour lines only, and in some, colours were blended by blowing powdered pigment by mouth through hollowed-out bones or reeds on to the painting. The pigments include red and yellow ochre, manganese or carbon for black, and china clay for white. Some of the ground, dry pigment was mixed with animal fat, some with water and some used dry, all applied by finger, chewed sticks, or fur or moss for brushes. The paint was held on small flat rocks or seashells as the artists worked in the shadowy light of sandstone lamps using animal fat as fuel. For this painting, the outline of the animal was first drawn on to the cave wall with charcoal or manganese. Next, red ochre was used to create the impression of the horse's coat, then details were added in black and white and areas were blended to create softness and the appearance of three dimensions.

Although paintings were created throughout the length of the cave, humans only inhabited the cave mouth. As with all prehistoric art, the purpose of these paintings remains a mystery, although theories abound. Some believe that such works may have incorporated prehistoric star charts, or that they celebrated hunting successes. Alternatively, it is highly likely that they were part of mystical or shamanistic rituals to induce success in future hunts.

Artists unknown

Hall of Bulls, charcoal and ochre on white calcite nonporous rock, c.17,000–15,000 BCE

Nebamun Hunting in the Marshes secures immortality

Accompanied by his wife and daughter, Nebamun, a wealthy scribe and grain-counter, is hunting birds in the marshes of the Nile. A caption in hieroglyphics says that he is 'enjoying himself and seeing beauty'.

Found on the west bank of the River Nile at Thebes (present-day Luxor), Egypt, this is part of a wall painting from a tomb chapel constructed in about 1350 BCE. Only the wealthy could afford tomb chapels in ancient Egypt, and before his death, Nebamun commissioned his to contain his mummified body, some of his belongings and images of him as a young, healthy man undertaking activities he had enjoyed during his life, which he and his contemporaries believed he would need in the afterlife. The tomb comprised rooms, passages and a grave shaft, cut into a rocky hillside. Inside, the walls were plastered and then a team of artists painted on to them the idealized scenes from Nebamun's life. The rooms were left open so that his family and friends could pray and leave offerings in his memory, while the grave shaft containing Nebamun's body and belongings was sealed. As well as being seen by friends and family, the paintings were created for the gods to see the lifestyle the dead hoped to continue in the afterlife.

Here among the vegetation are lotus flowers, papyrus, plain tiger butterflies and Nebamun's ginger cat, which helps him to catch the birds. In ancient Egypt, cats were family pets, but they were also worshipped as deities, for instance the cat goddess Bastet, who represented fertility, Mafdet (the god of justice) and Sekhmet (the god of power). Cats often appeared in the *Book of the Dead*, usually representing Ra, the sun god, creator of the universe and giver of life, warmth and growth, and the most worshipped god of all. In this painting, the golden eye of Nebamun's cat suggests immortality. Nebamun holds a snake in his left hand and uses it as a weapon.

Further symbols in the painting include the fertile marshes that were associated with the gods Isis and Osiris, and particularly with life and resurrection. The pastime of hunting animals conveys Nebamun's triumph over nature, and his dynamic, dominating figure surrounded by flourishing life captures the essence of youthful vigour. The artists of this painting departed from several strict conventions, creating an idea of texture in the detailed fur, feathers and scales, and intricate pattern in the plants. Overall, the image conveys to the gods Nebamun's energy and zest for life. Wall paintings alongside it featured him engaged in various other activities, including attending a banquet and overseeing a count of geese and cattle as part of his job as a government scribe. Some showed the food and drink he would need in the afterlife.

Artists unknown

Nebamun Hunting in the Marshes, tempera on plaster, c.1350 BCE

'The artists of this painting departed from several **strict conventions**, creating an idea of **texture** in the detailed fur, feathers and scales, and **intricate pattern** in the plants.'

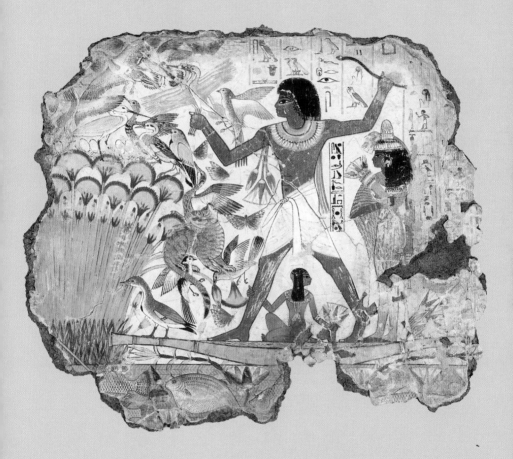

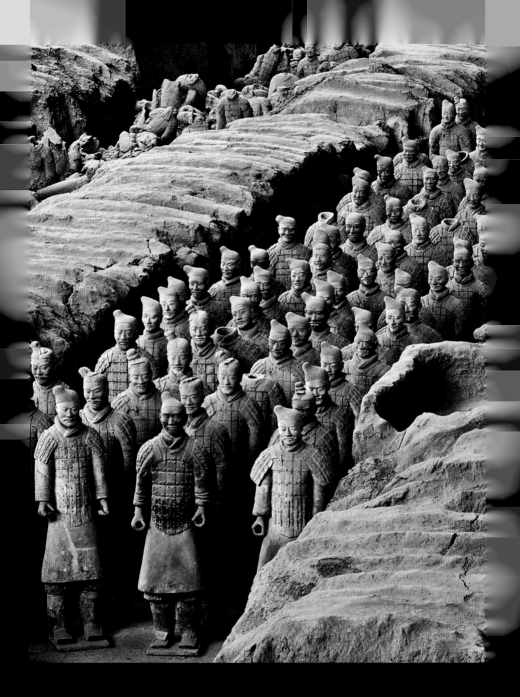

'The purpose of this **huge creative endeavour** was to **protect** the emperor and help him continue to rule in the **afterlife.**'

Terracotta Army
protects a dead emperor

In 1974 workers digging a well outside the city of Xi'an in Shaanxi province, China, next to the mausoleum of the country's first emperor, Qin Shi Huangdi, found a life-sized clay soldier posed ready for battle. The workers immediately notified the Chinese authorities, and government archaeologists were sent to the site, where they found thousands more similar soldiers, dressed as infantry, archers, generals and cavalry, each one with a unique facial expression and carrying individual weapons and armour, with different hairstyles and beards. The soldiers were positioned according to rank, and further excavation unearthed horses, chariots, swords and other weapons, as well as life-sized musicians, acrobats, concubines, officials, strongmen and birds, including waterfowl, cranes and ducks. Evidence of paint shows that the figures were once brightly coloured, but this has mainly worn off. Much taller than most Chinese people at the time, the figures vary in height between 184 and 197 cm (6–6 ft 5 in), according to rank, with generals being the tallest.

Known as the *Terracotta Army*, this massive clay hoard was created as funerary art and is estimated to comprise more than 8,000 soldiers, 130 chariots and 670 horses. Part of a large necropolis, the statues were buried in a large area around the emperor's tomb mound, and archaeologists have located hundreds of pits and underground vaults, but even now, by no means all of this huge collection has been uncovered.

Soon after he ascended the throne at the age of 13, in 247 BCE, Emperor Qin Shi Huangdi commissioned the statues, and work began on them in 246 BCE, ending 40 years later after the emperor's death and at the start of the Han Dynasty. Chinese craftsmen had been producing clay pots since 18,000 BCE, so the artisans had the skill that was needed to create the *Terracotta Army* with precision, dexterity and naturalism. Approximately 700,000 government labourers and local craftsmen created the figures, moulding them in parts, firing them, then assembling and painting them. Once finished, the soldiers were positioned in the tomb in precise military formation. They were buried with the emperor in 210–209 BCE, and the completed tomb was covered in grass and trees, to make it look as if it were part of the natural landscape. The purpose of this huge creative endeavour was to protect the emperor and help him continue to rule in the afterlife. The models were intended to allow his life to carry on after his death, since it was generally believed that anthropomorphic objects could come to life in the hereafter. It is testament to Qin's status that his grave goods constitute the largest collection of ceramic art found anywhere in the world, and the greatest sculptural masterpiece of Asian art.

Artists unknown
Terracotta Army of Emperor Qin Shi Huangdi, clay, paint and metal, c.210–209 BCE

Ellora Caves
recognizes religions

With their monuments, statues, carvings and paintings, the Ellora Caves in Maharashtra, western India, spread over 2 km (1½ miles). Comprising 34 caves – 5 Jain, 12 Buddhist and 17 Hindu – they are among the largest rock-cut monastery-temple caves in the world. Ultimately, the ornate structures convey the reverence and esteem paid to religion at that time, and epitomize the religious mix and harmony characteristic of Indian culture.

Comprising temples (*caityas*), shrines (*stupas*), monasteries (*viharas*) and sleeping cells for travelling monks and pilgrims, the Ellora Caves were constructed during different periods. The Buddhist caves date from c.200 BCE–600 CE, the Hindu caves from c.550–950 CE, and the Jain from c.800–1000 CE. Most dramatic in design are the Hindu caves, while the Buddhist are the least embellished. Scholars have numbered the caves, to differentiate them. The Hindu caves were built over two periods, 550–600 CE and 730–950 CE, and the largest of them is the particularly elaborate Kailasha or Kailasa temple. This was probably commissioned by the Rashtrakuta king Krishna I (r.756–73 CE), but, since it features different architectural and sculptural styles, it is likely that its construction spanned the reigns of several kings. Cut and carved into a huge temple, Kailasa, or Cave 16, contains a courtyard, shrine and cloisters, with sculptures depicting gods, goddesses and mythology found in Vaishnavism and Shaktism, relief panels that illustrate parts of the two major Hindu epics, a huge chariot-shaped monument dedicated to Lord Shiva, and several wall paintings. The earliest murals were produced as the caves were first built, and the second some centuries later. Reliefs and statues are everywhere, including friezes of elephants, pillars and gods. The massive two-storey Cave 15 or Dasavatara (Ten Incarnations of Vishnu) contains a vast court with an inscription that outlines the lineage of the Rashtrakuta dynasty. The exterior of this cave features intricate carvings, with carved human and animal figures embellishing the roof.

Primarily monasteries, the Buddhist caves include shrines carved with images of Lord Buddha and *bodhisattvas*, altruistic Buddhist deities. Cave 10 is also known as Vishvakarma or the Carpenter's Cave because the carving of the rock creates the appearance of wooden beams. Vishvakarma is the engineer and architect god. With its portico and massive hall, this elaborate cave served as the Buddhists' prayer house, and inside the hall is a 4.6 m-tall (15 ft) statue of Buddha. Numbered 30–34, the five Jain caves display carvings depicting the mythology of Jainism, and also comprise architectural features such as pillared verandas and *mandapas* (temple porches). Cave 32 is embellished with carved flowers, while Cave 30 contains two colossal statues of Lord Indra dancing.

Artists unknown
Ellora Caves, basalt, c.200 BCE–1000 CE

'The **ornate structures** convey the **reverence and esteem** paid to religion at that time, and epitomize the religious mix and harmony characteristic of **Indian culture**.'

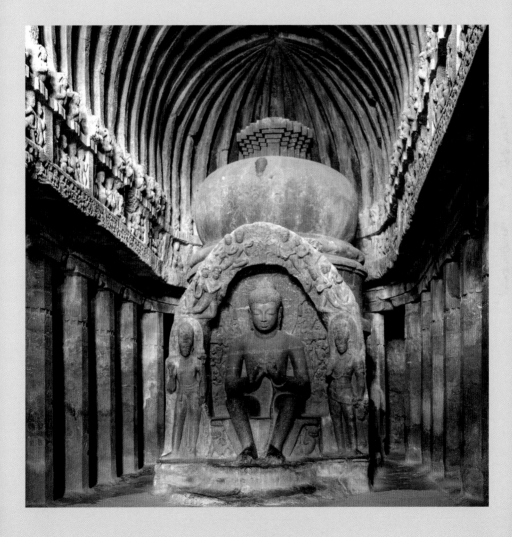

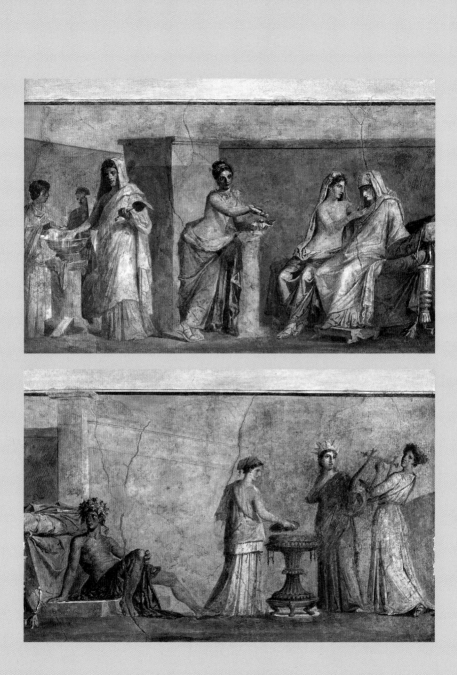

'The **symbolism** in this image would have been
readily understood by all who saw it.'

The Aldobrandini Wedding
celebrates a marriage

A copy of a Roman wall painting in the Vatican Museum, this may originally have been part of the upper frieze of a wall decoration in a house near the Arch of Gallienus on the Esquiline Hill in Rome. Discovered in about 1600, the fresco remained in the possession of the Aldobrandini family until 1818, when it was bought by the Vatican authorities. This type of fresco was painted on the walls of villas owned by wealthy Romans. Ancient Roman artists learned techniques of creating the impression of three dimensions through perspective from the Greeks, while the symbolism in this image would have been readily understood by all who saw it.

The artists and owners of this work are no longer known, but it was probably painted in the house of a newly married couple. Marriage (*conubium*) in ancient Rome was strictly monogamous by law, and this distinguished the Greeks and Romans from other ancient civilizations. The subject is clearly a wedding scene, featuring ten figures arranged in a straight line along the picture plane. It depicts a bridal chamber containing on the left-hand side (in the top image here) two women or goddesses and a man or god approaching them. He may be the groom or the Roman god Hymen, the son of Apollo and one of the winged love gods. The two females stand on either side of a basin; one in a white cloak and with veiled head holds a flabellum, a leaf-shaped fan made of metal, leather,

silk, parchment or feathers that was used in religious ceremonies to swat away insects. She appears to be testing the temperature of the water that is being poured into a small basin on a pedestal by the other woman with her, who is probably a maid. From the basin hangs a towel and on the ground, leaning against the pedestal, is a writing tablet. Further along in the mural, another female figure leans against a low column topped by a shell-shaped basin. She is possibly the goddess Suada, the handmaiden and companion of Venus, the Roman goddess of love. She pours perfume into the basin from a bottle.

In the centre of the mural, sitting on a bed, are two females. The semi-nude is probably the goddess Venus herself, reassuring the bride next to her, swathed in white, as she anxiously awaits her new husband. A golden-skinned, semi-nude man reclines on a low block of stone next to the bed, his back to Venus and the bride on the bed, but he turns his head towards them, indicating that he is involved in their conversation. The group of three women on the right-hand side gather around a *thymiaterion* (incense-burner). One of the women holds a lyre, and leans back. She is the only figure in the scene to look out of the fresco, directly at the viewer.

Artists unknown

The Aldobrandini Wedding, fresco, c.27 BCE–14 CE

Trajan's Column
flaunts a victory

Apollodorus was a Greek engineer and architect, born in Damascus, who worked mainly for the Roman emperor Trajan (r.98–117 CE) and designed most of Trajan's buildings and structures. Made of white Carrara marble in 20 massive marble drums, this towering column – an example of the Doric order of Roman architecture – was erected as the focal point of Trajan's Forum in the centre of Rome. It is surrounded on three sides by two libraries and the Basilica Ulpia. As well as containing valuable works of literature, the libraries were built with special viewing platforms to allow visitors to observe the frieze, based on Greek pottery designs, that winds around the column. The frieze is more than 190 m (620 ft) long and spirals around the shaft 23 times from bottom to top. The column could be entered through bronze doors at its base, and inside is a spiral staircase of 185 steps, leading to a viewing platform at the top and a chamber that held two golden urns containing the ashes of Trajan and his wife. The capital at the top weighed even more than the heavy marble drums that make up the shaft, and it is not known how such a colossal structure was built, but it is likely that the builders used a tower, capstans, pulleys and thousands of men and horses.

Created to commemorate one of Trajan's greatest victories, the column had to be prominent. As emperor, Trajan waged several wars in Dacia (present-day Romania and Moldova),

and – largely because of a huge bridge built across the River Danube, engineered by Apollodorus – the Romans were ultimately victorious. When Trajan and his army returned home, Apollodorus was commissioned to build a massive monument to commemorate the successful campaign. The first column in this style, it was widely copied.

Carved in shallow relief, the frieze winds round the column in continuous scenes, detailed with paint and metal fittings, following Trajan's account of his Dacian victories. The lower half narrates the first campaign and the upper half the second. Overall, there are 155 scenes featuring more than 2,500 figures, including 60 images of Trajan himself. Fewer than 20 scenes show actual fighting; most depict the daily activities of the soldiers, and the frieze also shows the first crossing of the Danube by the Romans, Trajan's voyage up the river, the surrender of the Dacians, the attack on the Dacian capital and the death of the Dacian king Decebalus. Until Trajan's death, the column was topped with a bronze eagle, but after he died the eagle was replaced with a bronze statue of him, and in 1587 that was replaced with a bronze statue of St Peter.

Apollodorus of Damascus (fl.2nd century CE)
Trajan's Column, marble, 107–13 CE

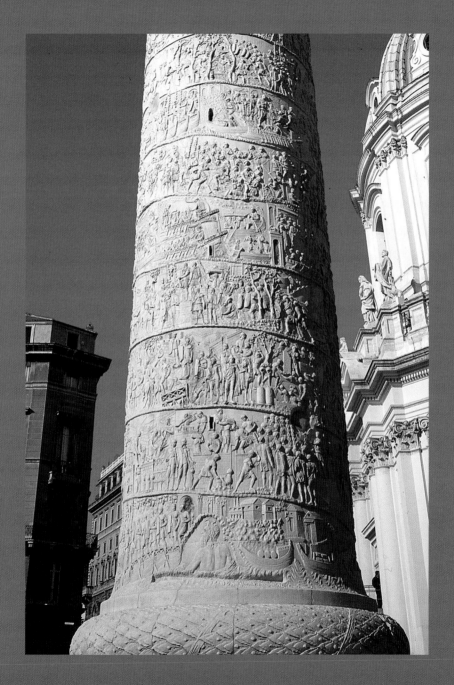

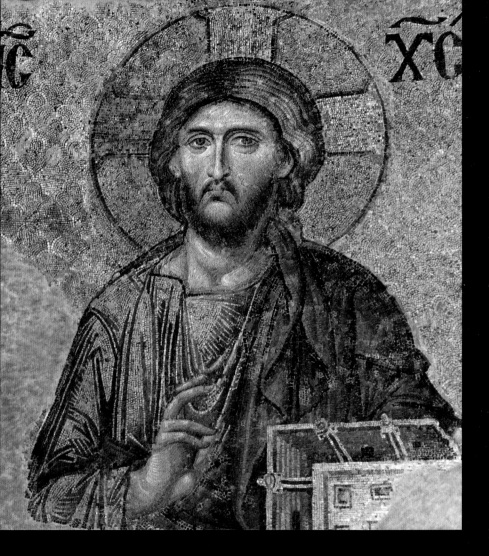

'Byzantine mosaics were created to help worshippers **imagine**
what the **saints and heaven** might look like.'

Deësis
humanizes saints

Hagia Sophia, also called Church of the Holy Wisdom or Church of the Divine Wisdom, is a cathedral built in Constantinople (now Istanbul, Turkey) over a period of just six years from 532 to 537 CE, under the direction of the Eastern Roman emperor Justinian I (c.482–565 CE). This mosaic was created on the ceiling of the church, most probably after the restoration of Byzantine rule in Constantinople in 1261.

Byzantine mosaics were produced to help worshippers imagine what the saints and heaven might look like, and the Deësis – meaning prayer or supplication – became an established motif in Byzantine and later Eastern Orthodox art. It depicts Christ on a throne flanked by the Virgin Mary, his mother, and St John the Baptist, his first cousin. The two saints are appealing to Jesus for mercy on behalf of all humanity. Known also as *Christ in Majesty* or *Christ Pantocrator*, in this image, he is conventionally enthroned, carrying a holy book. Sometimes, as well as his mother and cousin, other saints and angels are present. In this mosaic, the Virgin Mary and St John are shown in three-quarters profile as they implore Christ to intercede on behalf of humanity on Judgement Day. The entire work is created to make Christ and other saints accessible to 'ordinary' people.

Made up of tesserae – small pieces of coloured glass and stone set at different angles

in plaster – the mosaic was created to glitter in the light of flickering candles in the church. Set in a semi-dome, the figures appear to float in the golden background, creating the sense that they are in a spiritual, other world, high above the worshippers. 'Pantocrator' commonly translates as 'almighty', 'all-powerful' or 'omnipotent', from the Greek words *pas* meaning all and *kratos* meaning strength, might or power, and here he is portrayed in what became a traditional representation, to make him more accessible to white-skinned viewers. His hair, eyes and beard are brown, his skin pale, his hair centrally parted and his face bearded; he looks directly at the viewer, his right hand raised in blessing and his left hand holding a book of gospels. His extremely costly blue and gold robes – made with precious gold and lapis lazuli – convey his magnificence and holiness. While the image is largely two-dimensional, the slight shifting of Christ's head to the left conveys a subtle impression of depth and perspective. His face is also foreshortened; the eyes are of different sizes when viewed from some angles.

On either side of his halo, Christ's name is written as IC and XC. Additionally, his fingers are depicted in a pose that represents the letters IC, X and C, which together make up the name Jesus Christ.

Artists unknown
Deësis, mosaic, c.1261

Wang Xizhi Watching Geese
contemplates the unreal

Long before Western artists painted landscapes for their own sake and not as mere backdrops for figures, Chinese painters had seen them as important subjects in their own right, and often used them to convey the power of nature. The exotic and varied landscape of China was an essential aspect of the Chinese psyche, and for centuries mountains were perceived by the people as sacred, home to deities. The Chinese term for landscape painting, *shanshui hua*, translates as 'mountain water painting'.

The legendary Jin Dynasty calligrapher, writer, politician and practitioner of Daoist alchemy Wang Xizhi (303–361 CE), also known as Yishao, was nicknamed the 'Sage of Calligraphy' by future generations and is traditionally also called one of China's 'Four Talented Calligraphers'. Here he is depicted standing in a waterside pavilion with a young attendant. They look out on to an open river, framed by distant mountain peaks, as two graceful long-necked white geese glide across the still waters before them. It is said that the elegant forms and movements of geese inspired Wang's refined calligraphic style, and for this purpose he bred them. According to legend, he was so fond of these birds that he would travel for miles to study a particularly interesting breed. He loved his geese and they lived in luxury while he watched their movements closely on his own pond. This inspired him to develop his unique method of turning his wrist as he produced his calligraphy.

In creating his suggestions of the past, the artist of this work, Qian Xuan, deliberately evokes an atmosphere of unreality. Although he painted the image in the late thirteenth century, he incorporated earlier stylistic elements to reflect Wang's era. This 'blue-and-green style' was developed and became popular during the Tang Dynasty (618–907 CE), and the serene, structured forms recall even earlier landscapes painted from the fourth to the sixth centuries, often by artists illustrating Buddhist or Daoist ideas of paradise.

Qian Xuan – who lived through the Mongol conquest (which brought the fall of Hangzhou, the Southern Song capital, in 1276) and the subsequent total collapse of the Song Dynasty – seems to have intentionally emphasized aspects of China's calmer and happier past in his work. After those events, he and many other disheartened Chinese intellectuals withdrew from public life and instead chose to live as a *yimin*, or 'leftover subject', of the dynasty. Qian Xuan worked privately, shut away from others, and concentrated on his painting. In particular, he rejected much of the earlier emphasis on Chinese traditional painting, technical skill and naturalistic devices in favour of a freer method of self-expression.

Qian Xuan (1239–1301)
Wang Xizhi Watching Geese, handscroll, ink, colour and gold on paper, c.1295

'Long before Western artists painted **landscapes** for their own sake and not as mere **backdrops for figures**, Chinese painters had seen them as **important subjects in their own right**.'

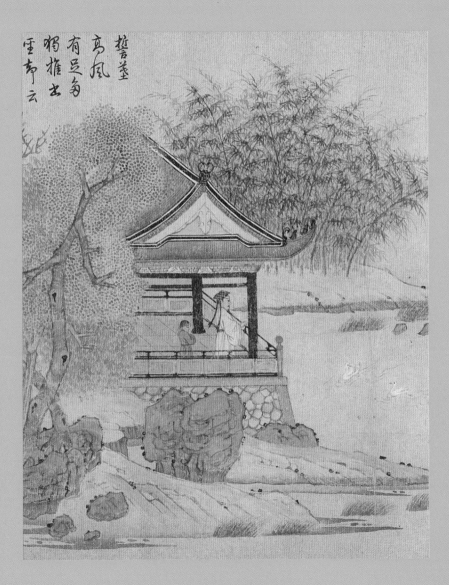

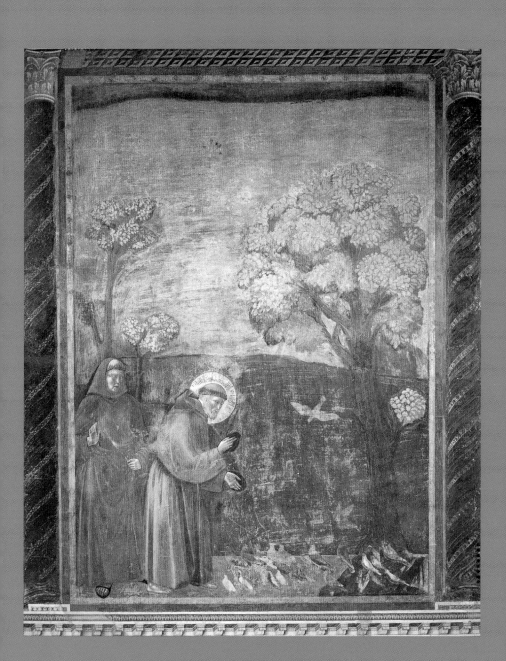

'Read like a **huge, colourful cartoon**, the scenes give
a **chronological account** of St Francis's life.'

The Legend of St Francis chronicles a saint's life

In his youth, the Italian theologian and monk St Bonaventure (c.1217–1274) reported that he was saved from untimely death by the prayers of Francis of Assisi (1181/2–1226). In consequence, in 1260 Bonaventure wrote the official biography of St Francis, dividing his life into 97 episodes. Almost 40 years later, it is generally believed that the artist Giotto di Bondone began illustrating 28 of those events on the walls of the basilica of San Francesco in Assisi.

The Legend of St Francis is customarily attributed to Giotto, but in fact this is not verified, since all the Franciscan friars' documents relating to artistic commissions during the period were destroyed by Napoleon's troops in 1800. Some scholars suggest that the frescoes were painted by at least three other artists. However, the images are so naturalistic and break so definitively with most art of the time that Giotto has been commonly credited with their creation, being one of the first to change the accepted styles of Byzantine art by introducing more natural poses and emotions.

Whoever created it, the work relays some of the most significant incidents in the life of the founder of the Franciscan Order and the patron saint of the environment and of animals. Read like a huge, colourful cartoon, the scenes give a chronological account of St Francis's life. In the first, *Homage of a Simple Man*, an ordinary man spreads out his cloak before a young nobleman. With his golden halo, the nobleman can be identified as St Francis. In the second scene, *St Francis Giving his Mantle to a Poor Man*, Francis hands his expensive golden cloak to a poor man. This is the first suggestion that he will give away his worldly goods.

The fourth scene, *The Miracle of the Crucifix at San Damiano*, shows Francis as a soldier going to battle, when he hears God's voice urging him to return home. He goes back to Assisi and, in the nearby dilapidated church of San Damiano, hears the voice of Jesus saying, 'Francis, go and repair my house, which, as you see, is falling into ruin.' Subsequently, Francis sold all he owned, including many of his father's goods, to raise money to repair the church. Furious, his father disinherited him. Francis freely relinquished all the possessions that would be his through his father, even his own clothes, symbolizing that from that time, God would be his only father.

The imagery continues throughout the saint's life, describing many of the events leading to his canonization and miraculous happenings after his death. The fifteenth scene is the *Sermon to the Birds*. Francis believed in the brotherhood of all, and one day, as he was travelling, he noticed a huge flock of birds watching him from some trees. He began an impromptu sermon, telling the birds that God had given them the greatest gift, the freedom of the air. As he spoke, the birds bowed, then flew away to pass on the news of God's love.

Giotto di Bondone (c.1267–1337)
The Legend of St Francis, fresco, 1297–1300

The Wilton Diptych
turns a king into a saint

Created as a portable altarpiece for the private devotion of King Richard II (1367–c.1400), this diptych combines spiritual and secular elements. It is generally believed to have been made around the time of Richard's second marriage, to the 6-year-old Isabella of Valois. Small, hinged paintings of this kind were carried on travels and opened for prayer. The artist is unknown, but the title derives from Wilton House in Wiltshire, where it was housed between 1705 and 1929.

On the left-hand side, Richard is presented by three saints to the Virgin and Child, who are surrounded by 11 angels. Identified by their attributes, the saints with Richard are (from left to right) Edmund the Martyr with an arrow, Edward the Confessor with a ring, and John the Baptist with a lamb. They are in an earthly landscape, while opposite, the Virgin, Child and angels are in a meadow strewn with flowers. All the angels wear badges depicting the white hart, Richard's personal device. One holds a pennant displaying the red cross of St George, which refers both to Christ's Resurrection and to England.

As Richard kneels before the holy figures, Christ appears to bless him while gesturing towards the pennant above his head. The scene also references Richard's birth on 6 January, the feast of Epiphany, when Christ was visited by three Magi. The feast of the Baptism of Christ by John the Baptist was celebrated on the same day, and the depiction here of John in his hermit's dress carrying a lamb recalls the shepherds who visited the Holy Family soon after Christ's birth (in art, the event is often combined with the Magi visit). The 11 angels probably refer to the Old Testament story of Joseph's dream in which the sun, the moon and 11 stars bowed down to him.

The Virgin, Christ and the angels all wear blue made from the costly semi-precious stone lapis lazuli. Richard's robe is painted in gold and vermilion, also extremely expensive pigments. It is decorated with white harts, and with sprigs of rosemary, the emblem of his late wife, Anne of Bohemia. He also wears a gold collar decorated with broomscods, seed pods of the common broom. Richard's Plantagenet dynasty derives its name from a variety of common broom known as *planta genista*.

The image is possibly also a family portrait. The three saints resemble Edward III, Richard's immediate predecessor, with his sons Edward the Black Prince (Richard's father) and John of Gaunt (Richard's uncle). The Virgin Mary bears a resemblance to Richard's mother, Joan of Kent, and the infant Jesus seems to depict Edward of Angoulême, Richard's older brother, who died in childhood. Overall, the painting indicates Richard's belief in his divine right to rule, his devout Christian faith and the importance of his late family.

Artist unknown
The Wilton Diptych, egg tempera on oak, c.1395–99

'Created as a portable altarpiece for **private devotion**, this diptych combines **spiritual and secular elements**.'

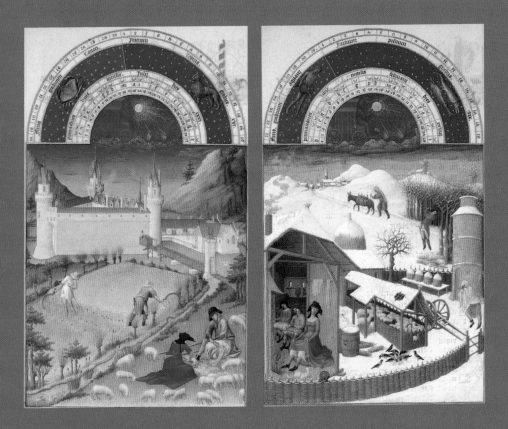

'In all, it is likely that a **wide range of artists and assistants** worked on the manuscript, which contains 131 images, including **miniatures**, **calligraphy**, **illuminated letters** and other **decorations.**'

Les Très Riches Heures
celebrates the seasons

Les Très Riches Heures du Duc de Berry (*The Very Rich Hours of the Duke of Berry*) is a book of hours, a collection of prayers to be said at certain times of day that was particularly popular in Europe during the medieval period. The artist brothers Herman, Paul and Johan Limbourg began the work in the late International Gothic style for John, Duke of Berry (1340–1416), the third son of the future king of France. However, by 1416, before they had finished it, all three brothers and the duke were dead, probably of the plague, so the manuscript was left unfinished. Nearly 30 years later, in the 1440s, an anonymous artist – generally thought to have been Barthélemy d'Eyck (c.1420–after 1470) – added to the illuminations, and in 1485–89 Charles I, Duke of Savoy, commissioned the painter Jean Colombe (c.1430–c.1493) to complete it. In all, it is likely that a wide range of artists and assistants worked on the 206-page manuscript, which contains 131 images, including miniatures, calligraphy, illuminated letters and other decorations.

That number of illustrations, plus the use of rare and expensive pigments – including *vert de flambe*, a green obtained from crushed flowers mixed with the mineral massicot; *azur d'outreme*, an ultramarine made from crushed Middle Eastern lapis lazuli; and gold leaf – means that *Les Très Riche Heures* is generally perceived as one of the greatest examples of this type of art. Within it is a calendar, and these two images are part of that, representing February and July, both painted by Paul Limbourg. His exacting detail is achieved through fluid paint, extremely fine brushes and lenses to help him see each tiny element.

In February, thick snow covers a farm. A sheep pen, four beehives and a dovecote with doves on the ground can be seen. A man chops down a tree with an axe, bundles of sticks at his feet; another blows on his hands for warmth; and in the background, another is driving a donkey, loaded with wood, towards a nearby village. A wooden house is cut away so that the interior can be seen, revealing a woman and two younger figures warming themselves – especially their legs – in front of a fire.

The painting for July is bathed in sunlight. Two figures with scythes are harvesting wheat, while nearby a man and a woman shear sheep. The River Boivre is behind them, and the resplendent white and blue Comtal Palace of Poitiers, which represents wealth and contrasts directly with the poor labourers. Above each image are the astrological signs for those particular months – Aquarius and Pisces, and Cancer and Leo – with the chariot of the sun below them.

Limbourg Brothers (fl.1385–1416)
Les Très Riches Heures du Duc de Berry, tempera on vellum, 1410–16

The Holy Trinity
with the Virgin
mixes religion with reason

Representing God the Father, Christ the Son and the Holy Spirit, this mural was commissioned by members of a local family for their remembrance chapel in the Santa Maria Novella in Florence. The artist was Tommaso di Giovanni di Simone Cassai, known as Masaccio (meaning 'clumsy Tom', because allegedly he paid attention to his art and little else). Despite a career that lasted just seven years, he was one of the most important artists of the Early Renaissance, with an enduring influence, particularly through his introduction of single-point linear perspective and naturalism, ideas that dominated painting until the late nineteenth century.

Masaccio's skill in painting lifelike figures, combined with the powerful impression of depth and distance, made him instantly admired. Linear perspective is the technique of portraying three dimensions on two-dimensional surfaces. It was first written about by Leon Battista Alberti in his treatise *Della Pittura* (*On Painting*) of 1435, but was used by Masaccio several years before that, as can be seen in this fresco. It stunned contemporary viewers. To unaccustomed eyes, it looked as if another chapel had been built in the church, with Ionic columns, Corinthian pilasters and a barrel-vaulted ceiling. Inside it, the crucified Christ is supported by God standing behind him and the Holy Spirit – a white dove – above, flanked by John the Evangelist and the Virgin Mary. As well as linear perspective, Masaccio's original and naturalistic use of tone made his life-sized figures seem real and solid at a time when most other paintings looked flat. In front of the entrance pillars to this holy chapel, Masaccio painted life-sized images of the husband-and-wife donors kneeling, facing each other. Below this, seemingly beneath the floor of the chapel, is a skeleton representing Adam, the first man. Accompanied by the inscription 'I was once as you are and what I am you also shall be', this is a memento mori, a reminder of the inevitability of death.

In 1570 a stone altar was built in front of the painting, hiding it from view for almost three centuries. Then, in 1861, the altar was removed, revealing most of the fresco once more. In 1952 the skeleton was also uncovered and the entire image was on show again. The two themes of Jesus on the Cross attended by God the Father and the Holy Spirit, plus Mary and John, and the memento mori were fairly common in fifteenth- and sixteenth-century art, but this was the first time they were merged. This image is a combination of religion and reason: reason in the linear perspective and the harmony of the classical architecture; and religion apparent in the suggestion that through piety and prayer, we will all find everlasting life in heaven.

Masaccio (1401–1428)
The Holy Trinity with the Virgin, Saint John and Two Donors, fresco, 1426–28

'Masaccio's skill in painting **lifelike figures**, combined with the powerful impression of **depth** and **distance**, made him **instantly admired**.'

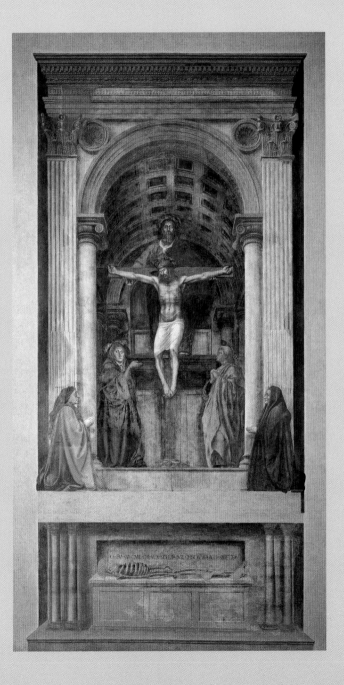

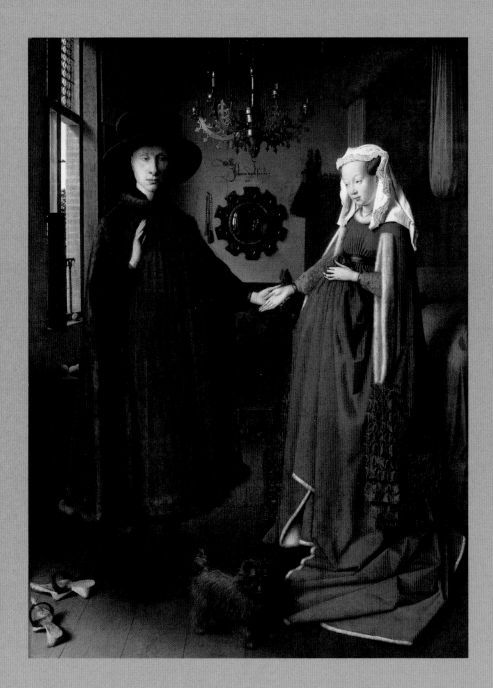

'Costanza is **not pregnant**, as has often been suggested, but is holding up the **heavy green broadcloth gown** with its **expensive cutwork**. Away from the portrait, she would need a maid to hold the garment off the ground.'

The Arnolfini Portrait
shows off riches

A man and a woman stand in a room, holding hands. They are generally believed to be Giovanni di Nicolao Arnolfini and his late wife, Costanza Trenta, who died the year before this was painted. The artist was Jan van Eyck. Although little is known of his life, he is recognized as one of the earliest artists to use oil paint. Pigment mixed with linseed oil dries more slowly than egg tempera, allowing him to make semi-transparent, richly coloured glazes and adjust elements as he worked.

Both an artist and a diplomat, Van Eyck worked mainly for the prosperous Philip the Good, Duke of Burgundy. Arnolfini, a member of a successful merchant family from Lucca in Italy, lived in Bruges, and supplied silk and velvet to the duke. The painting is abundant with symbols showing the Arnolfinis' wealth and social standing. Both Giovanni and Costanza came from successful mercantile families, and they are shown in an upstairs room in early summer, indicated by a cherry tree outside the window. Flanders was the centre of a great trading empire, and some of its merchandise is in evidence, including fur, silk, wool, linen, leather and gold. Dyes of red, black, green and blue used in the clothing and soft furnishings were all highly expensive. Costanza is not pregnant, as has often been suggested, but is holding up the heavy green broadcloth gown with its expensive cutwork. Away from the portrait, she would need a maid to hold the garment off the ground. The sleeves and blue underdress are trimmed with either squirrel or Arctic fox fur, and Giovanni's velvet tabard is lined with the fur of the pine marten. Fur was tremendously costly. His tabard is dyed a plum colour – another statement of affluence, because dark and bright dyes were more expensive to produce than lighter colours – and beneath this he wears a silk-damask doublet. The fine lace around the edge of Costanza's veil and the gold and silver cuffs on the couple's wrists all place them among the wealthy citizens of Bruges, but they are bourgeois rather than aristocratic, since their jewellery is restrained and they wear fur from certain animals but not others.

Ripe oranges on the chest beneath the window and on the windowsill have been imported from the south. Expensive bed hangings, an Oriental rug, the gleaming brass chandelier and the mirror on the wall further indicate prosperity. Only the rich could afford mirrors, and this shiny convex glass is surrounded by a frame featuring miniature scenes of Christ's Passion. The backs of the Arnolfinis are reflected in the mirror, along with two figures in the doorway, probably the artist and his wife.

Jan van Eyck (before 1395–1441)
The Arnolfini Portrait, oil on oak, 1434

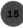
The Descent from the Cross
displays despair

Internationally famous during his lifetime, Rogier van der Weyden became painter to the city of Brussels and worked for several of the most powerful characters of the time, including Philip the Good of Burgundy and, in Italy, the Medici and d'Este families. Unfortunately, he did not sign his work, so many paintings cannot be formally attributed to him.

This is the central panel of a triptych, painted for a chapel in Brabant, Flanders. It became hugely influential to other artists even centuries after Rogier's death. Set on a gold background, it conveys a story of great grief. After the Crucifixion, Christ's body is taken down from the Cross. Ten almost life-sized figures are contorted in despair. Stretching diagonally across the composition, Jesus is lowered, still wearing the Crown of Thorns, the strong light giving his pale skin a pearlescent glow. His head falls to the side and the wound on his chest produces blood and water, as described in the Bible. His translucent loincloth, made from one of his mother's veils, is untouched by the blood.

The three men lowering Christ's body are a servant (at the top), holding two bloodstained nails removed from Christ's hands; a bearded man in red who is probably Nicodemus, a Pharisee (member of an ancient Jewish sect); and a man in cloth of gold lined with fur, almost certainly the wealthy Joseph of Arimathea, who gave Christ his own new tomb. On the far right,

Mary Magdalene weeps, wringing her hands. A bearded man in green stands nearby, behind Joseph of Arimathea, holding a pot that is traditionally Mary Magdalene's device, containing spikenard, an extremely expensive ointment that she used to anoint Christ's feet before the Crucifixion. On the left-hand side, the Virgin Mary swoons in grief, her face deathly white and her pose echoing that of her son. Her fainting in this way was completely unprecedented in early Netherlandish art. She is supported by St John the Evangelist and a woman in green, probably Mary Salome, her half-sister and St John's mother. The sobbing woman behind her is most likely Mary Cleophas, the Virgin's other half-sister.

The Virgin's brilliant blue gown is made of the costly semi-precious pigment lapis lazuli. Rogier has extended it to cover the base of the Cross and part of the ladder. The man in green tilts so that his right foot and the furred hem of his robe hide the other side of the base of the ladder. Symbolism is everywhere. Golgotha, the Place of Skulls, where Jesus was crucified, is indicated by the skull and bones on the floor. Traditionally, the skull is Adam's, which creates the biblical link between original sin and the offer of salvation by Christ's sacrifice on the Cross.

Rogier van der Weyden (c.1399–1464)

The Descent from the Cross, oil on oak panel, c.1435

'The Virgin Mary **swoons in grief**, her face deathly white and her pose echoing that of her son. Her fainting in this way was **completely unprecedented** in **early Netherlandish art**.'

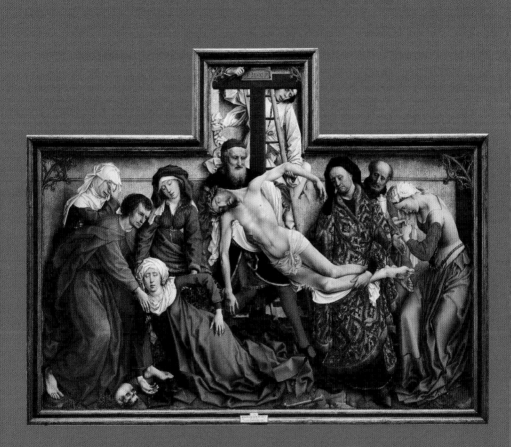

Penitent Magdalene
shocks with reality

Donato di Niccolò di Betto Bardi, known as Donatello, was one of the greatest Florentine sculptors, a prolific and versatile figure of the early Renaissance who worked in stone, metal, wood, terracotta and bronze. This innovative artist developed sculpture from the Gothic style in which he was trained, creating anatomically accurate figures that are astonishingly realistic. He pioneered the use of the single vanishing-point perspective system in relief sculpture, and he created the first male nude statue since classical antiquity. His expressive, naturalistic works stunned early viewers and influenced sculptors for centuries.

Probably commissioned for the Baptistery of Florence, this work was received with astonishment for its unprecedented realism. Almost life-sized, it represents Mary Magdalene, who is described in the Gospel of St Luke as a woman 'who lived a sinful life ... [and] stood behind [Jesus] at his feet weeping [and] began to wet his feet with her tears. Then she wiped them with her hair, kissed them and poured perfume on them.' After reciting one of his parables, Jesus told her, 'Your sins are forgiven.'

The *Penitent Magdalene* was a popular theme in art during the Renaissance and afterwards. According to the Bible, Mary Magdalene had been a prostitute but regretted her past, and after the Crucifixion she spent 30 years in the desert atoning for her sins. Western legends proclaimed that she was not affected by the ravages of time, and was fed each day in the desert by angels. For this reason, most Western artists portrayed her as an ageless beauty, but Donatello's version bears more resemblance to Eastern Orthodox icons of Mary of Egypt, the patron saint of penitents, who was worn and emaciated. Donatello shows her as she might have looked without any spiritual protection: haggard, gaunt and wrinkled, clothed in rags, her long, straggly hair matted and her slightly open mouth revealing missing teeth. She epitomizes repentance.

No contemporary documents about the work are known, so its original location cannot be verified, but during the 1480s it was seen in the Baptistery of Florence by Charles VIII of France when he camped nearby with his army. The fact that the figure is not completely finished at the back suggests the possibility that she was originally in a frame against a wall. Donatello was over 60 when he created this statue, after spending a decade in Padua and suffering from a long illness. He now understood the feelings of weariness and weakness associated with age and illness, and he faced his own mortality. This stunningly realistic interpretation of the subject was unprecedented, and indeed for centuries afterwards most artists still represented holy figures as beautiful and ageless. Donatello's treatment brings the subject into stark reality: Mary Magdalene's life of prostitution has stolen her beauty.

Donatello (1386–1466)

Penitent Magdalene, white poplar wood, 1453–55

'Donatello shows her as she might have looked **without any spiritual protection**: **haggard, gaunt and wrinkled**, clothed in **rags**, her long, straggly hair matted and her slightly open mouth revealing missing teeth.'

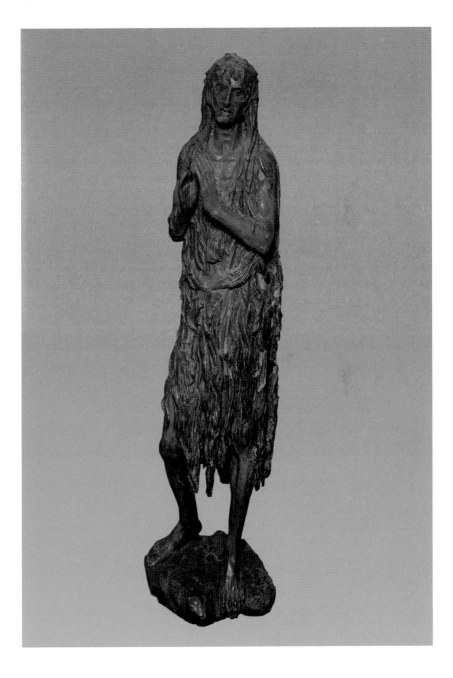

'This is one of the few works Lippi executed **without his assistants**, and it influenced many **later artists' depictions** of the **Madonna and Child**.'

Madonna and Child
announces secret liaisons

Surrounded for much of his life by scandal, Filippo Lippi grew up in monasteries, was ordained as a priest, became a chaplain to nuns, lived with a nun, fathered children and faced lawsuits. He was inspired to become a painter by watching Masaccio at work.

In 1456 Fra Filippo – as he was known – was chaplain of the monastery of Santa Margherita in Prato, near Florence. He was also painting frescoes in the cathedral there, and a young novice nun, Lucrezia Buti, posed for him as the Virgin Mary. As Lucrezia sat for him, they fell in love. In similar circumstances to Lippi, Lucrezia had been forced to enter the monastery because of her family's poverty. It was an impossible situation, and during a procession, Lippi 'kidnapped' Lucrezia and took her to his house, where they lived as man and wife.

The commission and execution dates of this painting are not verified, but in 1457 – the year in which Lippi and Lucrezia had a son, Filippino – the powerful Giovanni de' Medici commissioned the artist to paint a panel for the King of Naples. This may be that work; some scholars suggest that it was instead produced by Lippi purely to celebrate the birth of his son, but this has not been substantiated. It is one of the few works he executed without his assistants, and it influenced many later artists' depictions of the Madonna and Child, especially Sandro Botticelli.

Unlike most paintings of the period, this work conveys softness, spontaneity and naturalism. The Madonna sits on a throne, of which only an embroidered cushion and a carved wooden arm can be seen. She looks lovingly at her plump, blond baby, who is wrapped in swaddling and carried by two angels. He reaches out to her as she prays, her delicate, elegant hands pressed together. Her expression is gentle and contemplative, as if she anticipates her son's tragic destiny. The angel in the foreground looks at viewers and smiles, while the other three figures seem to be aware only of each other. It is an intimate scene; the four figures are in close proximity to each other. Behind them, a window opens on to an open, rocky landscape, with trees and buildings nearby and the sea in the distance.

Dressed stylishly in a dark-blue velvet gown, with pearls in her carefully dressed hair, the Madonna projects the notion of a contemporary Florentine noblewoman. The halos are merely hinted at as fine rings of light. The sixteenth-century artist, critic and biographer Giorgio Vasari wrote that Lippi was so lustful that Cosimo de' Medici had him locked in when the artist was working for him. However, the enduring passion of his life was Lucrezia Buti, as can be seen in this love-filled painting.

Filippo Lippi (c.1406–1469)
Madonna and Child, tempera on panel, c.1460–65

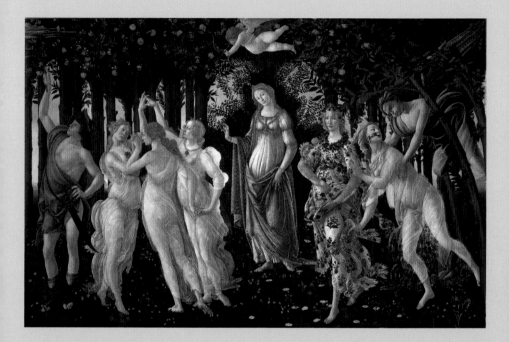

'Contemporary viewers would have enjoyed interpreting the **symbolism** throughout the image.'

La Primavera
mixes pagan with Christian

Created for Lorenzo di Pierfrancesco de' Medici, a member of the most powerful family in Florence, this painting is an allegory. It is set in the garden of Venus, the ancient Roman goddess of love and beauty, and conveys the abundance and fecundity of spring.

Alessandro di Mariano Filipepi, nicknamed Sandro Botticelli (from *botticello*, a small wine cask), was the first artist to create large-scale mythological scenes and treat them with as much earnestness as religious themes during the Renaissance. In 1550 Giorgio Vasari called this painting *Primavera* and described it as depicting 'Venus as a symbol of spring being adorned with flowers by the Graces'. Drawing inspiration from classical and contemporary poetry, including the works of Ovid, Lucretius and Poliziano, Botticelli filled the image with symbolism. Through the fresh growth of spring and the ideals of Neoplatonic love that were popular at the time, the painting portrays notions of love, marriage and fertility. Neoplatonism was a philosophical and aesthetic movement that aimed to blend the theories of the Greek philosopher Plato with Christianity, and the Neoplatonic conception of ideal beauty and absolute love was highly influential during the Renaissance. Neoplatonic philosophy considered Venus to be an embodiment of both earthly and divine love. She was an equivalent of the Christian Virgin Mary, and in this image, she seems to portray both.

Contemporary viewers would have enjoyed interpreting the symbolism throughout the image. For instance, Venus is framed by an arc of blue sky that draws the eye towards her and the dark leaves of a myrtle bush that was traditionally thought to represent sexual desire, marriage and fertility. Above Venus, her son, a blindfolded Cupid, fires his arrow of love. On the far right, the blue-faced Zephyr, god of the west wind, chases the nymph Chloris and, after taking her as his bride, transforms her into Flora, the goddess of flowers, who scatters roses across the grass. Flora symbolizes spring, beauty and the city of Florence itself.

On the left of Venus, the three Graces, Aglaea, Euphrosyne and Thalia, embody the beauty and fruitfulness of spring. Their names mean splendour, joy and festivity, or pleasure, chastity and beauty. Further to the left, Mercury, the messenger of the gods, guards the garden and chases away clouds. His red cloak symbolizes rising heat, as spring transforms into early summer and everything becomes more fertile, suggested by the ripening fruit on the trees and the unfurling flowers. Five hundred different varieties of plant grow in this garden, including roses, daisies, cornflowers, coltsfoot, carnations, periwinkle and hyacinths. Oranges – which in real life do not ripen at the same time as the flowers – are featured as the emblem of Botticelli's patrons, the Medici dynasty.

Sandro Botticelli (c.1445–1510)
La Primavera, tempera grassa on wood, c.1480

The Garden of Earthly Delights
discourages sinning

Jheronimus van Aken, who later called himself Hieronymus Bosch, was born to a family of painters in the busy town of 's-Hertogenbosch in the Netherlands. Little else is known of his life, but he became internationally renowned during his lifetime for his imaginative and unique biblical depictions. His moralizing messages were expressed through distinctive and fantastic ideas that powerfully influenced the Surrealists almost 500 years later. He painted this triptych to show the consequences of sin. The patron was Engelbert II of Nassau, of Brussels, but not much more is known about the work except that it was created as an altarpiece. Overall, it aims to deter viewers from sinning by showing the terrible consequences if morals are disregarded in the pursuit of pleasure during life.

Filled with symbolism, the three panels convey stories from the Bible that describe humanity's origins and activities. In the left-hand panel, God presents Eve to Adam. As Adam awakes, he gazes at Eve in amazement, while she modestly averts her eyes. Behind them is a lush landscape filled with creatures of all kinds, both real and mythical. This is the heavenly Garden of Eden. Bosch had never seen many of the animals he painted, so it is likely that he copied several of them from travel books. Throughout the triptych, he uses pink to represent divine influences; for instance, the pink fountain in the centre symbolizes the flow of divine energy from heaven to Earth.

In the centre panel, humans and animals thrive in the Garden of Earthly Delights. It's a hedonistic place, and the now numerous males and females mingle happily with animals and imaginary creatures. All is bizarre and fantastic; all the people are naked and enjoying life amid giant pieces of fruit and strange, organic-looking objects. A great bird perches on a red tent-like structure crowded with figures, and another massive bird feeds a man from its beak. A huge fish is on the grass, a large blue orb rises from a lake, figures are suspended in a transparent sphere and a giant owl emerges from another lake. The fruit represents temptation and the transitory, fleeting nature of pleasure. In this panel, there are no children or old people and God has disappeared. It seems to represent the time before God expelled humans from paradise.

With a landscape immersed in darkness and chaos, where nothing grows and where humans are trapped in darkness and discomfort, the right-hand panel is hell, or after the Last Judgement. Musical instruments depict different forms of excess and vice, especially lust, vanity and gluttony; and those who have indulged throughout their lives are now being crucified on the instruments, while a bird-like creature is eating humans.

Hieronymus Bosch (c.1450–1516)
The Garden of Earthly Delights, oil on oak panels, c.1500–5

'Bosch's **moralizing messages** were expressed through **distinctive** and **fantastic** ideas that powerfully influenced the **Surrealists** almost 500 years later.'

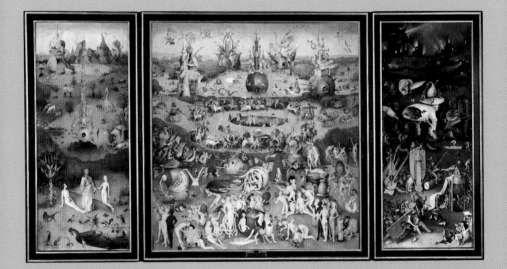

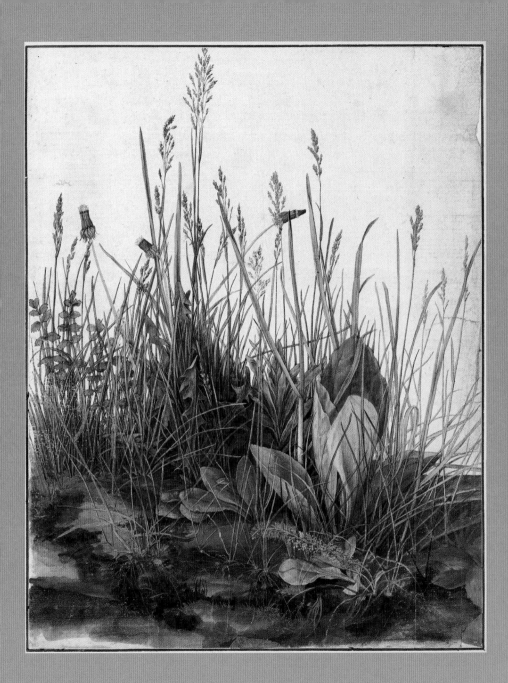

'At the time Dürer produced this painting,
the **realistic representation of nature** was not something
that **Western artists** aspired to.'

The Great Piece of Turf
studies nature

Born in Nuremberg, the painter, printmaker and theorist Albrecht Dürer established a reputation across Europe from a young age, mainly through his detailed engravings and woodcut prints that were sold widely. The first German artist to study art in Italy rather than the Netherlands, Dürer met and became inspired by Italian artists including Raphael, Giovanni Bellini and Leonardo da Vinci, and he was commissioned by several prestigious patrons. His vast body of work includes engravings, woodcuts, oil paintings and watercolours, and he was one of the first artists to produce self-portraits and landscape paintings in their own right, rather than as elements in religious scenes. Through his knowledge of Italian artists and German humanists and his theoretical treatises that explore facets of mathematics, perspective and proportion, he became one of the most important figures of the Northern Renaissance.

Painted in watercolour with details added in ink, this is a study of a seemingly arbitrary group of wild plants that appear to be naturally interwoven and entangled. They include cock's-foot, creeping bent, smooth meadow-grass, daisy, dandelion, germander speedwell, greater plantain, hound's-tongue and yarrow. The apparent disarray of the arrangement, combined with the meticulous detail of each plant, creates an impression of exceptional realism, while the blank background is a foil to the disorder and imparts a sense of harmony.

At the time Dürer produced this painting, the realistic representation of nature was not something that Western artists usually aspired to, and even though he depicts each blade, stem, leaf and flower in an intensely detailed manner, this was probably a study, created so that he could add authenticity to his other works, such as his engraving *Adam and Eve* of 1504 and the oil painting *The Feast of Rose Garlands* of 1506. The accuracy of each plant's depiction could be mistaken for a scientific botanical drawing, but, rather than each specimen being distinguished clearly, all overlap and intertwine, just as they grow in nature.

Dürer probably dug up the section of undergrowth and placed it in his studio, where he could study it. There is no focal point. The closely observed plants and grasses are a little larger than life size and the composition, although seemingly haphazard, is carefully planned, running at a diagonal angle from bottom right to top left. Dürer wrote books on compositional techniques, and this was arranged deliberately to draw the eye towards and around the vegetation. Rather than adding anything else, he surrounded it with white space. Contemporary designers understand the power of white space and how it draws the viewer's eyes towards an area of activity; having done this in the early sixteenth century, once again Dürer shows how advanced he was.

Albrecht Dürer (1471–1528)

The Great Piece of Turf, watercolour, body colour and pen and ink on paper, 1503

The Virgin and Child with St Anne
conveys a mother's love

Across an abyss, in a dreamlike landscape, two women and a toddler are close to each other. Misty, distant mountains convey atmospheric perspective and foreground rocks show detailed realism, demonstrating the work of an artist interested in optics and geology.

Painted for the French king Louis XII by Leonardo da Vinci, this depicts St Anne, the Virgin Mary and the infant Jesus; or, in relationship terms grandmother–mother, daughter–mother, grandson–son. The painting was possibly commissioned by Louis to celebrate the birth of his daughter Claude in 1499, since Anne was the name of both his wife and the patron saint of infertile and pregnant women. However, because Leonardo spent so long finishing it – as always, he was involved with several other projects at the same time – Louis never received it. Eighteen years later an observer saw it in Leonardo's workshop. This was two years after Louis XII's death and when Leonardo was living with the succeeding French king, François I, in France.

In the painting, Christ plays with a lamb and his mother tries to restrain him. The lamb is a symbol both of Christ's innocence and of his later sacrifice for humanity. In the Bible, John the Baptist sees Jesus and exclaims, 'Behold the Lamb of God, which taketh away the sin of the world.' Similarly, the prophet Isaiah refers to Jesus: 'Though harshly treated, he submitted. Like a lamb led to slaughter ...

he did not open his mouth. Seized and condemned, he was taken away.' The Lamb of God is a familiar term for Jesus among Christians, so the symbolism would have been apparent to contemporary viewers. To create a sense of intimacy and draw the eye towards the focal point, Leonardo arranged the figures as a pyramid within the landscape. Although the depiction of these three holy figures together was fairly common at the time, the Virgin Mary had never been portrayed sitting on her mother's lap. Leonardo did not explain why he painted the two adult women in this way, nor why the somewhat young-looking St Anne is larger than her daughter. As Anne looks at Mary, in turn, Mary looks at Jesus. The artist was drawing attention to maternal love.

Leonardo's characteristic *sfumato* or soft, smoky method of conveying tonal changes and depth adds to the enigmatic aspects of this painting, including the softness and sense of love between the figures. Mary's position on her mother's lap and the painting's unfinished state have generated several psychoanalytical interpretations. Sigmund Freud, for instance, wrote that Leonardo was drawn to exploring and depicting maternal love because he was raised from birth by his blood mother but then, from the age of 5, grew up with his father and stepmother.

Leonardo da Vinci (1452–1519)
The Virgin and Child with St Anne, oil on wood, c.1503–19

'Leonardo's characteristic *sfumato* or soft, smoky method of conveying **tonal changes** and **depth** adds to the **enigmatic aspects** of this painting.'

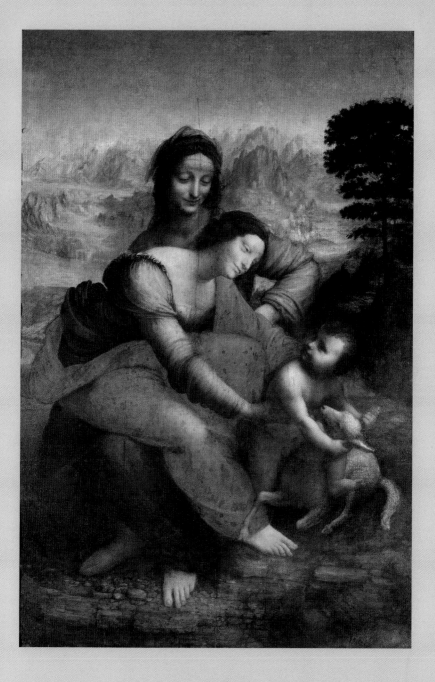

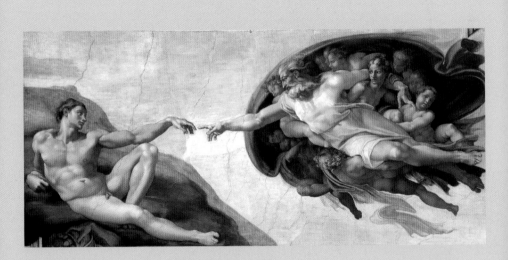

'God is **energetic**, but Adam **lounges**, languorously raising a finger towards his maker. God's imminent touch will **give life** not only to Adam, but to the **entire human race**.'

The Creation of Adam
shows God in action

Painted by the sculptor, architect, painter and poet Michelangelo di Lodovico Buonarroti Simoni, known best as simply Michelangelo, this is the most famous section of the Sistine Chapel ceiling in the Vatican. Michelangelo filled the vast barrel-vaulted ceiling with colourful scenes from Genesis and other books of the Bible, overall painting more than 300 larger-than-life-sized individuals.

Michelangelo was the first Western artist to have not just one, but two biographies published during his lifetime, to be called *Il Divino* (The Divine One), and to have his art described as his *terribilità*, which means having the ability to inspire awe. Here, God floats inside billowing red drapery that is believed by some scholars to form the shape of a brain, symbolizing God's gift of consciousness and intellect along with human life. Other historians believe it is a uterus containing a placenta, indicating that God is creating Adam from a womb.

Whatever it is, within this shape, God is surrounded by other figures. With grey hair and a long beard, he contrasts directly with previous Western portrayals of him. He is still omnipotent, but now gentle and accessible. Michelangelo painted God naked, but after the deaths of Pope Julius II, who commissioned the work, and Michelangelo himself, the subsequent pope, Paul IV, assigned another artist, Daniele da Volterra, the task of painting drapery to cover God's nudity, earning Volterra the nickname 'Il Braghettone' (or 'Brachettone' – 'The Breeches Maker').

God's right arm is outstretched towards Adam as he imparts life from the tip of his finger. Adam's left arm is extended in a pose that mirrors God's, echoing the statement in Genesis that 'God created man in His own image.' The space between their fingers creates tension and dynamism as God bestows life on his creation. God is energetic, but Adam lounges, languorously raising a finger towards his maker. God's imminent touch will give life not only to Adam, but to the entire human race.

Many suggestions have been made regarding the identity and meaning of the figures around God. The woman protected by his left arm could be Eve, Adam's future wife, who will be created next out of Adam's rib. The 11 other figures could represent the souls of Adam and Eve's unborn children, embodying the human race. However, this interpretation has been challenged, since Catholics view the teaching of the pre-existence of souls as heretical. Another theory suggests that the woman is the Virgin Mary, who takes her place of honour next to God, and the child next to her is Jesus, an idea that is corroborated by God placing his fingers on the child as if in blessing.

Michelangelo (1475–1564)
The Creation of Adam, fresco, 1508–12

The School of Athens
assembles great minds

In 1509 Pope Julius II commissioned Raphael Sanzio to decorate some of the rooms in the Vatican's Apostolic Palace. One of those rooms was the Stanza della Segnatura, a council chamber where most of the important papal documents were signed and sealed. Reflecting the contents of the Pope's library, in this room, Raphael aimed to express ideas of both Humanism and Christianity, and the theme of this fresco is the celebration and veneration of wisdom.

In a spacious hall in classical times, a throng of intellectuals from the past have gathered. Raphael departs from centuries of artistic tradition by depicting mainly philosophers from ancient Greece, making philosophy and reason more consequential than faith. Since most of these men were alive at different times, Raphael shows an ideal community of thinkers who can discuss their theories with each other in a way that would not have been possible in reality.

In the centre of the composition, Plato and Aristotle are deep in conversation. Plato, represented as a portrait of Leonardo da Vinci, points to the sky and holds his book the *Timaeus* (c.360 BCE). Aristotle points to the ground and holds a copy of his book *Nicomachean Ethics* (c.350 BCE). Their books and gestures indicate the contrast between Plato's Idealism and Aristotle's Realism. The brooding, black-haired figure on the steps – not included in Raphael's preliminary drawings – is a portrait of

Michelangelo, representing Heraclitus, another Greek philosopher, who wept over human folly. Nearby, standing to Plato's right in a green robe, is Socrates, talking to a group of people, and in front of this group is another with Pythagoras in the middle, writing in a book. Leaning over behind Pythagoras in a white turban and green robe is the Arabic philosopher Averroes (Ibn Rushd), who was responsible for transmitting the philosophies of Plato and Aristotle to the West. Behind him in a blue robe, writing in another book, is Epicurus.

Sitting on the steps in front of Aristotle, half-naked in blue, is Diogenes, who praised self-sufficiency and rejected luxury. In the right foreground, a group of five figures consider a geometrical problem. The bald man is a portrait of the Pope's architect at the time, Donato Bramante, and represents either Euclid or Archimedes, both important ancient Greek mathematicians. He uses a compass and writing slate on the floor to explain a problem. Next to him, in a golden robe, holding a globe and wearing a crown, stands the Greek astronomer and geographer Ptolemy, who believed that the Earth was the centre of the universe. Facing him, with a grey beard and holding a celestial globe, is the ancient Persian prophet Zoroaster. Just to the right of these two is Raphael himself, the only figure in the entire fresco who looks directly out of the image.

Raphael (1483–1520)
The School of Athens, fresco, 1509–11

'Since most of these men were alive at different times, Raphael shows an **ideal community of thinkers** who can **discuss** their theories with each other in a way that would not have been possible in **reality**.'

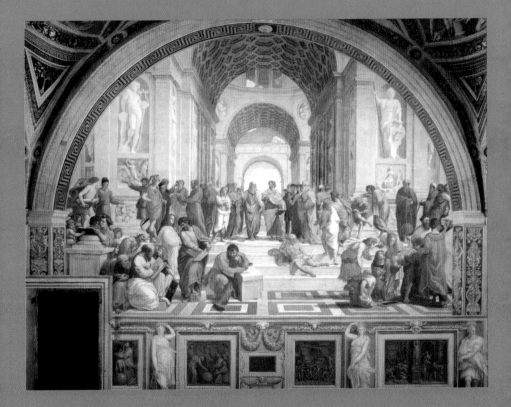

'Pontormo's style contrasted with the **naturalistic** art of the **Renaissance**, rejecting **harmony** and instead **exaggerating, elongating, distorting and flattening space**.'

Deposition from the Cross
stresses irrationality

Jacopo Carrucci da Pontormo, now often known as Pontormo after the town in which he was born, apprenticed in the workshops of highly respected artists including Leonardo da Vinci, Piero di Cosimo and Andrea del Sarto. He was also heavily influenced by the work of his friend Michelangelo. Pontormo was described as a Mannerist painter, and his style contrasted with the naturalistic art of the Renaissance, rejecting harmony and instead exaggerating, elongating, distorting and flattening space, using unnatural colours and frequently featuring *serpentinata*, elongated, curving S-shaped figures.

An almost swirling composition in brilliant colours, this altarpiece contains a group of grief-stricken figures as they lower Christ's lifeless body from the Cross, even though, unusually, no cross is shown in the painting. It could equally be 'The Entombment', but neither is there a tomb. Larger than most of the other figures, Christ's pale, elongated body is itself a *figura serpentinata* as it is carried by two similarly elongated, angelic-looking figures. Although they are bearing the weight of a man, they barely seem to touch the ground; the lower figure in particular balances daintily and improbably on his toes. At the upper right-hand side, dressed in blue, the Virgin Mary – like her son, larger than the other figures – faints. The Swoon of the Virgin was a theme that developed in the medieval period, based on texts of the

apocryphal gospel the Acta Pilati. Although this gospel gained wide credit in the Middle Ages, by the sixteenth century, when Pontormo painted this work, it had become controversial for its lack of substantiation.

The figures, dressed in unnaturally bright colours including blue, pink, orange, red, yellow, green and lilac, are closely intertwined. The setting is an artificial hill, a strategy formulated by Pontormo to justify the figures being placed so high up. One cloud and a crumpled piece of green fabric denote sky and ground. Each figure represents an individual from the Bible, but they do not necessarily conform to their descriptions, and overall the image seems fairly irrational. Some have noted that the poses of Christ and his mother echo those of Mary and Jesus in Michelangelo's *Pietà* (1498–1499), although here they are placed apart. Pontormo has also squeezed in a self-portrait: the bearded man on the far right-hand side, looking directly at the viewer.

This painting took Pontormo three years to complete. He was creating this exaggerated image at a time when the precision of the art of the Renaissance was hugely admired. However, he knew he wanted to create a mystery, so he moved away from much of what he had learned. According to Giorgio Vasari, he screened off the chapel in the Santa Felicità to prevent onlookers from watching him as he worked and offering interfering opinions.

Jacopo da Pontormo (1494–1557)
Deposition from the Cross, oil on canvas, 1525–28

Madonna of St Jerome
makes saints real

Also known popularly as *Il Giorno* (*The Day*), this painting was commissioned by Briseide Colla, a wealthy, recently widowed woman of Parma, as an altarpiece for her family chapel in the church of Sant'Antonio Abate. A companion painting, *The Nativity*, also known as *The Holy Night* or *La Notte* (*The Night*), was completed in about 1530 for the same patron by the same artist, Antonio Allegri da Correggio, known simply as Correggio. This dynamic, naturalistic composition features rich colours, brilliant light, dramatic foreshortening and strong tonal contrasts (chiaroscuro), and it was popular from the moment it was unveiled, being described by Giorgio Vasari as having '*il mirabile colorito*' (wonderful colour).

One of the greatest Italian Renaissance artists and the foremost painter of the Parma school, Correggio became known for his exuberant, spirited paintings characterized by a sophisticated palette, the use of chiaroscuro, and idealized faces and figures. Here, gathered beneath a red awning stretched between trees, with a classical, undulating landscape in the background, animated figures are arranged in a semicircle around the Madonna, who holds the infant Christ on her lap. In the centre of the composition, Mary cradles her baby with a gentle smile. She uses a rock for a footstool, while her golden-haired baby eagerly stretches out his tiny hand for a large book held by St Jerome. An angel turns the pages of the book,

watching Jesus with a smile to make sure he is entertained. The bearded Jerome, with a scroll in his right hand, his identifying lion behind him, fills almost the entire height of the painting on the left-hand side, unconventionally towering over the Madonna. Opposite him is the blonde figure of Mary Magdalene. Dressed opulently as a sixteenth-century lady, she holds Christ's little foot in her hand and leans gently against him so that his left hand can play with her golden hair. Behind her is St John the Baptist, represented as a putto (sacred cherub) and looking out of the painting directly at the viewer – the only figure in the image to do so.

The painting contrasts with traditional images of the Madonna Enthroned or the *sacra conversazione* (sacred conversation), where the Madonna and Christ are usually depicted high up on a golden throne and the holy figures flanking them are conventionally placed on a lower level. This meticulous, apparently motionless treatment of the subject is almost unrecognizable; all the figures are together, touching, moving and on the same level. Because of his height, St Jerome dominates, and the painting breaks with the pyramidal compositions made popular by Leonardo da Vinci. In this lively scene, every holy figure is relaxed, informal and in motion, a state that is emphasized by the billowing clothing and drapery.

Correggio (1494–1534)
Madonna of St Jerome, oil on panel, 1525–28

'In this **lively scene**, every holy figure is **relaxed,
informal and in motion**, a state that is emphasized by
the **billowing clothing and drapery.'**

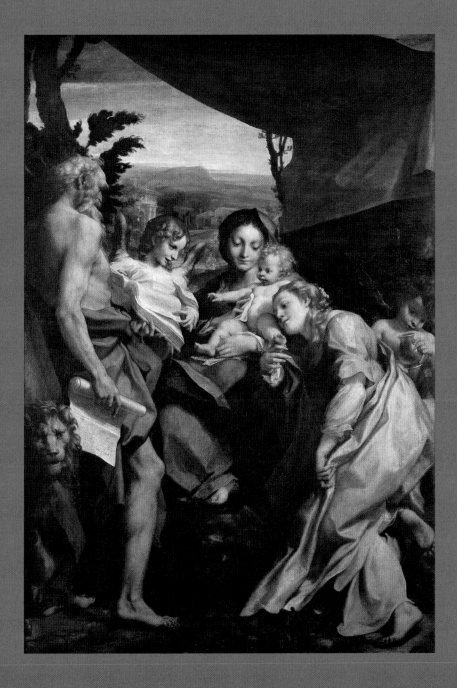

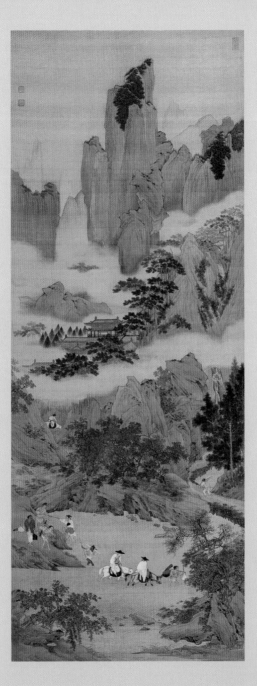

'From early on, in contrast with Western art, Chinese artists were **admired** for painting **landscapes**, and here Qiu has created a **clear, light-filled scene** with tiny figures in the foreground.'

The Emperor Guangwu Fording a River honours a former ruler

Celebrated for his dexterity and technical abilities, Qiu Ying was one of the four most famous painters of the Ming Dynasty (1368–1644) and became the most copied painter in Chinese history. This is an example of what is known as a 'blue-and-green' landscape, and it demonstrates Qiu's proficiency in applying delicate, finely textured ink using elegant brushwork.

The scene conveys a particular moment in history, an incident in the life of Emperor Guangwu (r.25–57 CE), who lived during the Han Dynasty (China's second imperial dynasty; 206 BCE–220 CE). Guangwu initially ruled over only some parts of China, but through his conquest and suppression of regional warlords, by the time of his death the whole of China was consolidated, and his reforms and improvements enabled the Han Dynasty to continue for another two centuries. He formed the Later (or Eastern) Han Dynasty with its capital in Luoyang, 335 km (208 miles) east of the former capital. This was a time of relative peace. Guangwu often found diplomatic, rather than violent, solutions to problems; this was unusual for the period, and for it, as much as for his reforms, he was revered by later generations.

The blue-and-green painting style had been developed during the Tang Dynasty (618–907 CE), and Qiu began using it early in his career. Painting smoothly using azurite and malachite pigments, he built up the landscape with painstaking care. From early on, in contrast with Western art, Chinese artists were admired for painting landscapes, and here Qiu – painting at a time that corresponded with the High Renaissance in Europe – has created a clear, light-filled scene with tiny figures in the foreground. Soft blue and green blend and fade in subtle tonal gradations. The sophisticated marks create a misty, atmospheric scene. The elegant surroundings complement the emperor and his entourage, and the tranquil atmosphere reflects Guangwu's merciful approach.

Another traditional method employed here is *baimiao* ('plain drawing'), a Chinese brush technique that focuses on sinuous, fine outlines. It can be seen in the tall, slender tree trunks fringed by dark-green, feathery leaves. The only white areas in the image are the small figures moving below the mountains. Subtle invocations of tonal contrast and soft colour play against the outlines, including the twisting ribbon waterfall and the crisply delineated temple in the centre of the composition.

Qiu Ying (c.1494–c.1559)

The Emperor Guangwu Fording a River, hanging scroll, ink and colour on silk, c.1530–52

The Ambassadors
reminds us of death

One of the finest portrait artists of the German Renaissance, Hans Holbein the Younger lived and worked in England in 1526–28 and 1532–43. This painting was made during the year in which Henry VIII of England, Francis I of France, Charles V the Holy Roman Emperor and the Pope hovered on the brink of war; when Henry broke with Rome because the Pope refused to annul his marriage to Catherine of Aragon; and when he married Anne Boleyn and fathered the future Queen Elizabeth I. Elsewhere, the Protestant Reformation was challenging the absolute authority of the Catholic Church.

This life-sized double portrait depicts the wealthy landowner Jean de Dinteville, ambassador to Francis I, dressed in silk, velvet and fur, with his friend Georges de Selve, Bishop of Lavaur. Commissioned by de Dinteville to hang in his chateau at Polisy, it commemorates de Selve's visit to London, when the two friends were on a diplomatic mission to try to reconcile Henry with the Church of Rome. The meticulously detailed painting includes many objects of hidden significance. Clutching a dagger, de Dinteville seems to be a man of action, while de Selve rests his arm on a book, suggesting a more introspective nature. Both dagger and book are inscribed in Latin with the men's ages: 29 and 25, respectively. This may be young, but these inscriptions reinforce the idea of their mortality, as does the skull brooch on de Dinteville's cap.

Three levels are symbolized around the two men: the heavens, the living world and death. Standing with the figures on a floor mosaic based on a design in Westminster Abbey is a table containing open books. One, a German maths book, is open at a page about division, and a hymn book is open at hymns about the Commandments and the Holy Spirit, which was customarily called on to unify the Church. A lute with a broken string conveys ecclesiastical discord. On the upper shelf, a celestial globe, a sundial and other instruments used in astronomy and for measuring time relate to the heavens.

People of the time were acutely aware of death, and within this exacting scene is a distorted or anamorphic object that works as a visual puzzle, but is chiefly there to remind all of the inevitability of death. When viewed from high on the right or low on the left, it can be seen as a human skull. It is a memento mori (literally, 'remember thou shalt die'), a reminder that death comes to us all and overrides all earthly matters. It is counterbalanced by a partially hidden object behind the green curtains in the top left-hand corner: a crucifix symbolizing Christ's Resurrection, or God's promise of eternal life.

Hans Holbein the Younger (c.1497–1543)
The Ambassadors, oil on oak, 1533

'Within this exacting scene is a **distorted** or **anamorphic** object that works as a **visual puzzle**, but is chiefly there to remind all of the **inevitability of death**.'

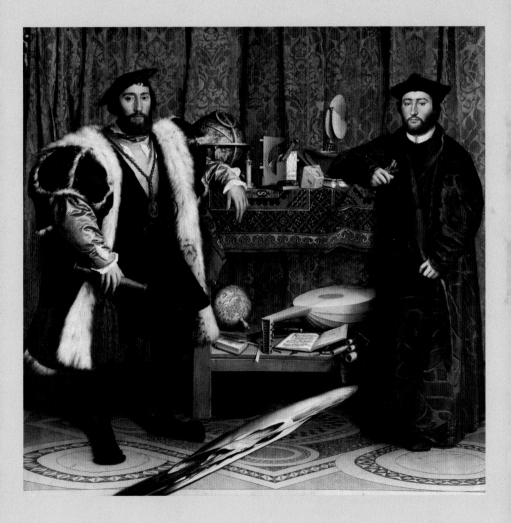

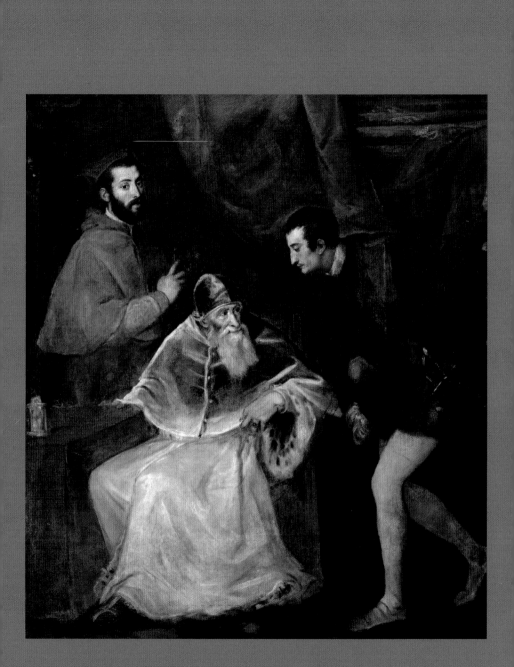

'Although **unfinished**, this painting conveys the
strained relationships within the Farnese family, but also
portrays a **frail pope** who retains his power through cunning.'

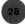

Pope Paul III
and his Grandsons
advances a son

From a wealthy family, Alessandro Farnese was the last pope to be appointed by the ruling Medici family of Florence. He became Pope Paul III in 1534, when he was 66 years old. An ambitious, irreligious man, he used the papacy to amass wealth and advance members of his family. He kept a mistress and fathered four children, and, despite accusations of nepotism, he appointed his eldest grandson a cardinal.

Although unfinished, this painting by Tiziano Vecelli or Vecellio, known as Titian, conveys the strained relationships within the Farnese family, but also portrays a frail pope who retains his power through cunning. Titian was summoned from Venice to Rome in the autumn of 1545 by the Farnese family and commissioned to paint the portrait. The Pope is sitting in the centre of the work with two of his grandsons: Ottavio, who enters and kneels deferentially; and the Pope's namesake, Alessandro, in cardinal's dress, standing behind his grandfather. The image conveys underlying tension between the three as well as the physical effect of ageing with an astute mind.

As Titian was painting this, Charles V, the Holy Roman Emperor, took military advantage, weakening the Pope's power, but Titian knew both men and so this portrayal is complex and subtle. While he illustrates the Pope's fragility, he also conveys the fact that Paul III retained his intellect and shrewdness. There are also clear psychological undercurrents between the sitters. When Alessandro was 14, the Pope broke with the Farnese tradition of finding a wife for the eldest male to continue the family name. Instead, he made his grandson a cardinal. This was because the next eldest, Ottavio, was only 10 at the time, too young to be accepted as a cardinal. Alessandro was compelled to celibacy and Ottavio was later married to Margaret, the daughter of the Holy Roman Emperor. Alessandro resented this bitterly. To assuage matters, the Pope promised Alessandro the papacy after him. By the time of this painting, however, Alessandro had realized that his grandfather's promise was empty, and was even more embittered.

This was a particularly difficult portrait, then, with a complex psychological dynamic between the subjects, requiring an understanding of the relationships and the skill to please all. Titian resolved it well, showing that Paul retained his position as the dominant patriarch – old but still in control of his quarrelling descendants. Ottavio appears cold and impervious, but also strong, and Alessandro has his hand on the Pope's throne, indicating his claim on the papacy. Meanwhile, Titian had his own personal agenda. His son Pomponio wanted to enter the clergy, and Titian asked that, in return for the portrait, Pomponio be granted the abbey of San Pietro, in grounds bordering Titian's own in Venice.

Titian (c.1488/90–1576)

Pope Paul III and his Grandsons, oil on canvas, 1545–46

Children's Games
teaches morals

A bird's-eye view of a square, a street and a river is the setting for more than 230 children, all playing games. Painted by Pieter Bruegel the Elder, the work is usually interpreted as a moralizing picture, a reminder to viewers of the thoughtlessness of human behaviour. Bruegel's panels were made to be conversation pieces, inspiring debate among the wealthy owners and their friends, and they were understood to represent double meanings.

Bruegel was the head of a large and successful family of artists from Brabant. An inventive painter and printmaker, he lived and worked mainly in Antwerp and became known for his landscapes and peasant scenes (genre paintings). When gathering material for these genre paintings, he often dressed in peasant's clothing in order to mix undetected with his subjects, and so earned the nickname 'Peasant Bruegel'.

In this painting, many activities are taking place, including 83 different games. Almost entirely without the supervision of adults, the children are all occupied, jumping, riding on sticks, blowing bubbles, walking on stilts, climbing fences, doing handstands, swimming and more. Copying adults, some pretend to joust, to serve in a shop or to marry. Some play with each other, some play alone. Some have toys such as hoops, spinning tops and a hobby horse. Three boys sit on a fence, pretending to ride horses, some children play leapfrog and some have a tug of war. Near to the bottom of the painting, two girls play knucklebones, a boy blows bubbles while two other boys are climbing on a barrel. Further back, boys swing on a wooden horse-tethering post, a girl plays a musical instrument and another plays with a doll. A boy swimming in the river wears inflated bladders as water wings, a boy clings to a tree as he climbs, and a girl scrapes and measures red brick dust as if making pigment for paint (a trade that was unique to Antwerp). In the left foreground, a boy in a hat studies the tail of a bird, while at the far right, another stretches across a log, trying to catch insects in his net.

These are games played by rich and poor, throughout the year, and this is one of Bruegel's least understood paintings. The subject was unprecedented in art – both the games and the fact that they are children – but it is generally viewed as a humorous warning of human stupidity because of Bruegel's reputation for painting cautionary tales. For example, the boy blowing a bubble in the left foreground could be a vanitas symbol of the transience of life.

Although the children predominantly do as they please without supervision, there are at least six adults in the work, including a woman who throws a blue cloak over a group of children. At the time, a blue cloak thrown over someone was perceived as a symbol of folly.

Pieter Bruegel the Elder (c.1525–1569)
Children's Games, oil on panel, 1560

'This work is usually interpreted as a **moralizing picture**, a **reminder** to viewers of the **thoughtlessness** of human behaviour.'

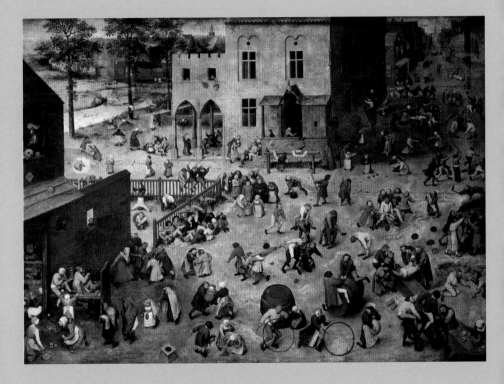

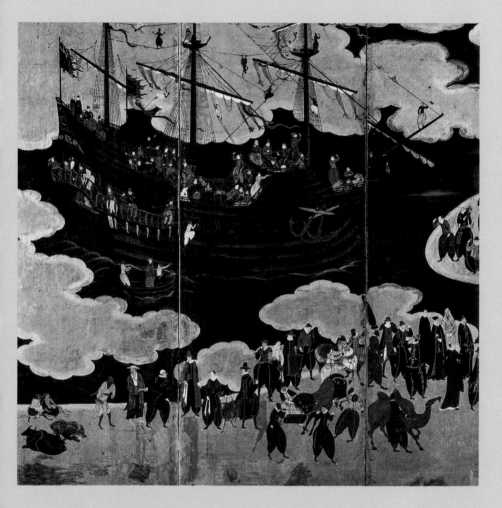

'Overall, the image conveys the **novelty** of the brief relationship between **East** and **West**.'

Arrival of the Portuguese
invokes mystery

Part of the Kanō school – or family – of Japanese painters, Kanō Naizen worked with his father and brothers in their workshop in Kyoto, and he became known for his *byōbu* screen paintings. *Byōbu* screens were usually made in pairs, each with several hinged leaves, covered with paper and enclosed in thin lacquer frames. They were used in Japan to create intimate spaces within larger areas, or to close off areas, usually for rituals or other intimate gatherings. They were decorated by artists, and these two screens (only one shown here) made Naizen famous.

They illustrate the time when, in 1543, the Portuguese *namban jin*, 'southern barbarians', arrived in Japan. (The term originated in China, where all foreigners were regarded as barbarians.) The repercussions of this event lasted for decades, and these two images record the first encounter of the two different and distant cultures for the first time. When Portuguese sailors arrived in the port of Nagasaki, commercial and cultural exchanges were made. Naizen depicted this in the two screens, showing, for instance, the curiosity of the Japanese people and the festive atmosphere provoked by the arrival of the Portuguese black ship (*kurofune*). To the Japanese, the Europeans and their cargo were fascinating and exotic. Also present in one screen are the Jesuit missionaries who organized the Portuguese visit and travelled there with the Portuguese traders. Once there, they set to work spreading Christianity.

In one image, the black ship that left Portugal carrying goods from Goa, Malacca and Macau is preparing to leave Goa, the capital of the Portuguese settlement in India. The scene features bright colours, two elephants and some unusual architecture including a hexagonal Christian chapel and an Indian-style ogee arch. Tiles, verandas with balustrades and a rock garden also show Naizen's limited knowledge of foreign lands and architecture. Nonetheless, his inventions communicate a sense of mystery.

Golden clouds separate different time periods across the composition. In the second screen, the black ship arrives in the port of Nagasaki. Acrobats perform in the masts, while ashore, a group watches the unloading of the cargo, which includes exotic animals: a deer, two goats, a greyhound, a peacock, a falcon, a parakeet and an ocelot. The Portuguese made large profits selling Chinese silk to the Japanese in exchange for silver. Some European goods were traded, but in the main, the Portuguese served as middlemen between the Chinese and Japanese. Nearby is a lively procession led by the ship's captain under an umbrella. It includes prosperous Portuguese gentlemen and merchants and various colourfully dressed travellers from other countries. Overall, the image conveys the novelty of the brief relationship between East and West.

Kanō Naizen (1570–1616)
Arrival of the Portuguese, wooden lattice covered with paper, gold leaf, polychrome tempera painting, silk, lacquer and copper gilt, 1593

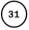

View of Toledo promotes a city

Dark, heavy clouds gather over a city, threatening to break into a storm at any moment. They throw an eerie light over the hills, roads and buildings below. Painted by El Greco ('The Greek'), whose real name was Doménikos Theotokópoulos, this is one of the first 'pure' landscape paintings in Western art, that is, a landscape painted for itself rather than as a backdrop for a story.

Born on the island of Crete, where he trained in Byzantine icon-painting, El Greco studied under Titian in Venice, then moved to Rome. An intellectual and spiritual man, he spent much of his life in Italy, where he learned to paint in the Mannerist style from various other artists, including Tintoretto, Jacopo Bassano and Parmigianino. He left Italy for Spain in 1577, and then lived in the city of Toledo until his death.

El Greco was working during the Counter-Reformation, after the Council of Trent (which ended in 1563) set rules for religious art, decreeing that landscapes were unsuitable subjects for paintings as they did not focus on Catholicism. So rather than giving it any religious connotation, El Greco painted this dramatic view of Toledo as a sign of his personal affection for the city. Undulating hills, curving roads and a river are emphasized by El Greco's rearrangement of certain buildings. For example, the cathedral would not have been seen from this viewpoint, so he moved it to the left of the royal Alcázar palace. Other aspects are fairly accurate, however, such as the palace itself, the towering castle of San Servando, the Agaliense monastery and the Roman Alcántara bridge over the Tagus River, which are all in their correct positions. The painting therefore glorifies and idealizes Toledo, and the dramatic viewpoint, supernatural lighting and menacing sky convey a spiritual, almost mystical atmosphere.

Although he had learned to paint in the prevailing Mannerist style, El Greco makes use of an expressive handling of colour and form that is unique and innovative. For instance, the contrasting colours and tones of the sombre sky and the glowing greenery of the hills, as well as the silvery highlights on the buildings below, suggest that everything is under the influence of God. The ominous sky suggests danger and vulnerability for the city and its people. Downstream from the Alcántara bridge are several tiny figures fishing in the river with spears, and another crossing the stream on a horse.

The changes made by El Greco to the landscape, and his distortions and liberties with light and colour, give the sense that this work is more than just a landscape of the city he loves; it conveys feelings of spirituality. The apparent impending cataclysm is happening over the city. God has singled out Toledo as the setting for his ultimate judgement, making it the most important city on Earth – a holy place.

El Greco (1541–1614)
View of Toledo, oil on canvas, c.1599–1600

'Although he had learned to paint in the prevailing **Mannerist style**, El Greco makes use of an **expressive** handling of **colour and form** that is **unique and innovative**.'

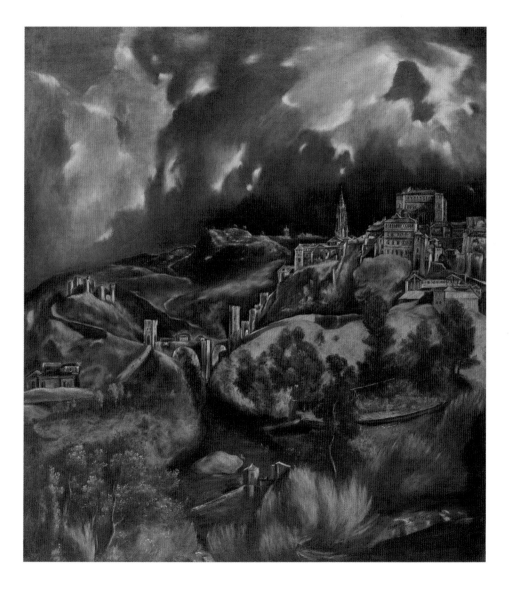

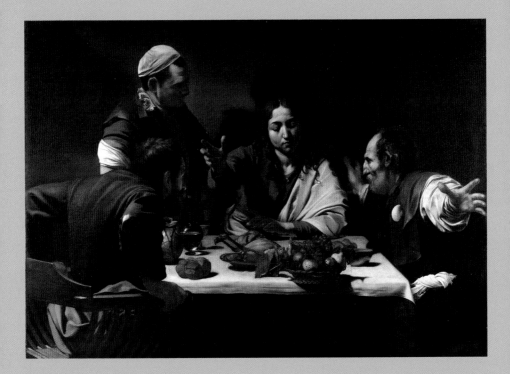

'Based on **real-life models** with no attempt at **idealization**, the two apostles are ragged and unkempt, while the youthful, beardless Christ contrasts with **traditional depictions** of him.'

Supper at Emmaus
brings the Bible to life

Three days after the Crucifixion, two of Christ's apostles were walking from Jerusalem to the nearby town of Emmaus. On the road they met a man who asked them about what had happened. Enthralled by the stranger, the apostles invited him to share a meal with them. That evening, at supper, the stranger blessed and broke bread, and suddenly 'their eyes were opened and they knew him' (Luke 24: 30–31). They realized he was the resurrected Christ.

This depiction of that story was painted by Michelangelo Merisi da Caravaggio, known as Caravaggio, commissioned by one of the most prolific art collectors in Rome, the nobleman Ciriaco Mattei. It depicts the moment of revelation, when the seated apostles discover that they are having supper with Jesus, who had been crucified three days earlier. Their actions convey their astonishment. One is about to leap out of his chair and the other throws out his arms in disbelief. Based on real-life models with no attempt at idealization, the two apostles are grubby, ragged and unkempt, while the youthful, beardless Christ contrasts with traditional depictions of him, explaining why he was unrecognizable to his friends.

To intensify the drama, Caravaggio uses his characteristic strong contrasts of light and shade (chiaroscuro) and foreshortening. A strong light from the left falls on the faces of Christ and the apostle on the right, and casts a shadow on the blank wall behind. The back view

of one apostle, and the other's outstretched arms, shown in extreme foreshortening, draw attention to Christ's tranquil face. Unaware of what is happening, the innkeeper watches, his shadowed face conveying his ignorance of the situation. Light shines on the detailed illustrations of food and drink on the white tablecloth. Even these simple objects are symbolic: the bread and wine refer to the Eucharist; the apples suggest the Fall of Man; and the pomegranates symbolize the Church. The fishtail-shaped shadow to the right of the fruit basket may be an *ichthys* (fish) symbol, representing Jesus.

Caravaggio's brief career created a defining moment in the history of art. His dramatic chiaroscuro made biblical stories exciting and compelling. Discarding the affectations of Mannerist painting, he created instant impact and appeal. He created drama through realism and chiaroscuro, and used the poor as models for his holy figures. The Baroque movement was a deliberate counterattack to the Protestant Reformation, authorized by the Catholic Church to re-establish its importance in society. Crucial characteristics of the style can be seen here, including implied movement in the bending, twisting poses, the out-thrown arms and the grabbing of the chair, and an emphasis on drama and the effect of light.

Caravaggio (1571–1610)
Supper at Emmaus, oil on canvas, 1601

Samson and Delilah
reveals Italy's influence

A biblical tragedy of love and betrayal, this painting by Peter Paul Rubens relays an episode from the Old Testament story of Samson and Delilah. Samson was a Jewish man with superhuman strength, who killed a thousand Philistine soldiers. Seeking retribution, the Philistine leaders bribed Delilah, the woman Samson loved, to discover the source of his strength, and after several attempts she persuaded him to tell her that his secret was his uncut hair. The work depicts the moment when, after an evening of passion, Samson falls asleep in Delilah's lap. She calls a servant to come and cut his hair, instantly removing his strength. Once he is weakened in this way, the Philistines, who can be seen at the door, will capture him.

Well educated and charming, Rubens was one of the most productive, creative and popular painters of the Baroque era and the leading artist of seventeenth-century Flanders. Born and raised a Catholic, he was also a humanist and a diplomat, and his art was influenced by apprenticeships in Antwerp and time spent in Italy, where he was influenced by Titian, Caravaggio, Michelangelo, Raphael and Leonardo da Vinci. Soon after his return to Belgium, he was appointed a court painter by the Archduke of Austria Albert VII and the Infanta Clara Eugenia. He was known for his extravagant, sensual painting style using rich colour, dynamic composition and vigorous brushwork. He painted this on his return from Italy for the private collection of his friend and patron Nicolaas II Rockox, the mayor of Antwerp. It was designed to hang above the mantelpiece of Rockox's large town house, and the brazier blazing beside Delilah echoes the fire that would flicker in the fireplace below. While in Rome, Rubens had made drawings from sculptures admired and made famous by Michelangelo, such as the *Farnese Hercules* and the *Belvedere Torso*, which gave him the basis for the musculature of his sleeping Samson.

Here, asleep and vulnerable, Samson lies in his lover's lap. With loosened hair and exposed breasts, Delilah sits motionless as her servant cuts Samson's hair. Rubens creates the appearance of sumptuous texture: pale flesh, golden and brown curling hair, and shimmering, lavish fabrics, among them red, violet, gold, white and patterned silks. Caravaggio's use of chiaroscuro had a great impact on many artists, including Rubens, as is seen here in the strong tonal contrasts, including the vivid light on the soldiers waiting in the dark outside the room, all conveying an intimate atmosphere and sense of tension. On the wall behind Delilah is a statue of Venus, the goddess of love, and her son Cupid. Behind her in reality is an old woman whose profile closely resembles hers. The presence of this figure suggests that Delilah will one day lose her own strength, the beauty that was Samson's downfall.

Peter Paul Rubens (1577–1640)
Samson and Delilah, oil on wood, 1609–10

'Rubens was known for his **extravagant, sensual painting style** using **rich colour, dynamic composition** and **vigorous brushwork.**'

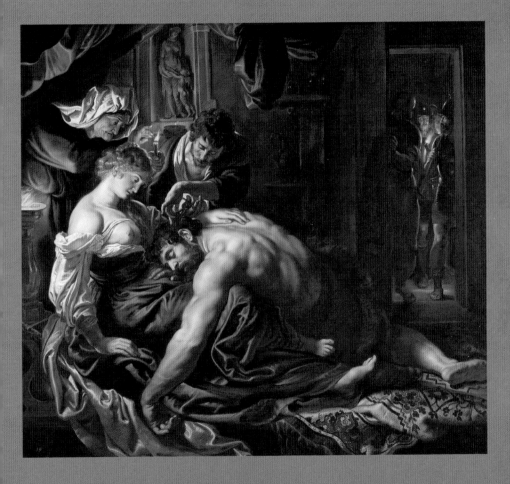

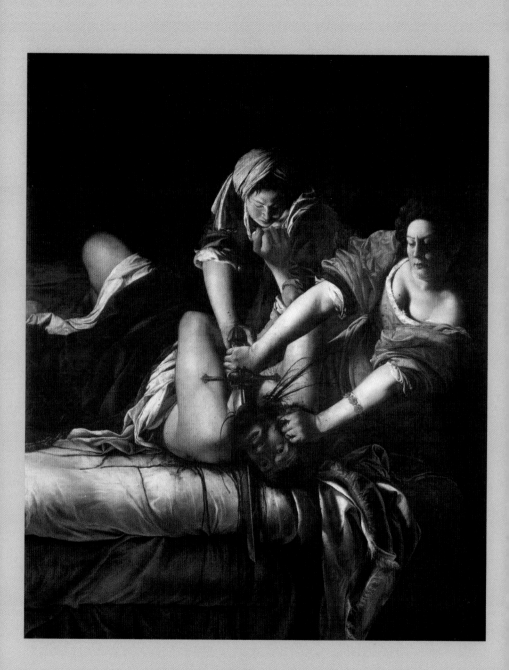

'It is a **violent** and **graphic** scene, dramatizing the immense **physical effort** required by Judith and her maid to kill the **powerful man.**'

Judith Slaying Holofernes
overcomes trauma

Influenced particularly by Caravaggio, Artemisia Gentileschi was the first female artist to be elected a member of the prestigious Academy of Art (Accademia dell'Arte del Disegno) in Florence. Widely acclaimed and respected during her lifetime, she worked as the main breadwinner to support her husband and children. Unusually, rather than the still-life paintings produced out of necessity by many of the female artists of the time, Gentileschi painted ambitious religious and historical subjects, and this work probably helped her to overcome a horrific ordeal she endured at the age of 18. While working in her artist father's workshop, she was raped by her father's friend and colleague the artist Agostino Tassi, and at the trial that was held to test the truth of her evidence, she was tortured and humiliated. In this painting, she used herself as the model for the heroine and Tassi for the villain, which suggests that the work (which she painted in two versions) was her own form of retribution and way of managing her suffering.

The dramatic scene is based on the story from the apocryphal biblical Book of Judith, which tells how Judith, a beautiful and virtuous Jewish woman from Bethulia, frees the people of Israel from a siege by Nebuchadnezzar's army. Realizing that no one from her home city can save them, she dresses in her finest clothes and enters the encampment of the fierce Assyrian general Holofernes. On seeing her, Holofernes is struck by her beauty, and invites her to his tent. While trying to seduce her, he drinks too much alcohol and passes out. This image portrays the moment that Holofernes awakes from his stupor, as Judith and her maidservant Abra are beheading him. It is a violent and graphic scene, dramatizing the immense physical effort required by Judith and her maid to kill the powerful man as, still drunk and semi-conscious, he finds himself pinned down with the sword cutting through his neck.

With dramatic foreshortening, Gentileschi paints Holofernes as if his head is projecting from the canvas, held down by Judith's hands and the sword slicing his neck. Blood spurts from the incision on to the pure white sheet. The powerful chiaroscuro that highlights the three figures renders the shocking action doubly intense. It is a scene of epic struggle, displayed through the concentration on Judith's face, her gripping hands, Holofernes's efforts to breathe and to overcome his assailants, the sword and the blood-soaked sheets. Contrasting with the gruesome action are Gentileschi's rendition of the sumptuous and costly textures of the different fabrics – gilded damask, deep-burgundy velvet, white linen sheets – and the smooth, pale skin of the figures.

Artemisia Gentileschi (1593–c.1652)
Judith Slaying Holofernes, oil on canvas, c.1620

Cheat with the Ace of Clubs
Colludes with us

Portraying the dangers of indulgence in wine, women and gambling, this painting by the French Baroque artist Georges de La Tour presents a psychological drama and invites the viewer to become part of it. La Tour, who spent most of his working life in the Duchy of Lorraine, painted mostly theatrical night scenes lit by candlelight using strong chiaroscuro, showing influences of Caravaggio. He also used a rich, deep palette of colours, as seen here, where he emphasizes various textures, including soft skin, shiny satin, sparkling crystals, iridescent pearls, soft velvet, sumptuous brocade, and feathers and ribbons.

Four figures are gathered around a table playing cards. The plain, dark background and the effects of light project each of them forward, demanding attention. The three left-hand figures exchange surreptitious glances and make signs to each other, while the fourth, an elaborately dressed man on the right-hand side, seems oblivious to it all. The many coins in front of him on the table suggest that he is about to make a bet. Clearly, he is a wealthy young man who is being deliberately seduced by wine, women and gambling by the three cheats opposite him. Although he is unaware of this, the viewer is not, but is invited to participate in the dubious activities.

The three scheming figures comprise a young man, a maidservant and a courtesan

– who can be identified by her expensive finery and, particularly, by her low-cut dress. The wealthy young man, dressed in satin, brocade, damask and ribbons, with an embroidered collar and a large feather in his hat, concentrates on his cards and appears to relax among his new friends, enjoying the attention of the woman who sits close to him. Meanwhile, she watches the maidservant, also in a low-cut bodice, who prepares a glass of wine in order to create a diversion. She is about to place the glass on the table, which will give the other man the chance to cheat the rich one. Dressed rather plainly in comparison to his victim, he tilts his cards towards the viewer, while sliding the ace of clubs from under his belt behind his back. Instantly, this makes the viewer complicit in his scam. His furtive, sidelong glance, the flick of his hand and the pile of coins under his elbow show what he is scheming.

The theme of this painting directly recalls Caravaggio's *Cardsharps* (c.1594), and explores a comparable lack of morals. In a period when Protestantism was weakening the power of the Catholic Church, such Baroque imagery highlights the danger of falling prey to the unscrupulous. The moral is: remain with the Catholic Church, which will protect you.

Georges de La Tour (1593–1652)

Cheat with the Ace of Clubs, oil on canvas, c.1630–34

'In a period when **Protestantism** was weakening the power of the **Catholic Church**, such Baroque imagery **highlights the danger** of falling prey to the unscrupulous.'

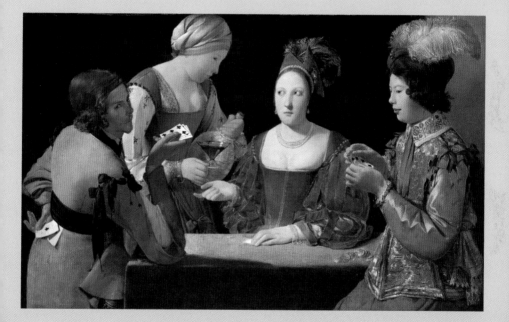

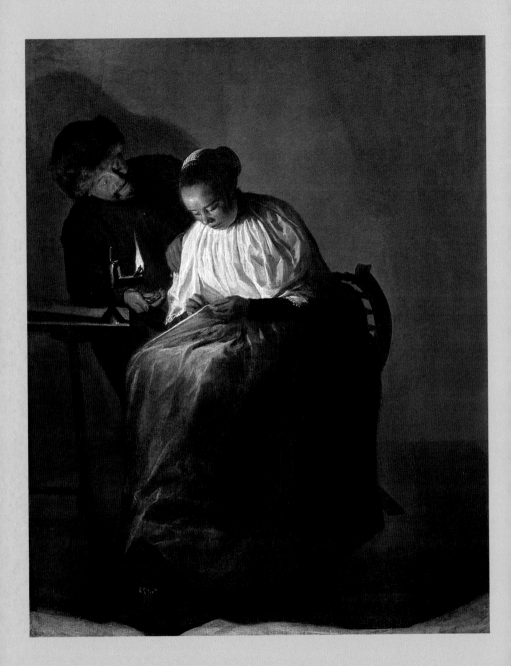

'All elements create an **ominous** and **ambiguous** impression, leaving the viewer **uneasy**.'

The Proposition
portrays virtue and vice

A woman sews by candlelight as a dark-clad man leans over her, touching her shoulder with his hand. In his other hand, he offers her coins, but she seems to ignore him, instead concentrating intently on her sewing. The room is sparsely furnished and the meagre lighting throws long shadows that generate a sense of unease, especially around the man, with the oversized shape on the wall behind him and the darkness across his face. Contrastingly, the woman's face is brightly illuminated by the reflection from her white blouse and the candlelight. All elements create an ominous and ambiguous impression, leaving the viewer uneasy.

Painted by the Dutch artist Judith Leyster, one of the first women ever to be registered as a member of the prestigious Haarlem Guild of St Luke, this is an early genre painting, or an image of ordinary people doing everyday things. Leyster was also one of the first artists to produce genre paintings. Although she was well known and esteemed by her contemporaries during her lifetime, after her death her work was largely forgotten until 1893, when she was rediscovered. During that period of obscurity, almost her entire output was attributed either to Frans Hals or to her husband, Jan Miense Molenaer, but she is now recognized as one of the great masters of the Dutch Golden Age, which lasted from about 1581 to 1672. It was a time of independence, prosperity and discovery, with huge successes in trade, exploration and finance.

Influenced by Caravaggio's chiaroscuro, here Leyster creates drama, suspense and enigma. The painting's title comes from one of its interpretations: that it represents a sexual proposition that the woman is resolutely ignoring. This interpretation is generally seen as Leyster's way of responding to the treatment of similar subjects by male artists, who frequently demean women by representing them as temptresses and sirens. Another theory about the image is that it depicts the start of a romance, following a Dutch tradition. As part of early Dutch courtship, the woman was expected to act modestly and the man would offer her money.

Either way, the woman seems meek, restrained and respectable, engaged in an honest everyday domestic chore. Beneath her demure, plain skirt, a foot-warmer can be seen. At the time Leyster painted this, foot-warmers were sometimes used as symbols to indicate a married woman. Contrastingly, they were also often used to symbolize female sexual arousal. Of course, the foot-warmer might simply be there for its practical use; the man's fur hat shows clearly that it is cold in the room. This enigmatic painting seems to be portraying either vice or virtue – or possibly both together.

Judith Leyster (1609–1660)
The Proposition, oil on panel, 1631

Equestrian Portrait
of Thomas of Savoy
allegorizes power

Born in Antwerp, Sir Anthony van Dyck worked initially for Peter Paul Rubens. By the age of 15 he was a highly accomplished painter; he became a master in the Antwerp guild before he was 20, and was successful in his own right soon after that, while living in the southern Netherlands and then in Italy. It has been speculated that he worked for Rubens, since his style shows several similarities, but this has not been verified. In 1632 he moved to London, where he became the leading court painter and was knighted by King Charles I. His portraits of the aristocracy, including those of Charles and his family, were innovative and widely admired across Europe. Created with loose brushwork, this portrait conveys a sense of restrained power, energy and elegance, and establishes the sitter's authority.

The painting depicts Thomas Francis of Savoy, Prince of Carignano, an Italian military commander and the founder of the Savoy-Carignano branch of the House of Savoy, which reigned as kings of Sardinia and Italy in the nineteenth and early twentieth centuries. With his hair flowing loosely over his shoulders, the prince wears highly polished armour with a costly lace-edged linen collar, and points his baton of command, signifying his senior military rank. His gold medal and large red sash indicate that he has the Supreme Order of the Most Holy Annunciation, conferred on him in 1616 by his father, the Duke of Savoy. This was the highest order of chivalry given by the Royal House of Savoy, showing that he is a member of an elite society. He is glamorous, but also a man of action and ready for battle. Here he sits on a large, glossy, muscular white horse. It rears dangerously, but, calmly holding the reins in one hand, Carignano demonstrates his strength and symbolizes that he can keep control over his lands, no matter how difficult or challenging things may become. With a long, elegantly crimped mane and elaborate caparison, the horse rears in front of a large classical marble column draped with pale-green watered silk. Behind the horse's head is a dark, stormy sky and a view of the open countryside.

The Prince of Carignano was a military commander who, for a while, acted as regent of the southern Netherlands for the King of Spain, it being under Spanish rule. The theme of a rider controlling a rearing horse as an allegory of power and the ability to lead had been developed fairly recently by Rubens and Diego Velázquez.

Anthony van Dyck (1599–1641)
Equestrian Portrait of Thomas of Savoy, Prince of Carignano, oil on canvas, c.1634–35

'Created with **loose brushwork**, this portrait conveys a sense of restrained **power, energy and elegance**, and establishes the sitter's **authority**.'

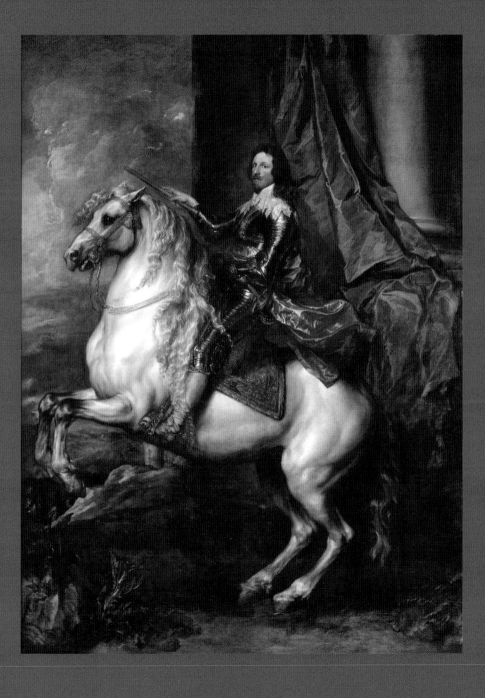

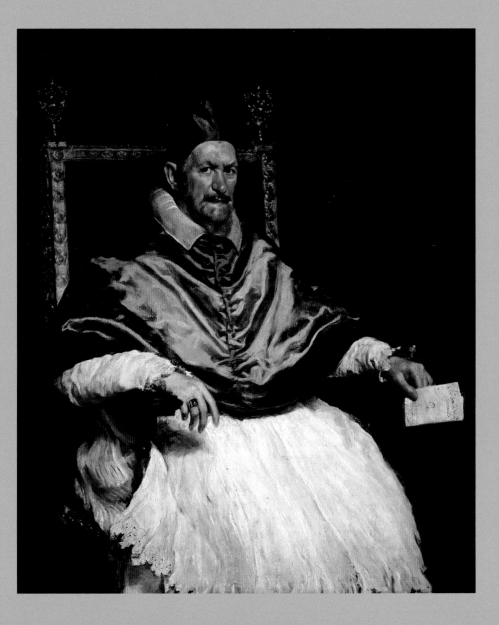

'According to contemporary accounts Innocent X was not **physically attractive**, and, although he intended to **please** his sitter, Velázquez did not **idealize** him.'

Portrait of Innocent X
portrays papal power

Born in Rome to one of the most powerful families in Europe, Pope Innocent X was intelligent, shrewd and industrious, as well as being widely perceived by his contemporaries as austere, volatile and scheming. Although he increased the power of the Holy See within Italy and abroad, his papal reign was marked by scandal and violence, and he was politically involved in various hostilities around Europe. Initially wary of having his portrait painted by Diego Rodríguez de Silva y Velázquez, he eventually agreed. Velázquez was the leading artist at the Spanish court of King Philip IV and of the Spanish Golden Age, and he impressed the Pope with some of his other portraits.

Velázquez probably executed the portrait in the summer of 1650, during his second trip to Italy, when he was collecting art for his king. He was also keen to attain papal favour to gain admission into the prestigious Spanish Order of Santiago. Ultimately, this portrait achieved that and also his entry into the most respected arts organizations in Rome: the Roman Academy of Art (Accademia di San Luca) and the Pontifical Academy of Fine Arts (Congregazione dei Virtuosi al Pantheon).

According to contemporary accounts Innocent X was not physically attractive, and, although he intended to please his sitter, Velázquez did not idealize him. Using his characteristic loose brushstrokes, he created subtle modulations of light and colour that convey the various textures of the Pope's skin, garments, ring, throne and background curtain. In a three-quarter pose, Innocent sits on the ornate, gilded papal throne surrounded by a heavy curtain of red velvet. His red biretta and silk cape are worn over his white linen vestment – or alb – and he looks directly out of the canvas, his expression watchful and wary. Velázquez always captured more than just a sitter's physical appearance. Here he captures the Pope's inner character, presenting a severe but true depiction of the man within those holy garments. His expression is fierce and tense, yet not aggressive. He is appraising the person before him; he was known for being alert and untrusting.

In his left hand the Pope holds a piece of paper, on which Velázquez signed his name, as if proudly stating his authorship of the work; Velázquez often signed his works in original ways. The entire painting is built up with different shades of red – a colour that traditionally conveys power – to indicate that this is a man who is aware of his supremacy. It is not a flattering portrait, but Innocent was not insulted. After staring at it for some time, he declared that it was '*troppo vero*', 'too true'. To show his thanks, he gave Velázquez an expensive gold chain. Velázquez himself must have been pleased with the portrait, because he painted a copy to take back with him to Spain.

Diego Velázquez (1599–1660)
Portrait of Innocent X, oil on canvas, 1650

Courtyard of a House in Delft
shows respect for women

Pieter de Hooch trained in Haarlem before moving to Delft and then Amsterdam. In Delft, he began painting genre scenes, mainly of interiors, featuring young men and women, but also some exterior scenes such as this one. Realism, close detail and witty glimpses of life were highly admired aspects of painting during the Dutch Golden Age, and de Hooch was a master at painting architecture convincingly. This work takes the viewer into a private courtyard, where life continues quietly.

Probably based on a specific location in Delft, this tranquil, sunlit scene depicts a private domestic instant. The composition is divided into two, with a brick-and-stone archway leading from a paved courtyard through a passageway to a street on the left-hand side, and on the right-hand side steps and a wooden doorway. In the passage, a woman dressed in black and red stands with her back to the viewer, looking out into the street. On the other side of the arch, a maid dressed in white and blue enters the courtyard through the wooden door and down the stone steps. She holds a child's hand and carries a dish in her other hand. The child clutches her own apron. In front of them, a bucket and a broom have been left on the ground.

Everything seems still, as if life has been frozen for a moment. Yet, despite its serenity, this is an enigmatic scene. It is not clear what the little girl is holding in her apron, nor what is in the maid's dish. Although behind the wooden door there is probably a scullery, this is not clear. The woman whose back is towards us could be the child's mother, but this is not certain, and for whom or what is she waiting? The dilapidated brickwork on the right-hand wall contrasts with the neat wall above the arch on the left-hand side. Why the broom and bucket have been left on the ground is another mystery.

This was the kind of painting that wealthy Dutch merchants loved to hang on the walls of their houses. In allowing a glimpse into other people's lives, it demonstrated that homes around the country were being efficiently run and children cared for by decent and diligent women, proving that the Dutch Republic was an honourable place in which to live. In the 1650s, having just gained independence from Spain, this was a young nation, experiencing economic prosperity and technological innovation. Women had slightly more authority there than in many other European countries of the time, girls were given a better education than in many other countries, and women in charge of their households enjoyed a high level of authority and respect.

Pieter de Hooch (1629–1684)
Courtyard of a House in Delft, oil on canvas, 1658

'In allowing a **glimpse** into other **people's lives**, it demonstrated that homes around the country were being **efficiently run** and children cared for by decent and **diligent women**.'

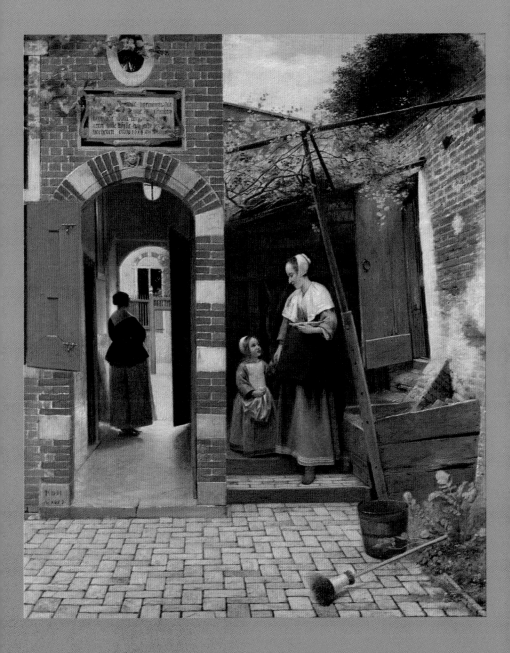

'Rembrandt's face is etched with **age, sadness, misfortune and disappointment**, but also with a certain **serenity and confidence**.'

Self-portrait with Beret
promotes an old master

Wrapped in a fur cloak with a high collar and a large beret, his hands clasped in his lap, a man looks steadily out from the canvas, illuminated from the upper right. One of approximately 70 self-portraits produced by Rembrandt van Rijn, this was made when he was 53. By the time he painted it, his early celebrity and prosperity had lessened considerably and he had experienced heartbreak and grief. Three of his children had died in infancy, his wife, Saskia, had died aged just 30 in 1642, and he had been declared bankrupt in 1656.

This is therefore quite a pitiful self-portrait, but also a brutally honest one that depicts the artist with a truthful rendition of what he saw in the mirror. Rembrandt's face is etched with age, sadness, misfortune and disappointment, but also with a certain serenity and confidence, an acceptance of his ability and his situation, and a determination to make the best of things. He had been declared bankrupt for several reasons, including the fact that his style of art was no longer fashionable, his passion for buying other artists' work was extremely costly and he had a tendency to overspend. A more introspective artist than many before him, Rembrandt had been exceptionally successful during the early part of his career. He and Saskia lived in a grand house in a fashionable part of town, he had a large workshop and he became an avid collector of art. However, after Saskia died and he had been declared bankrupt, almost everything he

owned was sold. In order to protect him and take care of his finances, at the time of this painting, his son and his mistress were making themselves legal guardians of the art he was yet to produce. He captured his reflection with as much authenticity as possible in order to demonstrate his dexterity to potential patrons, and he aimed to promote himself as a strong, resilient character who had been fêted during his younger years and who was now an even more outstanding artist.

Most of the image is in shadow, except for the highlighted face, where the skin is modelled with thick impasto to convey real surface textures. Rembrandt had initially depicted himself wearing a light-coloured cap, but changed it for a black beret to make his face the brightest and most prominent element of the painting. He seems to have modelled the pose on several of his earlier works, and also on portraits by other great masters he admired. One of just two of his self-portraits in which he is turned to the left, this work is less finished than many of his self-portraits, with broad brushwork and thinner, blurred marks in the shadows.

Rembrandt van Rijn (1606–1669)
Self-portrait with Beret and Turned-up Collar, oil on canvas, 1659

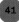

Girl with a Pearl Earring
captures imagined beauty

As if caught in a fleeting moment, a young girl set against a dark background, wearing a blue-and-gold turban and a huge pearl earring, turns her head to look over her shoulder at the viewer. Her eyes shine and a slight smile plays around her lips. Johannes Vermeer, or Jan Vermeer van Delft, created the painting with gleaming light effects and powerful realism. Despite being famous now, during his lifetime Vermeer was not well known outside his native city, and soon after his early death he was lost in obscurity until the nineteenth century. Only 36 paintings by him are known, and no preparatory works or sketches have ever come to light. He painted small images using expensive pigments, mainly images of middle-class domestic interiors.

However, unlike most of his work, here there is no background, and this girl is not concentrating on an everyday chore. Instead, she seems to come forward out of the darkness to look at us. Although the painting appears to be a portrait, this is a *tronie*, a type of work often painted by seventeenth-century Dutch and Flemish artists of a person either with an exaggerated expression or in a costume. The word translates roughly as 'face', and *tronies* enabled artists to practise and demonstrate their skill at creating convincing-looking people, either simply as appealingly lifelike images, or as characters who could be used in other works.

With her exotic turban painted in ultramarine, a pigment obtained from the rare semi-precious stone lapis lazuli, Vermeer captured a compelling image of a young girl. He used a model, but probably altered or enhanced her appearance. It is not known who his model was. Some have suggested that it was his eldest daughter Maria, who was 12 or 13 years old at the time he painted it, but this has never been proved. However, who she was is almost irrelevant since for this *tronie*, the painter was creating an imagined beauty, an idealized face.

Vermeer was a master at painting the effects of light, and here he judiciously placed tiny marks of white to highlight her lips, the corners of her mouth, her eyes, her white collar and her pearl earring. He also conveyed the effects of light falling across her turban and ochre-coloured jacket with soft colours. He captured the delicacy of her skin with shimmering colours and soft-edged darker tones using thick impasto paint. The unusually large pearl earring, which was either imagined or an imitation pearl, was achieved with just two deftly applied brushstrokes, and her eyes and lips seem as shiny as the jewel on her ear, while her nose has been underplayed.

Johannes Vermeer (1632–1675)
Girl with a Pearl Earring, oil on canvas, c.1665

'The **unusually large** pearl earring was achieved with just **two deftly applied brushstrokes**, and her eyes and lips seem as shiny as the **jewel** on her ear.'

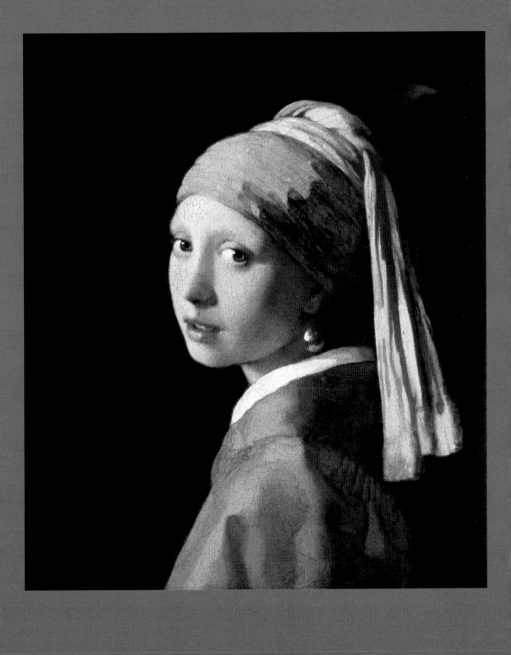

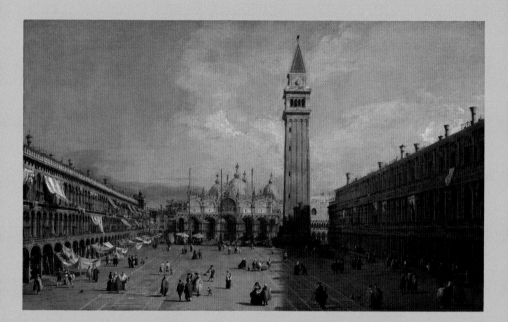

'Canaletto's careful mix of **topographical accuracy** and **idealized elements** creates a more **pleasing and harmonious** scene than would a **direct, unchanged copy** of the view.'

Piazza San Marco
decoration for a nobleman

The paintings of Venice by Giovanni Antonio Canal, known as Canaletto, were particularly popular with tourists. This was especially true of those who undertook the Grand Tour, a period of travel around Europe by mainly wealthy young English men and women during the seventeenth and eighteenth centuries. The Tour became a status symbol, and by the 1780s as many as 40,000 tourists did it each year. Accompanied by a teacher, these aristocratic travellers would spend two to five years visiting the cultural highlights of Europe, particularly in Italy, where they learned about the culture, history, languages, architecture and geography of the places they visited, and Canaletto's captivating views of the unique architecture and light of Venice became sought-after souvenirs of these trips.

This panoramic view (or *veduta*) features some of the city's most famous landmarks. Although Canaletto painted it from direct observation, he altered small aspects to make the scene more appealing. For instance, he reduced the number of windows in the bell tower and extended the height of the flagpoles. His careful mix of topographical accuracy and idealized elements creates a more pleasing and harmonious scene than would a direct, unchanged copy of the view. Such small changes were his way of portraying Venice at its best. It was his home city, and he often returned to paint this view of its main square, the Piazza

San Marco. Here, he painted St Mark's Basilica and its campanile (bell tower), with a slight view of the Doge's Palace on the right-hand side. On either side are the Procuratie Vecchie and the Procuratie Nuove. The Procuratie Vecchie, seen here on the left-hand side, was built in the early sixteenth century to replace an earlier structure. It was the first major public building in Venice to be erected in a purely classical style. The Procuratie Nuove on the southern side was similarly built to replace crumbling medieval structures. Both were constructed above arcades with spaces on the ground floor that were rented out for shops and later also coffee houses.

Although Canaletto often painted simply for the passing tourist trade, this work was commissioned by a Venetian nobleman to decorate his palace, along with three more paintings of the city. It is an intimate view of Venice, made for someone who knew and loved the landmarks and surroundings. The accuracy of the perspective and the details Canaletto includes in all his works made many speculate for years that he used a camera obscura to help him achieve almost photographic accuracy. However, more recent research has determined that it is more likely that he was extremely skilful and did not require technical assistance.

Canaletto (1697–1768)
Piazza San Marco, oil on canvas, late 1720s

Mr and Mrs Andrews
flatters a patron

On a summer's day, the recently married Robert and Frances Andrews pose beneath an oak tree on their estate, which can be seen stretching far away to distant hills and the town of Sudbury. In the distance is the square tower of Holy Trinity Church, Long Melford, and between the trees is All Saints, Sudbury, where the couple married in 1748. The artist was Thomas Gainsborough, who aimed to flatter his patron. Even though he preferred painting landscapes, he knew that portraits could be lucrative, and after making this one he became particularly sought after by other wealthy patrons.

Combining a portrait with a landscape, this image shows how accomplished Robert was in managing his vast lands and how skilful Gainsborough was as a painter of naturalistic landscapes and changing weather. The two men had known each other from childhood. Robert was two years older than Gainsborough, and they had attended Sudbury Grammar School at the same time. Two years after Gainsborough left school to train as an artist in London, Robert went to Oxford University, then spent most of his time farming and improving his land near the River Stour in Essex. Frances came from another local family that had helped Gainsborough's artist father when he was declared bankrupt. At the time the couple commissioned him, Gainsborough was 21, Robert 23 and Frances 16. Robert and Frances probably requested that their lands be included in their portrait, to show their wealth.

Gainsborough presents Robert as a prosperous landowner with his young wife, but, rather surprisingly, the newly married couple seem detached from each other. Neither looks at the other, they do not touch, and both look directly at the artist. Frances sits rather primly on a green wrought-iron bench, her wide, pale-blue dress stretching across the seat. Next to her in a tricorn hat and loose shooting jacket, Robert is more relaxed, standing with his legs crossed, leaning on the bench and holding a long-barrelled shotgun under his arm. Sitting close by, his dog gazes up at him – the only emotion shown in the painting. Frances appears to hold a small stick in her lap, but it is not clear what this is, since this part of the painting is unfinished. This is a mystery. Theories abound, the foremost being that Gainsborough left the space to add a baby later. The couple's first child was born in 1751.

By 1750, Robert owned nearly 1,215 hectares (3,000 acres), and much of the land shown here belonged to him. In the distance, parallel lines of stubble can be seen, demonstrating that he was using the latest technology of the seed drill for his crops. His sheep are grazing contentedly, and all seems efficiently run and serene.

Thomas Gainsborough (1727–1788)
Mr and Mrs Andrews, oil on canvas, c.1750

'Even though Gainsborough preferred painting **landscapes**, he knew **portraits** could be **lucrative**, and after making this one he became particularly sought after by other **wealthy patrons**.'

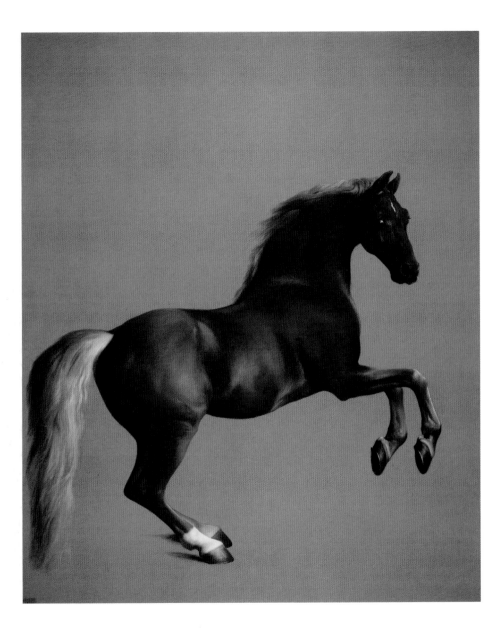

'Whistlejacket's ears are cocked, his nostrils flared and the whites of his eyes on show. Stubbs has conveyed the horse's **lively and proud character** as much as his **outward appearance.**'

Whistlejacket
shows the grace of
a champion

Commissioned by one of the richest men in England (who was briefly Prime Minister), Charles Watson-Wentworth, 2nd Marquess of Rockingham, this is one of a series of portraits of his horses. Rockingham was an art collector and a breeder of racehorses. The artist, George Stubbs, a specialist equine painter, stayed in Rockingham's main residence, Wentworth House in Yorkshire, for several months to paint this and four other horse portraits.

Set against an empty background, the life-sized painting of the 13-year-old thorough-bred Whistlejacket was unprecedented in art. Most horse paintings include riders and backgrounds, and Stubbs had painted many, both with and without human figures; most of his paintings of this scale had a rider and a background. Here he depicts Whistlejacket rising to a levade, a dressage movement in which a horse raises its forequarters, brings the hindquarters under the body and balances on its back legs for two or three seconds. Usually associated with a mounted ruler or a military commander, the levade pose traditionally conveyed the grandeur or superior rank of the human, but here, Whistlejacket is alone and turns his head towards the viewer. The pose echoes several equestrian portraits by Peter Paul Rubens and Diego Velázquez, although these focus on the rider. Stubbs possibly borrowed the pose either from one of those paintings or from sculpture, since he could not have drawn it from life.

The lone horse has no saddle or bridle; this is a painting solely of the pure-bred Arabian stallion, which grabs the attention immediately. Whistlejacket's coat was a rich coppery chestnut with a flaxen tail and mane that was allegedly the colouring of the original wild horses of Arabia.

As well as reproducing the anatomy accurately, Stubbs paid close attention to tiny blemishes, veins and flexing muscles beneath the surface of the skin. Just under three years before this painting was executed, Whistlejacket had retired after a fairly successful racing career, but Rockingham said he wanted Stubbs to paint him to show 'a supremely beautiful specimen of the pure-bred Arabian horse at its finest'.

Between 1756 and 1758 Stubbs had spent 18 months in a village in England, studying dead horses. Working in a barn, he dissected the animals and made detailed drawings. These studies formed the basis of a series of engraved plates that he published four years after this painting as *The Anatomy of the Horse*. Yet in this image, he took liberties with Whistlejacket's pose, showing more of his body than would be possible naturally in order to enhance the dramatic effect of the image. Whistlejacket's ears are cocked, his nostrils flared and the whites of his eyes on show; Stubbs has conveyed the horse's lively and proud character as much as his outward appearance.

George Stubbs (1724–1806)
Whistlejacket, oil on canvas, c.1762

The Swing
exhibits a patron's mistress

'I should like you to paint Madame seated on a swing being pushed by a Bishop,' was the rather unusual request of the notorious French courtier and philanderer Baron de St Julien for a portrait of his mistress. Other painters had turned down the commission, but Jean-Honoré Fragonard was happy to take it on, and he created what became the most iconic work of the French Rococo. Rich with symbolism, it suggests a moment of spontaneity and exuberance, while also alluding to an illicit affair and an amusing flirtation.

Fragonard's painting style is vivacious, sensuous and hedonistic, epitomizing the frivolous and frothy style of the Rococo. Although he won the coveted Prix de Rome, so was able to study his art in Italy, he rejected a successful academic career, preferring to paint more erotic and blithe images. Connotations of betrayal and immorality lurk beneath this light-hearted garden scene. An elegant young woman in a fashionable dress and shepherdess hat is on a swing. Hiding low in the bushes on the left-hand side, an equally elegant young man reclines and watches her from the shrubbery. Holding his hat in his hand, he extends his arm to point to her legs, which can be seen under her billowing dress, while almost hidden in the shadows on the right-hand side is an older man, who gazes fondly at the young woman's back. He seems unaware of the younger man in the bushes, and smiles as he propels the swing with ropes. As the young woman swings high, she throws up her left leg with abandon, allowing her dainty shoe to fly off through the air and revealing her dainty stockinged foot. Two statues in the scene hint at what seems to be occurring. One is a cherub, who watches from above the young man, its finger on its lips to denote silence and secrecy, indicating the clandestine love affair that he is watching. The other is a pair of cherubs, who watch from beside the older man. One looks up at the woman in alarm and the other looks away with a scowl. A small white dog in front of the older man barks up at the young woman.

The young man in the foreground is the playboy Baron himself. His specific instructions to Fragonard were: 'Place me in a position where I can observe the legs of that charming girl.' So this is his mistress, while the older man, who was originally going to be a bishop as requested by the Baron, has been changed by Fragonard to her cuckolded husband. With the deliberate ambition of flattering the Baron and his mistress, Fragonard also provides them with an intimate and lasting reminder of their relationship.

Jean-Honoré Fragonard (1732–1806)
The Swing, oil on canvas, c.1767

'With the deliberate ambition of **flattering** the Baron and his mistress, Fragonard also provides them with an **intimate and lasting** reminder of their **relationship**.'

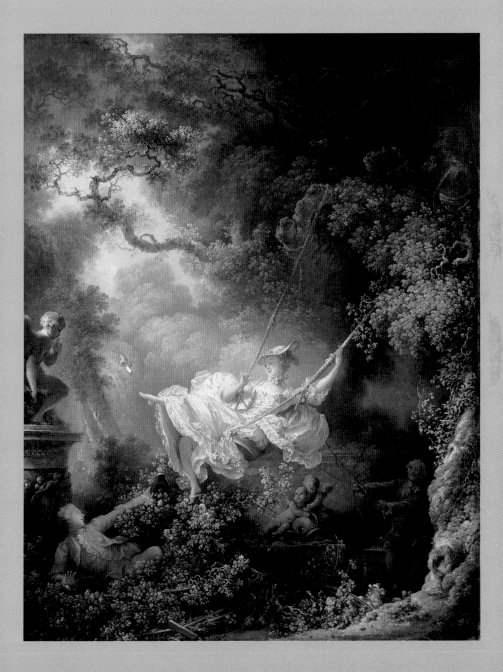

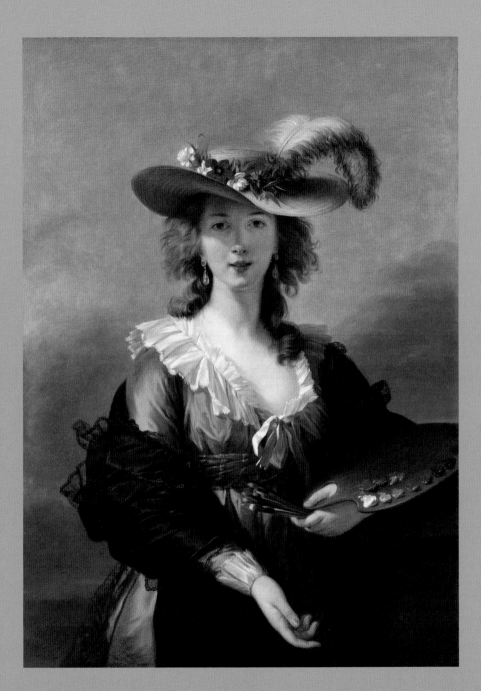

'Despite its apparent **informality**, the painting is **carefully contrived** to present the viewer with an elegant, feminine **woman of society** and an accomplished **professional artist**.'

Self-portrait in a Straw Hat
establishes social status

Élisabeth Vigée-Lebrun, the daughter of a minor painter, was born and brought up in Paris. Most women who managed to make a living in the arts during that time learned their trade from their fathers, but Vigée-Lebrun's died when she was 12, and – since women were forbidden to train at the French Academy or to take apprenticeships – she was largely self-taught. By her early teens she was painting portraits professionally, and in 1774 she was accepted as a member of the Académie de St-Luc, a Parisian guild of painters and sculptors. A few years later she was received as a member of the prestigious Parisian Académie Royale de Peinture et de Sculpture, one of only four women to be granted full membership in the eighteenth century.

As Vigée-Lebrun's career flourished, Queen Marie Antoinette became one of her most important and regular patrons, and she became one of the leading portraitists in Europe, commanding higher prices for her paintings than any other artist of her time. After fleeing the French Revolution in 1789, she lived and worked in the major European capitals, enjoying the patronage of aristocrats, actors and writers, and she was elected to art academies in ten cities.

In this self-portrait, Vigée-Lebrun paints herself in the open air, set against a blue sky flecked with clouds. She wears a fashionable straw hat adorned with flowers and an ostrich feather. Her hair – natural, unpowdered and not a wig – ripples in the breeze, and her low décolletage reveals her smooth, creamy skin. Vigée-Lebrun had studied and copied paintings by Peter Paul Rubens, and this is based on one of his portraits that she particularly admired: 'This painting ... inspired me to make my own portrait ... in search of the same effect. I painted myself wearing a straw hat with a feather and a garland of wild flowers, and holding my palette. When the portrait was exhibited at the Salon, I dare say it greatly enhanced my reputation.'

Despite its apparent informality, the painting is carefully contrived to present the viewer with an elegant, feminine woman of society and an accomplished professional artist. Vigée-Lebrun particularly admired the way in which Rubens combined diffused daylight with direct sunlight, and emulated that. She intended the painting to work as self-promotion. With her face only slightly shaded from the sunlight, she looks directly at the viewer with a relaxed and affable expression. She holds a palette and brushes in her left hand, conveying that she is assured and proficient, while her stance and clothing are those of a young, fashionable woman. This is a copy she made of her original portrait, indicating that she was pleased with her work.

Élisabeth Vigée-Lebrun (1755–1842)
Self-portrait in a Straw Hat, oil on canvas, 1782

The Oath of the Horatii
advocates patriotism

In the seventh century BCE, according to Roman legend, the three Horatii brothers were chosen by the Romans to defy the Curiatii brothers, champions of the town of Alba Longa. Here, with their father, the Horatii brothers are swearing to defeat their enemies or die. As they receive their weapons from their father, the brothers cast shadows over the women of the family, who swoon in grief.

The Horatii and the Curiatii families were linked by marriage. The woman in white with a blue turban is Sabina, a sister of the Curiatii, wife of one of the Horatii brothers and mother of the two little boys being hugged by their grandmother under the blue cloak. Sabina leans on Camilla, who is the sister of the Horatii and betrothed to one of the Curiatii brothers. The women are aware that whatever happens now, they will lose loved ones. However, the eldest boy cannot help peeping out at the brave men and their shining swords.

The painting highlights the importance of patriotism and self-sacrifice for one's country. Even a small boy cannot help but long for the honour of one day fighting for his country. Of the three brothers, only one will survive the confrontation, but he subsequently killed all three Curiatii brothers single-handedly.

Wearing bright colours, the men are constructed with straight lines and angles, while the women are made up of sinuous curves and soft colours. The painting became a model for a new style that contrasted with the light-heartedness and flowing forms of Rococo, and the artist, Jacques-Louis David, was immediately hailed as the leading proponent of the style that became known as Neoclassicism. Neoclassicism as an art movement developed after the excavations of Pompeii and Herculaneum in the mid-eighteenth century.

David was born, grew up and trained in Paris, and in 1780, after winning the prestigious Prix de Rome, went to Italy, where he became inspired by classical antiquity and the Neoclassical principles of the German artist Anton Raphael Mengs. He painted this work in Rome; it was exhibited there first of all in 1785 and later that same year at the Paris Salon, where it was an instant success.

Although it was painted nearly four years before the Revolution in France, this work's emphasis of the importance of loyalty to one's country made it one of the defining images of the time. The three brothers' strong profiles and arms and their determined facial expressions convey the vow they are making: that they are willing to sacrifice their lives for Rome. The focal point of the painting is the hilts of the swords and where the brothers' hands converge as they pledge their oath.

Jacques-Louis David (1748–1825)

The Oath of the Horatii, oil on canvas, 1784

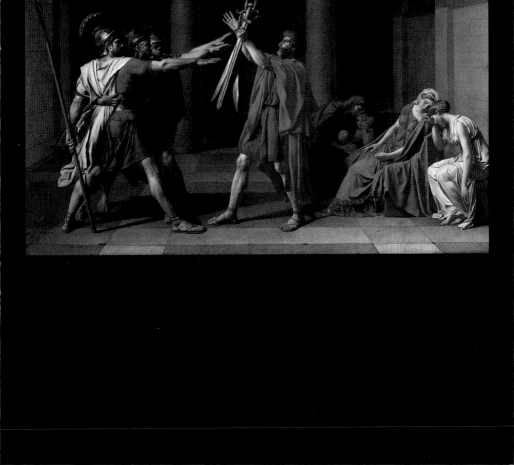

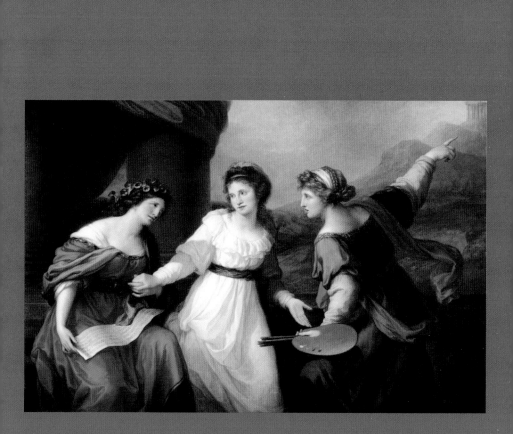

'The painting is **unprecedented** in the history of art
for portraying a female artist **making her own decisions**
about an **independent career.**'

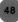

Self-portrait Hesitating symbolizes a life choice

A child prodigy, Swiss-born Angelica Kauffman was first trained by her artist father, as the family moved between Austria, Switzerland and Italy. She established her reputation early on in Italy, and was elected a member of the Roman Accademia di San Luca. She moved to London in 1766, and was one of only two women invited to become Founder Members of the newly established Royal Academy of Arts in 1768.

Unusually for women at the time, Kauffman became a respected and influential artist, commissioned by royalty and the nobility. Cleverly negotiating her position as a female artist, she produced prints of her work that became popular, and soon her imagery was being reproduced for homes around Europe, such as on furniture, crockery and fans. In the 1780s an engraver reflected that 'The whole world is Angelica-mad.' Along with portraits, Kauffman proved that a female artist could tackle large-scale history paintings without risking her feminine and modest reputation. In 1781 she returned to Rome, where her studio became the centre of the city's cultural life; she was so highly esteemed that it even became a stop on the Grand Tour, and she was described as 'possibly the most cultivated woman in Europe'.

Painted while she was living in Rome, this self-portrait presents Kauffman's younger self choosing between her profession as a painter, which was traditionally a male-dominated field

(the allegorical figure of Painting points to a faraway temple, symbolizing the difficulty of her journey), and a career devoted to the more traditionally feminine art of music. Proficient in several languages, Kauffman was also a gifted singer and played several musical instruments. The painting is unprecedented in the history of art for portraying a female artist making her own decisions about an independent career; women of the period did not usually make career choices.

There was at the time a general fascination with individuality – an interest in people's outer appearances and lives and their inner thoughts and selves, or the difference between one's face and one's heart – and here, Kauffman was investigating the psychology of individuality. In her composition, she adapted the classical format of a painting by Annibale Carracci, *The Choice of Hercules* (1596), where the protagonist chooses between the paths of vice and virtue. Similarly, Kauffman portrays herself casting a fond look towards Music, but she gestures towards the palette offered by Art, who seems more dynamic and who points to the distance in a brilliant-blue dress with a swirling red sash. Yet, while she chooses Art, Kauffman holds Music's hand, demonstrating that she will not abandon music completely.

Angelica Kauffman (1741–1807)
Self-portrait Hesitating between the Arts of Music and Painting, oil on canvas, 1794

The Naked/ The Clothed Maja personify sensuality

The Naked Maja (*La Maja Desnuda* in Spanish) and *The Clothed Maja* (*La Maja Vestida*) are the titles given to two paintings by the artist Francisco de Goya, who is generally recognized as both the last Spanish old master and the first great modern artist. Living and working in Spain through a turbulent period, Goya observed and commented on much of it with his insightful and often alarmingly truthful paintings and prints. He also worked as court painter for the Spanish royal family, and although he made little attempt to compliment his noble sitters, he was bestowed with several honours.

These two paintings, however, are cloaked in mystery. In January 1808 they were included in the inventory of Manuel de Godoy, Spanish royal favourite and twice prime minister, and in 1814 they were handed over to the Grand Inquisitor, with three other 'obscene' paintings, two of which also belonged to Godoy. In the 1808 inventory the figures are referred to as *gitanas* (gypsies), but they have also since been called *majas*, a term that was used to describe a person from the lower classes of Spanish society, especially in Madrid, who wore elaborate outfits and was known to have a mischievous personality.

On a green velvet divan that is draped with a white sheet, and leaning on two large lace-edged pillows, a naked woman reclines. This is the *Naked Maja*. The *Clothed Maja* depicts exactly the same figure and pose, but now the woman is dressed in a delicate, translucent white dress and pink sash with a yellow jacket trimmed with black. The paintings were probably commissioned to hang in Godoy's private collection, but this has never been proved. Mainly because of the country's particularly stringent Catholic beliefs and the related Inquisition, nude paintings were rare in Spanish art, yet Goya not only painted the shocking subject, but also presented it exceptionally boldly. Provocative and sensual, the naked woman looks brazenly at the viewer with her arms behind her head. Neither a goddess nor a prostitute, she seems not to mind that she is being looked at – which contrasts markedly with societal expectations. The work has been cited as one of the earliest Western paintings to depict a woman's pubic hair.

The model has never been identified. Scholars mostly believe that she was either the Duchess of Alba, with whom Goya had a close relationship, or Pepita Tudó, who became Godoy's mistress in 1797. In March 1815 the tribunal of the Inquisition issued a subpoena for Goya to appear before them, to disclose the identity of the work's patron and explain its purpose, but despite the Inquisition's questions, the artist revealed nothing.

Francisco de Goya (1746–1828)

The Naked Maja, oil on canvas, c.1797–1800; *The Clothed Maja*, oil on canvas, 1800–7

'Neither a **goddess** nor a **prostitute**, she seems
not to mind that she is being **looked at** – which contrasts
markedly with **societal expectations**.'

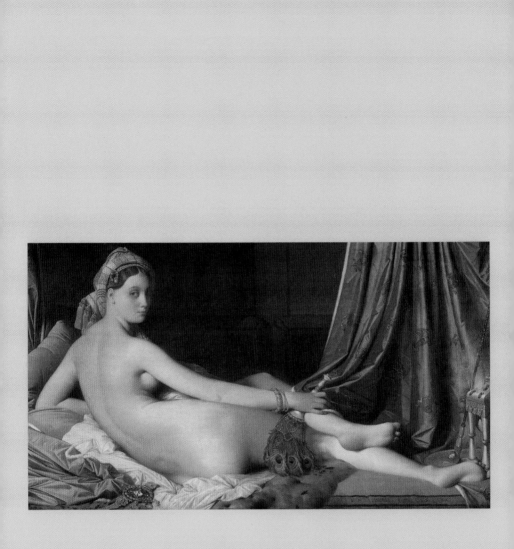

'Ingres believed in the **supremacy** of **line over colour**, yet some of his most famous figure paintings are **anatomically inaccurate**.'

La Grande Odalisque
embodies seduction

At the age of just 11, Jean-Auguste-Dominique Ingres was enrolled at the Académie Royale de Peinture, Sculpture et Architecture in Toulouse; he was later taught by Jacques-Louis David in Paris. He was a major contributor to Neoclassicism, yet his career was full of contradictions. He was influenced by the High Renaissance paintings of Raphael and Titian, and the Baroque paintings of Nicolas Poussin. He believed in the supremacy of line over colour, yet some of his most famous figure paintings are anatomically inaccurate. Considered revolutionary during his lifetime because several of his ideas conflicted with David's, he was also perceived by most as the leader of Academic art. His greatest ambition was to be recognized for his history painting, but his smaller, more intimate portraits and bathers, or 'odalisques', were more successful. At 21 he won the coveted Prix de Rome, but owing to the government's lack of funds he remained in Paris for five years, supporting himself by painting portraits.

La Grande Odalisque – the word *odalisque* comes from the Turkish for 'harem concubine' – was commissioned by Caroline Murat, Napoleon Bonaparte's sister and the wife of Marshal Joachim Murat, King of Naples. She may have wanted it to match another nude, *La Dormeuse de Naples*, which is now lost. The painting – Ingres's second major female nude – represents the idea of femininity for the male gaze, rather than a real woman. The odalisque reclines in a lavish interior that Ingres based on the tradition of the great Venetian masters, particularly Titian's *Venus of Urbino* (1538). The nude contorts her body in a languid and sensual pose, looking over her shoulder at the viewer, her right hand leading the eye to the sumptuous silk drapes, while plump velvet cushions and crumpled fabric suggest lavishness and comfort. The cool blue of the curtain with its red flower patterns enhances the diffused light on her skin. Ingres intentionally placed her in an exotic environment and adorned her with a turban, pearls, bracelets and a peacock-feather fan, adding a hookah (a pipe for hashish or opium) to the side of the composition to convey a sense of forbidden desire and general European ideas about the Orient.

The darkness behind the odalisque has the effect of projecting her forward, and Ingres significantly elongated her torso to create sinuous contours and to communicate instantly the fact that she is an invented figure in an imaginary location. He was a highly skilled draughtsman and professional in his knowledge of anatomy, so his distortions were created purely for stylistic effect, but at the time, neither the French Academy nor contemporary critics understood this. They criticized the painting, suggesting that he showed a deliberate, even arrogant disregard for human anatomy.

Jean-Auguste-Dominique Ingres (1780–1867)

La Grande Odalisque, oil on canvas, 1814

Wanderer Above the Sea of Fog
displays man's insignificance

A lone man dressed in a dark-green coat and boots, his back to the viewer, holds a walking cane and stands on craggy rocks looking out over a dramatic landscape. This pose is a compositional device known as a *Rückenfigur*, in which the back of a figure is seen, rendering that person anonymous so that the viewer can witness the scene through his or her eyes.

Born in the town of Greifswald on the Baltic Sea, Caspar David Friedrich is generally considered the most important German artist of the Romantic movement. He is best known for his haunting allegorical landscapes featuring such elements as fog, mist, eerie light, winter trees and Gothic ruins, often with ambiguous, spiritual connotations. After the early deaths of his mother and brother, Friedrich developed a somewhat gloomy, meditative outlook. His main interest was the contemplation of nature, and many of his landscapes feature enigmatic figures. Among other things, the Romantic movement involved a reconsideration of the natural world in all its grandeur and power, and often especially its impact on humans. Here, as well as creating a lifelike scene, Friedrich seems to have explored his own inner thoughts, looking for spiritual comfort. He wrote: 'The artist should paint not only what he has in front of him but also what he sees inside himself,' and 'Close your physical eye, so that you may see your picture first with the spiritual eye.'

With the man's back almost silhouetted against the white fog, a sense of awe, mystery and foreboding is created. His hair windswept and his left hand resting on his knee, he stands on a high place, looking down on the swirling white clouds and mist below. He seems to be in a moment of deep contemplation and reflection, possibly even undergoing a spiritual or religious experience. For this reason, the painting is often described as a metaphor for an unresolved future. As with many of Friedrich's paintings, it seems also to be a representation of human insignificance when confronted with the strength and force of nature.

Because of the *Rückenfigur*, we see the world through the man's eyes and share his personal experience. The vast, forbidding landscape stretches away in front of him. Rocks protrude through the fog, and mountains can be seen in the distance, also shrouded in fog. Many aspects of the landscape can be identified as the Elbe Sandstone Mountains, a mountain range on the border between Saxony in Germany and the Bohemia region of the Czech Republic. Friedrich travelled there before starting this painting, and sketched what he saw in meticulous detail. Back in the studio, he combined and altered aspects of his observational sketches as he created his breathtaking imaginary view.

Caspar David Friedrich (1774–1840)
Wanderer Above the Sea of Fog, oil on canvas, c.1818

'Friedrich's main interest was the **contemplation of nature**, and many of his landscapes feature **enigmatic figures**.'

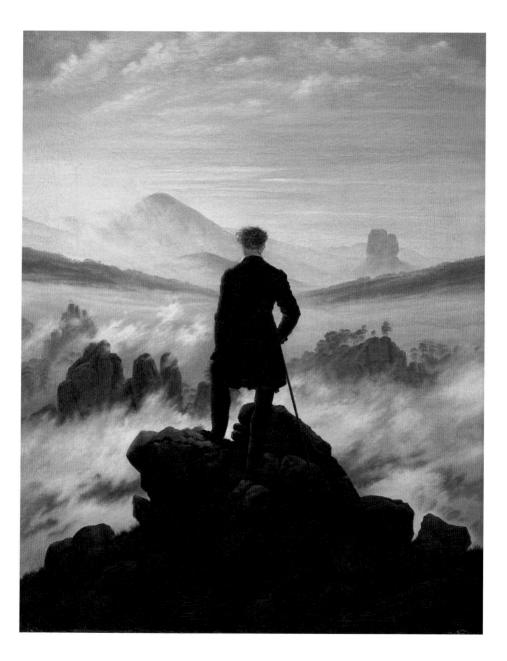

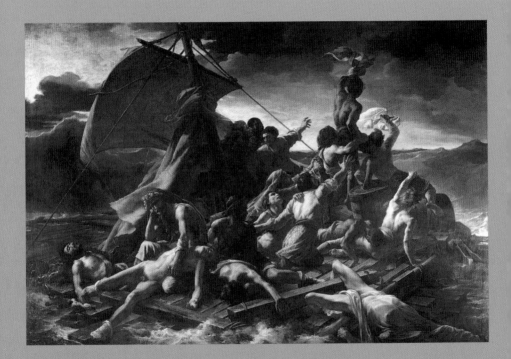

'With its **unsettling** depiction of **human suffering**,
this huge painting portrays an incident that became the focus
of a **major political scandal**.'

The Raft of the Medusa re-creates a scandal

With its unsettling depiction of human suffering, this huge painting portrays an incident caused by the shipwreck of the frigate *Medusa* in 1816, which became the focus of a major political scandal. The painting itself was also highly controversial, and it provoked a furore at the Paris Salon.

In the early summer of 1816 the French Royal Navy frigate *Medusa* was taking French officials to Saint-Louis in Senegal. The ship was captained by an officer who had not sailed for more than 20 years, and through his poor navigation it ran aground on a sandbank 80 km (50 miles) off Mauretania. Efforts to free it failed, but there was space for only 250 people in the lifeboats, while *Medusa* was carrying over 400 crew and passengers. A raft was hastily built to take the remaining passengers, to be towed by the lifeboats. However, fearful for their own safety, after just a few miles those on the lifeboats cut the ropes, leaving the raft powerless and the passengers on it without supplies.

Feverish, dehydrated and starving, these desperate people fought with each other, killed mutineers and the weakest among them, and – most scandalous of all – ate their dead companions. No search was sent out for them, but after nearly a fortnight at sea, the raft was rescued by chance by a ship called the *Argus*. By then, only 15 men remained alive – and five died soon afterwards. When the brutality and cannibalism came to light, the incident became a huge public scandal.

This monumental canvas portrays the moment when, after 13 days adrift, the survivors on the raft spot a ship in the distance. Rendered in pallid flesh tones, dark colours and strong chiaroscuro, the painting conveys the drama and tragedy of the situation. The story had fascinated the French artist Théodore Géricault, and he undertook exhaustive research, produced many preparatory sketches and worked on the painting for over a year. He interviewed two of the raft survivors and constructed a detailed scale model of the raft itself. He used friends as models, visited hospitals and morgues to study the colours and textures of decaying flesh, and filled his apartment with body parts, including a severed head from a lunatic asylum. In the final work, the raft is buffeted precariously in the waves, and the few living men on it are desperate. Surrounded by bodies, one man holds his son's corpse on his lap, while others have just seen a ship; one stands on an empty barrel and waves his handkerchief frantically to draw its attention.

At its first appearance in the Paris Salon of 1819, the painting was both loved and loathed, receiving both acclaim (and a gold medal) and disapproval. It made Géricault a legend during his career of just 12 years.

Théodore Géricault (1791–1824)

The Raft of the Medusa, oil on canvas, 1819

Totem Pole
links to the dead

Carved by the indigenous people of the Northwest Pacific coast – that is, British Columbia in Canada and southern Alaska in the United States – totem poles were created to represent a family or clan's pride, achievements, stories and beliefs, to express legends, clan lineage and memorable events, to mark graves and entrances to homes, to commemorate important events and communicate with dead members of that family or clan. Every totem pole was therefore carved with significant symbols or the emblems of families or clans and their ancestors.

Divided into clans, which are in turn divided into subgroups, the Tlingit, or 'People of the Tides', occupied a huge area. For centuries they and other local tribes both traded and fought with each other. Their complex philosophical and religious systems have both similarities and marked differences. All tribes practised shamanism, a belief in the supernatural. Shamans cured diseases, influenced the weather, aided hunting, predicted the future and protected people against witchcraft, and while every tribe had their own creation myths, legends and stories and worshipped different deities, they all believed that shamans could contact the spirits of the forests and the water. They also all believed in communicating with their antecedents in order to call upon guardian spirits for help and support, and totem poles were often used as conduits for this.

The tribes' decoration of their totem poles was distinguished by their use of animals or symbols, but there were also common figures. Animals represented different attributes. For example, the wolf is a natural leader and highly intelligent, with a strong sense of family, so on a totem a wolf symbolizes leadership, intelligence and strong family bonds. An eagle represents courage, leadership and prestige, and a fox cunning, stealth and feminine courage.

Carved from a single trunk of cedar wood, this totem pole is imbued with spiritual power and historical belief. It was made during the nineteenth century, when the Tlingit were using metal tools, which enabled the creation of complex, precise carvings. Tlingit culture places great emphasis on family, respect, generosity, good manners and spirituality, and this totem pole was created to be displayed outside a Tlingit plank or clan house. This totem pole symbolizes guardian spirits or helpers, and each animal and symbol carved on it has a specific meaning. It is built in three sections, to be read from the bottom up, and the position of each figure is significant. The lowest section is the most important, since it displays the symbols and images in the most visible and prominent position. The top section features mythical creatures and monsters. The images are intended only to represent human and animal faces, rather than to look exactly like them.

Artist unknown
Totem pole, painted cedar wood, 1820–40

'The images are intended only to **represent** human and animal faces, rather than to look **exactly like them**.'

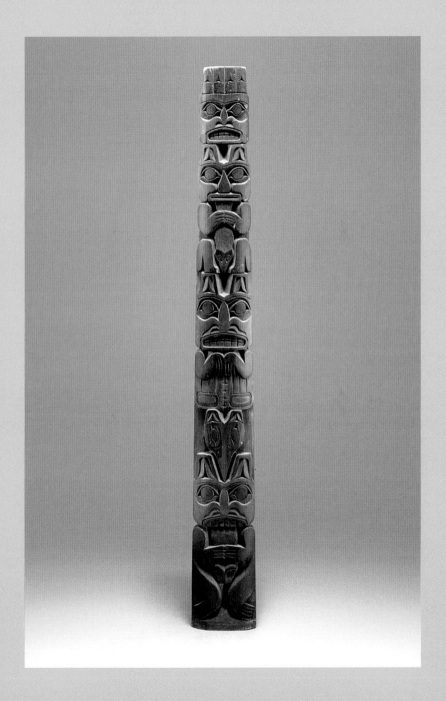

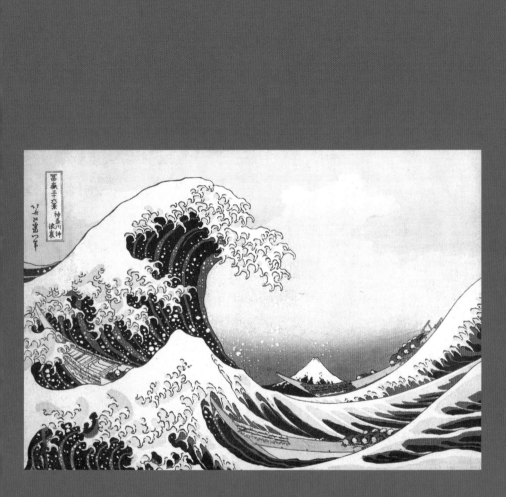

'In the **foreground**, a smaller wave forms the shape of a miniature Mount Fuji, and because of the **optical effects** of **perspective**, it appears **larger** than the distant mountain.'

The Great Wave Off Kanagawa expresses nature's power

This woodblock print by the Japanese *ukiyo-e* artist Katsushika Hokusai was published during the late Edo period as the first in his series *Thirty-Six Views of Mount Fuji*. Hokusai was also a painter, but woodblock prints were the most popular art form in Japan in the nineteenth century. *Ukiyo-e*, 'pictures from the floating world', describes a genre of Japanese art produced from the seventeenth to the twentieth century.

Mount Fuji is Japan's most sacred mountain, and emphasizing that, as well as the great power of nature and the subsequent fragility of human existence, Hokusai depicted it in different seasons and weather conditions, at different times of day and from different locations. Born in Edo (present-day Tokyo), he was nationally renowned before he created this series.

An enormous wave threatens to engulf three *oshiokuri-bune* (fast boats) carrying fish from the Izu and Bōsō peninsulas to the markets in the bay of Edo. Eight rowers are in each boat, all clutching their oars, with two passengers in the front. The tiny boats and figures convey the size of the wave. Mount Fuji can just be seen in the background, within the swell of the wave. The lacy foam tips point towards it, and drama is created by the fact that it is about to crash down. Waves were a popular subject in Japanese art from the sixteenth century, and fantastic paintings were made of them on folding screens known as *ariso byōbu*, 'rough seas screens'.

The wave dominates the composition and creates tension. In the foreground, a smaller wave forms the shape of a miniature Mount Fuji, and because of the optical effects of perspective, it appears larger than the distant mountain. Storm clouds hang in the sky around Mount Fuji, highlighting its snowy peak. The print exemplifies Hokusai's precise process of woodblock printing with restricted colours: three shades of blue for the water (a combination of traditional indigo and Prussian blue, a recently invented chemical pigment); yellow for the boats; dark grey for the sky behind Mount Fuji and the boat below; pale grey for the sky above the mountain and the foreground boat; and pink clouds in the sky.

At the time this print was made, Japan was not engaging culturally with other nations, except for trade with China, Korea and the Dutch, which was strictly controlled. Nearly 30 years later, in 1859, the country opened its ports and exports to foreign nations, and as Japanese prints arrived in Europe, their style strongly influenced artists such as Vincent van Gogh, James Abbott McNeill Whistler and Claude Monet, as well as design movements, including Art Nouveau.

Katsushika Hokusai (1760–1849)
The Great Wave Off Kanagawa, colour woodblock print, c.1829–33

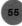

Rain, Steam and Speed
conveys modernization

A steam engine hurtles over a bridge in driving rain. The bridge is the Maidenhead Viaduct, which crosses the River Thames on the Great Western Railway (GWR) line west of London. Designed by Isambard Kingdom Brunel, the viaduct was completed in 1838. In the painting, the powerful steam engine pulls open goods wagons in which passengers could travel, paying the cheapest rates. At the time, the average engine speed on the Great Western Railway was 33 mph (53 kph), but on long, level stretches, such as here, an astonishing 60 mph (nearly 97 kph) could be reached.

The London-born artist Joseph Mallord William Turner lived through turbulent times. Britain was at war for much of his life, while revolutions and struggles for independence occurred globally. He witnessed the transition from sail to steam power and from manpower to mechanization, while scientific advances and political reform transformed society. Many artists were horrified by these developments, but Turner accepted and even welcomed them as challenges. One viewer related how, as a young woman, she had been travelling on the GWR during a stormy night in June 1843 when a fellow passenger 'with the most wonderful eyes' had leaned out of the train window for almost ten minutes as the train was stopped at Bristol. On seeing *Rain, Steam and Speed* at the Royal Academy, where it was first exhibited, she declared that the passenger must have been Turner.

At the bottom right-hand side of the composition, a hare runs along the track. It probably symbolizes speed and perhaps the limits of technology, although it might also be conveying the way that manmade technology was destroying the natural world. Because the hare was lightly brushed on top of dry paint, it can now barely be seen, since the paint has become transparent with age. To emphasize the drama of the moving train, Turner reduced the double track across the bridge to a single narrow line. Rain and sunlight fall on the woods and fields on either side of the bridge, and steam is represented by three small clouds emerging from the engine's funnel. On the left-hand side is a river with a small boat and, barely visible near the right-hand edge, a man drives a horse-drawn plough. Both the boat and the plough are examples of relatively slow, non-mechanized activity as Turner contrasts the pre-industrial with the modern.

All elements of the painting blend and merge – except for the train itself, which materializes and hurtles towards us. Turner created a diagonal recession from the foreground to a vanishing point at the centre of the image, while the foreshortening of the viaduct to the horizon suggests the speed at which the locomotive bursts into view through the driving rain.

Joseph Mallord William Turner (1775–1851)
Rain, Steam and Speed – The Great Western Railway, oil on canvas, 1844

'All elements of the painting **blend** and **merge** – except for the train itself, which **materializes** and **hurtles towards us**.'

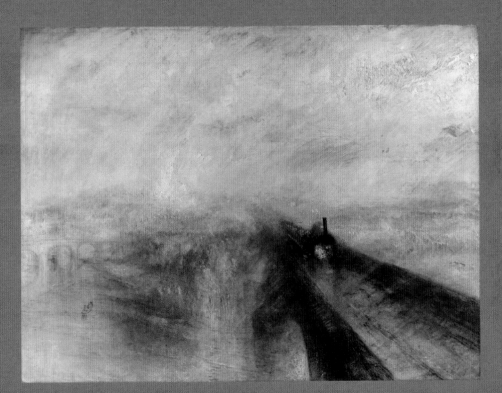

'Leutze filled the boats with soldiers of
several types and nationalities to represent a **cross-section**
of the American colonies.'

Washington Crossing the Delaware inspires revolution

The Revolutions of 1848 were a series of political upheavals that occurred throughout Europe. Essentially democratic and liberal, they aimed mainly to remove European monarchies and create independent nation states. Having started in France, they spread across Europe, and ultimately more than 50 countries were affected; but with no coordination or cooperation between revolutionaries, most were quickly suppressed. However, lasting reform did occur in some countries, including France, the Netherlands, Italy and Germany.

Born in Württemberg, Germany, Emanuel Gottlieb Leutze lived in the United States from the age of 9. He returned to his native country as an adult, and while there, during the Revolutions of 1848, he decided to paint an image that he hoped would inspire Europe's liberal reformers with the example of daring and determination in the American Revolution. Using American tourists and art students as models and assistants, he created the first version of this painting in 1850. Soon after he completed it, however, it was damaged by a fire in his studio, and later that year a larger version was commissioned by the Parisian art trader Adolphe Goupil. Placed on exhibition in New York in October 1851, it was viewed by more than 50,000 visitors.

The painting is an imaginative depiction of one of George Washington's most celebrated attacks during the American Revolutionary War. After many setbacks, on the night of 25 December 1776, he led the Colonial army across the Delaware River, intending to attack the Hessian encampment outside Trenton, New Jersey. (Hessians were German soldiers hired by the British Empire.) The next day Washington's surprise strike on the Hessian forces resulted in his victory. Providing hope for the Colonial cause, his bold move became a turning point in the war.

The huge scale of the painting conveys the importance of the event. Leutze filled the boats with soldiers of several types and nationalities to represent a cross-section of the American colonies. Among the other figures are an African American, a Scotsman, two farmers wearing broad-brimmed hats, and a Native American. Despite the treacherously icy water, Washington and his officer stand proudly in the bow of the front boat, wearing uniform. The officer clutches an early version of the 'Stars and Stripes' flag (the current version did not exist at the time). A more historically accurate flag would have been the Grand Union Flag that was hoisted by Washington in January 1776 at Somerville, Massachusetts, as the first national flag. It is unlikely that anyone would have stood in the boat as Washington does here, but Leutze has illuminated the sky to highlight his noble profile as the boat sails to victory – even though they actually sailed under cover of darkness.

Emanuel Leutze (1816–1868)

Washington Crossing the Delaware, oil on canvas, 1851

The Gleaners
sympathizes with the poor

Jean-François Millet spent ten years researching and planning this painting. When he showed it at the Paris Salon of 1857, it drew criticism from the middle and upper classes, who were concerned that it glorified peasants. At the time the poor considerably outnumbered the rich, and in the revolutionary climate, there was general anxiety about the growing Socialist movement.

The women in the painting personify the rural working class. Gleaners were given permission to follow the paid harvesters in the fields and pick up any wheat that was left behind. Here they are bent over, searching the ground. Each woman's pose demonstrates the arduousness of constantly bending over, picking up and standing up again, while the scene in the distance shows how much easier life is for the workers who are paid to do a less taxing job. The harvesters can be seen, upright, chatting companionably, while the gleaners are too weary and intent on their exhausting task to speak.

Since ancient times, gleaning had been common practice among the poor. Dressed for the job, the women wear calico aprons with deep pockets to be filled with stray pieces of wheat. Their hair is tucked under headscarves. Yet Millet has portrayed them as diligent and dignified. He was aiming not to highlight the harshness of their lives, but to convey their honest endeavour. His empathy for the

hardworking lives of the poor stemmed from his own farming background. Although he trained traditionally and initially worked as a historical and portrait painter, after the French Revolution of 1848 he moved to the village of Barbizon in the Forest of Fontainebleau and began painting rural life. In this way, he became known as one of the founders of the Barbizon School of painters and, along with Gustave Courbet, as part of the Realist movement and one of the main initiators of the change from traditional to modern painting.

Realist painting focused on modern issues such as social conditions, rural poverty and the lives of the common people, whereas the conventional, official Academic system considered such mundane subjects inappropriate for fine art. However, this painting was accepted for the annual Paris Salon, which at the time was almost the only way a French artist could become known. Millet used the soft, golden light of the setting sun to accentuate the sculptural quality of the gleaners, with dark shadows and their bent, curving forms emphasizing the laboriousness of their work. The contrast between abundance and scarcity, and between light and shadow, brings to the fore the class divide. The entire image is a commentary on the social classes of France and, in particular, the inability of the lower classes to rise above their station.

Jean-François Millet (1814–1875)
The Gleaners, oil on canvas, 1857

'Realist painting focused on **modern** issues such as **social conditions, rural poverty** and the lives of the **common people.'**

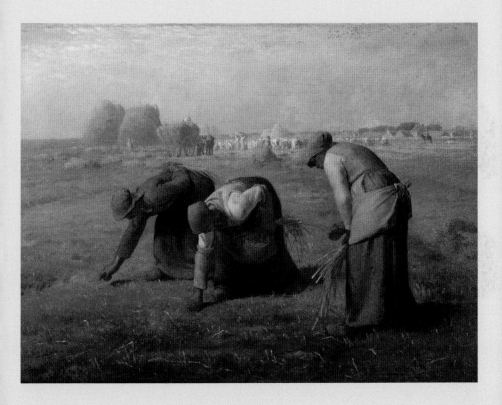

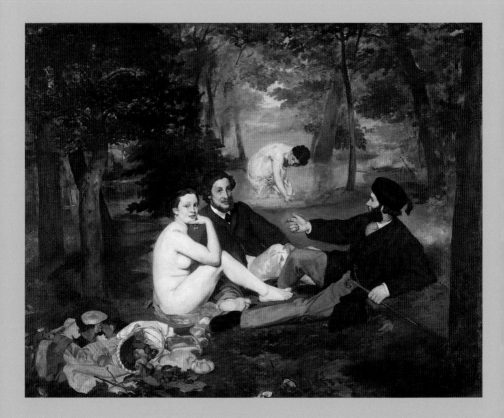

'Disregarding **traditional painting methods**, Manet left **visible brush marks** and **empty patches** on the canvas, and created a sense that the lighting was **artificial**, painted in his studio.'

Le Déjeuner sur l'Herbe
breaks artistic convention

A female nude appears to be having a picnic in the open air with two fully clothed men. Behind, a skimpily dressed woman bathes in a stream. The men talk to each other but seem to be ignoring the nude woman next to them, who looks out of the canvas directly at the viewer.

Rejected by the Paris Salon jury of 1863, this painting was instead shown that same year at the Salon des Refusés, an alternative salon for those who had been refused entry to the official one. Under the title *Le Bain*, the painting provoked offence, hostility and mirth among visitors, but the scandal propelled the painter, Édouard Manet, into the public eye.

The work broke with almost every artistic convention. A naked woman sitting with fully dressed men was an insult to respectable viewers. The modern-day attire of the men discounts any notion that the painting is an allegory, and the implication is that the women are not goddesses (acceptable) but models (unacceptable), or possibly prostitutes. Equally distasteful to viewers were Manet's techniques. Disregarding traditional painting methods, he left visible brush marks and empty patches on the canvas, and created a sense that the lighting was artificial, painted in his studio, despite the scene being set in the open air. There are no shadows, little attempt is made in the suggestion of depth, and the figures seem flat. Manet's application of paint is sketchy, and there are no subtle transitions between light and dark.

Only the still life of fruit, bread and the woman's clothes in the foreground is conventionally painted, and the perspective is confusing. The bather in the background is too large, in relation both to the nearby boat and to the other figures. There is no sense of distance as her form is outlined, and so she appears to float. However, Manet based the painting on two highly respected images in the Louvre that he had copied during his student days: *Le Concert Champêtre* (1509) by Titian, attributed at the time to Giorgione; and *The Judgement of Paris* (c.1510–20), an engraving by Marcantonio Raimondi after a design by Raphael.

The nude model was Victorine Meurent, whom Manet used regularly. Her direct gaze at the viewer projects her lack of modesty and her body is harshly lit, so no subtle shading softens the impact of her nakedness. The male figure on the right was based on a combination of Manet's two brothers, Eugène and Gustave, while the other man is based on his brother-in-law the Dutch sculptor Ferdinand Leenhoff. On top of everything, the large size of the canvas was conventionally used only for historical, religious and mythological subjects, and not something as mundane (and shocking) as this.

Édouard Manet (1832–1883)

Le Déjeuner sur l'Herbe, oil on canvas, 1863

The Sleepers
attacks bourgeois morality

Known variously as *The Sleepers*, *The Two Friends* and *Indolence and Lust*, this painting depicts the fantasy of the Ottoman-Egyptian statesman, diplomat and art collector Halil Şerif Paşa, who lived in Paris from 1860. He commissioned the work to join his collection of paintings by many other contemporary artists, and he was particularly interested in the depiction of realistic, sensual flesh. The work portrays two naked women entwined in bed. The implication is that they are lesbians who have just had a sexual encounter. Six years after entering Halil's private collection, the painting was exhibited in Paris by a picture dealer, but it was deemed so scandalous that it became the subject of a police report. After that, it was not permitted to be shown publicly for more than 100 years, until 1988.

The artist, Gustave Courbet, rejected idealism, the precision of the accepted Academic style of painting and the theatricality of Romanticism. Instead, his earthy, unsentimental paintings, unconcerned with convention and frequently extremely provocative, helped to establish Realism. Many of his paintings addressed social issues, such as the working conditions of the poor, and his spontaneous brushstrokes indicate that he was observing his subjects directly rather than adapting or idealizing them. He worked quickly, often applying paint with a palette knife. In the late 1860s he became even more unorthodox and controversial when he began painting erotic nudes, such as this. Although this particular painting was not shown at the Salon, Courbet's other fleshy nudes shocked viewers who were used to the smooth, alabaster-skinned goddesses of Academic painting.

Despite the shock value, however, Courbet was clearly celebrating the beauty of the female body. Aiming to please his patron, he painted an erotic image of two women, one dark-haired with honey-toned skin, and the other a reddish-blonde with pale skin. The white sheets are crumpled beneath them and feminine accessories, including pearls and a hair comb, are scattered around them. The setting is a bedroom, with a dark-blue velvet curtain and an ornamental table with a vase of flowers in the background. In the foreground, a small painted table holds a gold-and-blue cut-glass decanter and matching glass, and a crystal vase. One of the models here was Joanna Hiffernan, the mistress of Courbet's fellow painter James Abbott McNeill Whistler.

The large scale of the painting, its realism and the clarity of its style add to its impact. Because the two models are clearly 'real' women and not goddesses, and they have almost certainly fallen asleep after sexual activity, the image was perceived as erotic, sensual and shocking. While it captured Halil's fantasy, it attacked bourgeois conventions and morality.

Gustave Courbet (1819–1877)
The Sleepers, oil on canvas, 1866

'Despite the **shock value**, Courbet was clearly **celebrating** the beauty of the **female body**.'

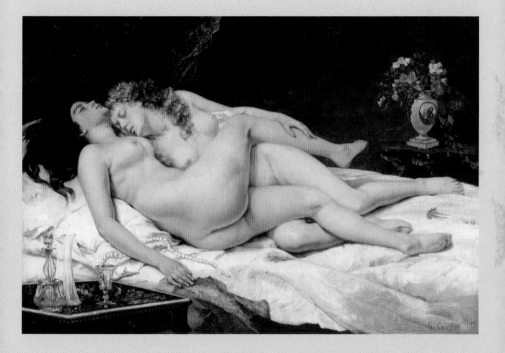

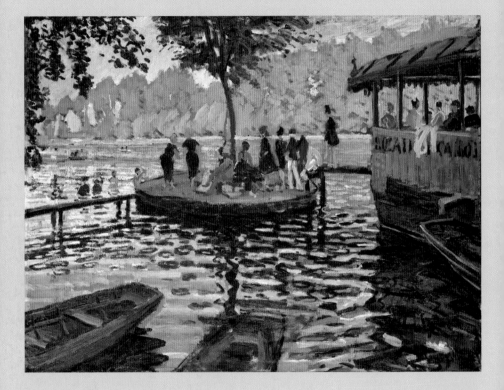

'Although this work is **ostensibly** an image of the middle classes
enjoying their leisure time, the **real subject** is **light**.'

La Grenouillère
engulfs with light

Claude Monet painted *La Grenouillère* before the term Impressionism had been coined. It was the summer of 1869, and he and Pierre-Auguste Renoir had set up their easels at the popular boating and bathing resort on the River Seine, close to Bougival, where Monet was living and working at the time. It had become a weekend hub where many Parisians came to relax out of the city.

The scene represents Flowerpot Island, also known as the Camembert, and the gangplank to La Grenouillère, a floating restaurant and boat-hire venue. Breaking with tradition, Monet increasingly painted in the open air, directly in front of his motif. His sketches had conventionally been made in the open air, but his finished works executed in the studio, yet from his early days painting in and around Le Havre, he often radically painted entire works outdoors, *en plein air*. This meant that his paintings were made with quicker, smaller and more visible brushstrokes than traditional works, and his subjects were objective views of things he saw and the way light fell on them. He used certain terms to describe his paintings, including *impression* and *enveloppe* (which describes the way an object is surrounded by light), and he painted rapidly, applying patches of colour that he called *taches*. These were broad, short brushstrokes, made possible by the recent invention of the metal ferrule, which enabled the manufacture of flat brushes. Flat brushes made

it easier than round brushes to apply paint quickly to a canvas. Here, for example, Monet applied quick, broken, horizontal marks to depict moving water and short dashes of colour to suggest the foliage of the central tree. Even the figures are built up with sketchy, flat brushstrokes, and they lose their individuality as they become aspects of an overall image of light and colour. Everything is created from what Monet saw in terms of light – or the absence of it.

Plein air painting became the basis for the Impressionist movement. Although the name Impressionism did not come into use until a few years after Monet painted this – and the name came from the title of another of his paintings – the philosophy of the style can be seen here, as he sought to capture the fleeting qualities of light, colour and atmosphere just from what he saw in front of him during the transitory moments he was painting. He is often classed as the leader of the Impressionists, and he was one of the first to use looser brushwork than was generally accepted. Picking up on Gustave Courbet's ideas, he painted objectively, but although this work is ostensibly an image of the middle classes enjoying their leisure time, the real subject is light.

Claude Monet (1840–1926)

La Grenouillère, oil on canvas, 1869

Still Life with Jar, Cup and Apples
deconstructs nature

Frequently called 'the father of modern art,' Paul Cézanne (1839-1906) was possibly the single most influential artist on early twentieth century art movements. Misunderstood for most of his life, after his death, he became widely admired, described as a Post-Impressionist and generally recognised for helping to inspire – among others – the art movements of Fauvism, Cubism, Expressionism and even abstraction. He was particularly influential to both Henri Matisse and Pablo Picasso. Although he painted with the Impressionists, he never enjoyed capturing surface appearances as they did, but always tried to blend their fresh approach with something more monumental and in line with the substance of the Old Masters. More than many other artists of his time, Cézanne painted still life compositions throughout his career and used them to explore spatial relationships. Although they are all varied, this is one of several compositions that feature the same wallpaper, green-topped jar, cup, crumpled white fabric and fruit.

Cézanne spent most of his career working out how to represent structure and solid, three-dimensional objects on flat, two-dimensional surfaces. While the Impressionists worked quickly, he painted extremely slowly, using tiny, directional brush marks as he depicted the same or similar motifs over and again. He developed a completely original pictorial language, discarding conventional methods of portraying perspective and tonal modelling, instead using subtly varied colours and illustrating objects from different angles at once, to replicate the ways in which our eyes see things naturally. This resulted in slightly distorted forms as can be seen in this composition with its seemingly precariously balanced objects. Still life for Cézanne was particularly useful as he could set up an arrangement in his studio and keep it for as long as he liked as he drew and painted it and studied it from different angles and in different lights. Totally absorbed by his motif, he aimed to transform nature into something harmonious and more truthful than the ways in which solid forms had been portrayed for centuries. It was a constant struggle for him to integrate his understanding and awareness of the solid objects in front of him with his sense of harmony and colour. Because of this and his introverted personality, he was ridiculed by many contemporaries and his perspective often looks odd and incorrect.

Overall, this still life is colourful and original. While not natural-looking, as if he has simply encountered the arrangement on a table in his home, it is carefully planned and arranged, with defined groups of objects that are held together visually by the stark white cloth that also emphasises the solidity of everything in view. The white of the cloth and the boldly coloured fruit, pot and cup are thrown into view by the muted colours of the wallpaper behind them.

Paul Cézanne (1839–1906)
Still Life with Jar, Cup and Apples, oil on canvas, c.1877

'Totally absorbed by his motif, Cézanne aimed to **transform nature** into something **harmonious** and **more truthful** than the ways in which **solid forms** had been portrayed for centuries.'

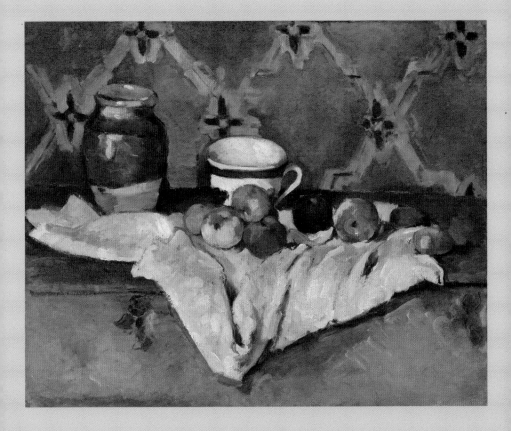

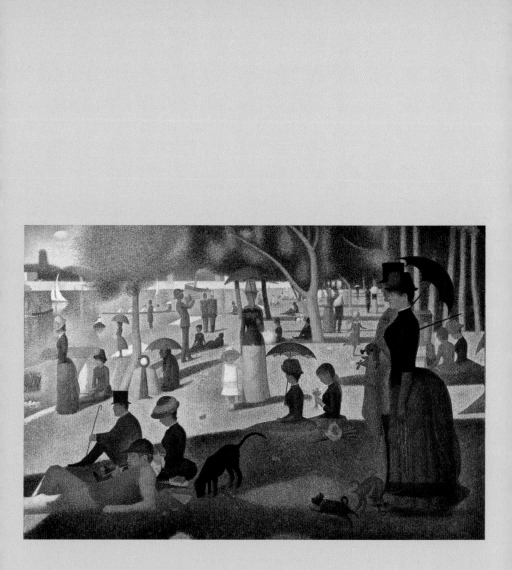

'The tiny **coloured dots** blend and merge when seen by the human eye, and Seurat called this form of painting **"Divisionism"**.'

La Grande Jatte
enhances colour

When first shown at the last Impressionist exhibition, in May 1886, this painting caused a sensation. Featuring Parisians relaxing on a small island on the River Seine, it was one of the first paintings to be created using the pointillist method.

In 1884 the Parisian artist Georges Seurat had begun working on this huge painting, which gained him recognition in the art world as the leader of a new form of painting labelled Neo-Impressionism. Unlike the Impressionists, Seurat did not paint intuitively and spontaneously, but studied his subject closely, making many preliminary sketches and drawings and then building his image out of careful, painstakingly placed dots of colour. Rather than mixing his colours on a palette or blending them with his brushstrokes, he followed the theories of the American physicist Ogden N. Rood (who proposed that when colours mix in the eye rather than on the canvas, they result in a more luminous effect) and the law of simultaneous contrast established by the French chemist Michel-Eugène Chevreul, in which juxtaposed complementary colours make each other appear more vivid. The complementary colours are red and green, orange and blue, and violet and yellow, and Seurat adopted these scientific discoveries wholeheartedly in his art.

This work was the first to demonstrate that by placing dots of pure colour side by side, rather than mixing colours and then applying them in strokes as in conventional paintings, an artist could create brighter effects. Seurat spent hours creating his meticulously planned painting using this painstaking technique. Over two sessions, between May 1884 and March 1885, and then from October 1885 to May 1886, he painted with tiny dabs of colour. He focused mainly on colour, light and form, and modelled the composition on the Panathenaic Procession from the Parthenon frieze, Athens. So, although this is an unusual subject for such a vast canvas, the artist's method of depicting the figures in the manner of classical statues makes it seem more monumental than a mere moment in time.

The tiny coloured dots blend and merge when seen by the human eye, and Seurat called this form of painting 'Divisionism', although it is now more commonly known as pointillism. His adherence to the scientific colour theories can be seen across the entire painting. For instance, the bright-green patches of sunlit grass are comprised of dots of yellow, orange and blue, while the shaded patches are predominantly blue, yellow and pink. Blue appears in shadows against orange objects and green next to red. The scientific objectivity here replaced the emotional subjectivity of most other paintings of the time, and when first exhibited, the painting was criticized as being too mechanical for contemporary taste.

Georges Seurat (1859–1891)

A Sunday Afternoon on the Island of La Grande Jatte, oil on canvas, 1884–86

Chair with Pipe
represents belongings

Although Vincent van Gogh worked as an artist for only ten years of his life, during that time he produced more than 2,000 works of art. He also achieved almost no success. His life was marked by illness, poverty and tragedy, but he is now one of the best known and most popular artists in the world, and helped to lay the foundations of modern art.

This may appear to be a straightforward and simple chair, but Van Gogh painted it to symbolize something that belonged to him and simultaneously to indicate his optimism for the future. Yellow was his favourite colour – the colour of the sun and of sunflowers – and this image, predominantly yellow with contrasting blue and violet shadows, represents hopefulness. He painted it while he was living in Arles in the South of France, when his fellow artist Paul Gauguin had come to stay with him, an event that Van Gogh believed was to be the start of an exciting and productive artists' colony there.

It was early December. Gauguin had been staying with Van Gogh since October, and at the same time as painting this chair, Van Gogh was also painting an image of his friend's chair. In a way, the paintings represented the two men. Particular colours were used in each painting to characterize the sitters. Van Gogh's own chair is predominantly yellow, while Gauguin's was mainly dark red. On his chair is a pipe and tobacco, while on Gauguin's are books.

Van Gogh was born in the Netherlands, and he moved to other places, including Belgium, France and England, as he attempted various careers. His early work while still in the Netherlands and in Belgium was dark, reflecting much Dutch painting of the seventeenth century, but when he moved to Paris, he befriended the Impressionists and subsequently lightened his palette and began creating simplified, asymmetrical compositions, influenced by the Japanese prints he collected. Gauguin encouraged him to paint from his imagination, but he found that difficult, and this painting of the chair was created from direct observation with elements from his imagination. Like the chair itself, the pipe and tobacco on the rush seat represent his ownership. He had few possessions, but for him, his chair, paint, and pipe and tobacco – almost all he owned – were essentials. In the corner, included partly for their colour and shape and perhaps also for their positive indications of new life, are some sprouting onions.

While Gauguin stayed with him (he left later that month, much to Van Gogh's distress), Van Gogh perfected the technique that made him famous posthumously. He used bright colours and contrastingly coloured contours, a flatness that did not adhere strictly to the rules of linear perspective, and thick, juicy impasto.

Vincent van Gogh (1853–1890)
Chair with Pipe, oil on canvas, 1888

'This may appear to be a **straightforward and simple** chair, but Van Gogh painted it to **symbolize** something that **belonged** to him and simultaneously to indicate his **optimism** for the future.'

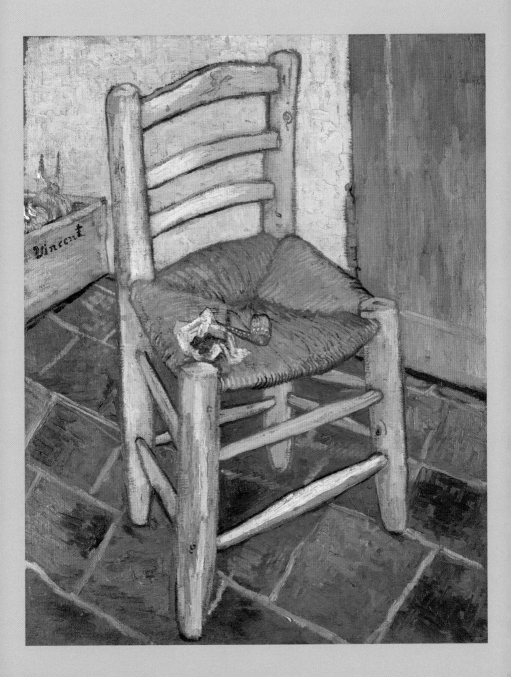

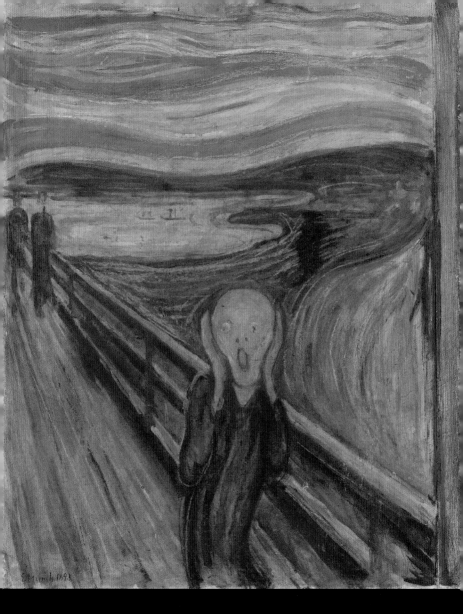

'Throughout life, Munch experienced various **morbid preoccupations**, and as an adult he **expressed** many of them in his **paintings and prints.**'

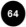

The Scream
acts as therapy

An early pioneer of Expressionism, the Norwegian painter Edvard Munch was 5 years old when his mother died of tuberculosis and 13 when his older sister, Sophie, to whom he had become attached in his mother's place, died of the same disease. His father became depressed and obsessed with religion, and another of his sisters suffered bouts of insanity. Throughout life, Munch experienced various morbid preoccupations, and as an adult he expressed many of them in his paintings and prints.

Munch produced several versions of this image: two in paint, two in pastels, and a lithograph. The location has been identified as the Kristianiafjord (now Oslofjord) seen from Ekeberg, and it has been suggested that the unnaturally harsh colours in the painted versions were his interpretation of the atmosphere at the time, which was affected by volcanic dust from the recent eruption of Krakatoa in Indonesia. Remarkable sunsets were seen around the world for months after this cataclysmic event.

The image was an expression of Munch's inner anxiety and troubled mind, as he described later: 'I was walking along the road with two friends – the sun was setting – suddenly, the sky turned blood red – I paused, feeling exhausted[,] and leaned on the fence – there was blood and tongues of fire above the blue-black fjord and the city – my friends walked on, and I stood there trembling with anxiety – and I sensed an infinite scream passing through nature.'

Composed to create maximum tension, the dramatic combination of straight and curving lines, violent colours and the distorted, screaming figure in the foreground give the impression of terror and anxiety. With its face simplified to a skull-like shape, with barely any indication of features, only two dots for nostrils and the eyes and mouth open, and two thin hands on either side, the screaming figure is one of the most recognizable in art, personifying fear and anguish. The jarring colours and juxtaposition of undulating and straight lines and shapes lead the viewer's eye around the image and to the figure. Tension is enhanced by two more faceless figures walking along the bridge, and the strong perspective created by the receding lines of the bridge itself.

Munch was one of the first artists to express feelings of angst and dread in art, and this image is a radical and timeless expression of human distress. It was his way of analyzing his feelings and his experience on that day, a form of therapy for himself. As the plunging perspective leads the eye towards the figures in the distance and across to the undulating fjord, it conveys how Munch was exploring his turbulent mind, visually expressing his morbid fear of death and his hallucinations.

Edvard Munch (1863–1944)
The Scream, tempera and crayon on cardboard, 1893

Where Do We Come From? symbolizes the stages of life

Although not appreciated during his life, the artist Paul Gauguin is now recognized for his experimental use of colour, his flat, decorative forms and his dark outlines that helped to inspire Expressionism and other artistic ideas. His strong sense of pattern and non-naturalistic colour contrasted deliberately with the prevalent Impressionist approach. Categorized as a Post-Impressionist, he is now also highly controversial for the way he lived.

Towards the end of his life, Gauguin spent ten years in French Polynesia, and this is his largest work from that period. Only after his death did it become admired and influential to many other artists, including Pablo Picasso and Henri Matisse. A painter, sculptor, printmaker, ceramist and writer, Gauguin was initially a stockbroker, but he left his job and abandoned his wife and five children in order to pursue his artistic dreams.

This monumental painting was created while Gauguin was living on Tahiti, and elements of that island can be seen in the background. He made the composition reminiscent of traditional religious frescoes or icons that are often on a gold ground; the bright-yellow patches in the two upper corners suggest this, and the figures are deliberately out of proportion with each other, as if they are floating, rather than being part of the real, everyday world. After finishing the painting in February 1898, he wrote to his friend George-Daniel de Monfreid, who managed his career in Paris: 'I believe that this canvas not only surpasses all my preceding ones, but [also] that I shall never do anything better, or even like it ... Two figures dressed in purple confide their thoughts to one another. An enormous crouching figure, out of all proportion and intentionally so, raises its arms and stares in astonishment upon these two, who dare to think of their destiny ... Lastly, an old woman ... completes the story! At her feet a strange white bird, holding a lizard in its claws, represents the futility of words ... I have finished a philosophical work on a theme comparable to that of the Gospel.'

Following the Eastern conventions of reading, the image can be 'read' from right to left. On the far right the sleeping baby represents the beginning of the human life cycle – or 'where do we come from' in the title of the painting. The oversized standing figure picking fruit in the middle – or 'what are we' – represents an adult and recalls the Garden of Eden. Also representing that part of the title is a young girl sitting eating a mango, with two cats. An idol represents 'The Beyond'. On the far left, a crouching old woman represents 'where are we going'. She sits on a shadow, waiting for death.

Paul Gauguin (1848–1903)

Where Do We Come From? What Are We? Where Are We Going?, oil on canvas, 1897–98

'I believe that this canvas not only **surpasses** all my preceding ones, but [also] that I shall **never** do **anything better**, or even like it.'

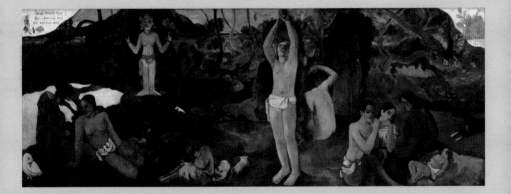

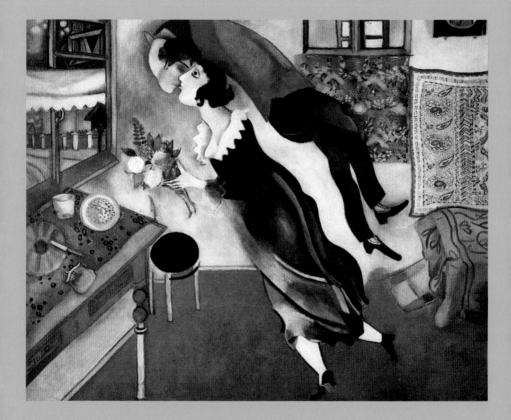

'Filled with **intimacy, affection and warmth**, this painting
expresses **happiness** and celebrates **love**.'

The Birthday
glorifies matrimonial love

Born in Vitebsk, Belarus, which was then part of the Russian Empire, Marc Chagall grew up in a devoutly Jewish household with nine brothers and sisters. His background became an important element of his colourful, poetic art that included paintings, stained glass, prints, ceramics, tapestries and illustrations. Travelling between Paris, St Petersburg and Berlin, he befriended several avant-garde artists and his work developed under the influence of Cubism, Fauvism and Expressionism, as well as the colourful folk art that surrounded him as he grew up. By the 1930s he was internationally successful, and he won many prestigious public commissions.

While back in Vitebsk between his stints abroad, Chagall met Bella Rosenfeld, with whom he fell deeply in love. He described their first meeting: 'Her silence is mine, her eyes mine. It is as if she knows everything about my childhood, my present, my future, as if she can see right through me.' Despite Bella's parents' opposition to the match – Chagall was still an impecunious painter at the time – they married in 1915, three weeks after his birthday. He worried that she would not marry him – she was young and came from a wealthy family, and he was not her social equal – but when she agreed, he produced this painting to express the joyous love between them.

The work features both his own portrait and one of Bella, conveyed in Chagall's naïve,

simplified and colourful style, ignoring the rules of linear perspective. In a living room, Chagall floats above Bella. His head contorts and turns upside down and backwards in order to kiss her on the mouth. Bella, in a simple black dress, holds a bouquet of flowers and her feet lift off the bright-red carpet to meet Chagall in the air. Thirty-five years after they first met Bella wrote in her memoirs of how she had managed – with great difficulty – to discover the date of his birthday, and when she did, she visited him on that day, carrying food and flowers in embroidered shawls. They draped the shawls around the room and Chagall began to paint this image to express their love. She wrote: 'Spurts of red, blue, white, black. Suddenly you tear me from the earth, you yourself take off from one foot. You rise, you stretch your limbs, you float up to the ceiling. Your head turns about and you make mine turn. You brush my ear and murmur.'

Filled with intimacy, affection and warmth, this painting expresses happiness and celebrates love. Bella was Chagall's inspiration, and the vibrant and intense colours portray his happiness. He referred to love as the primary source of all colour in his paintings. Chagall and Bella were married for 29 years, until she died of an infection in 1944.

Marc Chagall (1887–1985)
The Birthday, oil on cardboard, 1915

Fountain
questions what art is

In challenging the notion of what constitutes Art, Marcel Duchamp changed the path of art, and he is generally perceived as the father of Conceptual art. Along with Pablo Picasso, he was one of the two most influential artists of the twentieth century. Ironic, witty and astute, he refused to follow a conventional artistic path and produced only a small number of works during his short career as an artist. Influenced by Paul Cézanne and Francis Picabia, among others, he began his career working in a style that blended Futurism with Cubism, but he became more provocative, and through *Fountain* he affected the future of art enormously. In about 1913 Duchamp started to abandon painting in favour of readymades. These were objects that had previously been made for other purposes, and with little adjustment he attempted to exhibit them in places where art was expected to be viewed.

 This particular readymade is one of Duchamp's most famous works, and it became an icon of twentieth-century art. The artist signed this ordinary urinal with the pseudonym 'R. Mutt' and the date 1917, and gave it the title *Fountain*. He arranged for it to be submitted to the newly established American Society of Independent Artists, which he had helped to found. One of the Society's mandates was that all members' submissions had to be accepted. However, other members of the Society were horrified when Duchamp submitted *Fountain*, insisting that such a piece of sanitaryware was indecent and could not be considered a work of art. Declaring that the object was the work of a plumber, not an artist, the Society rejected it on the grounds of indecency and plagiarism.

 Soon after the exhibition opened, Duchamp found the urinal, which had been stored behind a partition, and took it to be photographed by the leading photographer and gallery owner Alfred Stieglitz. An article published in a magazine at the time, possibly written by Duchamp himself, claimed: 'Mr Mutt's fountain is not immoral, that is absurd, no more than a bathtub is immoral. It is a fixture that you see every day in plumbers' shop windows. Whether Mr Mutt with his own hands made the fountain has no importance. He CHOSE it. He took an ordinary article of life, placed it so that its useful significance disappeared under the new title and point of view – created a new thought for that object.' Duchamp proved that a work of art does not have to be made by an artist's hands, that it does not have to involve the transformation of materials for an artist to decide whether it is art or not, and also that institutions such as galleries and museums do a great deal to determine – and so influence – what constitutes art.

Marcel Duchamp (1887–1968)

Fountain, found ceramic urinal (replica; original lost), 1917

'Duchamp proved that a work of art does not have to be **made by an artist's hands**, that it does not have to involve the **transformation of materials** for an artist to decide whether it is **art** or not.'

'Few understood Cahun's **outlook** and **inability to conform,** but she spent her life **fighting convention.**'

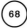

Untitled
explores gender

Born Lucy Renée Mathilde Schwob, Claude Cahun grew up in Nantes, France, and attended a private school in England after experiencing anti-Semitism in her home country. Back in France at the age of 18, while at the Sorbonne, she began producing photographic self-portraits and later also worked as a sculptor and writer. Believing that gender was exchangeable, in 1917 she adopted the gender-ambiguous name Claude Cahun, and for the rest of her life she challenged traditional concepts of gender and identity. Few understood her outlook and inability to conform, but she spent her life fighting convention, writing: 'Masculine? Feminine? It depends on the situation. Neuter is the only gender that always suits me.'

Despite producing a range of works, Cahun is remembered most for her carefully staged self-portraits and Surrealist scenes that she began producing in the 1920s. The co-founder of Surrealism, André Breton, called her 'one of the most curious spirits of our time'. Not dissimilar to Cindy Sherman's methods later in the twentieth century, Cahun adopted various photographic personas, dressing up as characters including a weightlifter, an aviator, a vampire, a soldier and a doll. For this image she shaved her head, dressed in men's clothes and looked directly at the viewer in order to confront society's notions of sexuality, gender and beauty.

When Cahun was 15, her divorced father married the widowed mother of Suzanne Alberte Malherbe, and the two girls became inseparable. As an adult, working as an illustrator, designer and photographer, Malherbe changed her name to Marcel Moore, and she and Cahun lived and worked together for the rest of their lives. Between 1920 and 1937 they lived in Paris, where they became involved with the Surrealist movement. They participated in several Surrealist exhibitions, and often collaborated.

Moore was probably the photographer of Cahun's many self-portraits, including this work. Many were never meant to be displayed, but were simply Cahun's way of exploring gender presentation – what viewers both expected and accepted. In 1937 Cahun and Moore settled on the Channel Island of Jersey, and after the fall of France and the German occupation they became active resistance workers and propagandists. They produced anti-German flyers that featured extracts from BBC reports on the Nazis' crimes, which were pasted together to create poetry that harshly criticized the Germans. They also dressed up and attended various German military events in Jersey. In 1944 they were arrested and sentenced to death; but the island was liberated from German occupation the following year, and the sentence was never carried out.

Claude Cahun (1894–1954)
Untitled, gelatin silver print, 1922

Urban Debauchery
highlights corruption

Neue Sachlichkeit or New Objectivity was an art movement that developed in Germany in the 1920s, named after an exhibition of the same title held in Mannheim in 1923. The artists associated most strongly with the movement are Otto Dix, George Grosz and Max Beckmann. The movement had no specific style, but most of the artists involved felt anger at the corruption and hedonism evident in Germany following its defeat in World War I, and the ineffectual Weimar Republic that was now governing the country. Neue Sachlichkeit art also expresses a general contempt at the human condition.

Because of the reparations that Germany was ordered to pay after causing and losing World War I, the Weimar Republic suffered hugely economically and socially, and because of the poor economy, the German middle class was almost completely eradicated, leaving only the extremely wealthy and the extremely poor. Unemployment, hunger and malnutrition occurred everywhere as livelihoods and homes were lost, and the streets of almost every city were filled with both civilian beggars and the war-wounded.

A fluent draughtsman, etcher, watercolourist and oil painter, Dix created ruthless satirical visual commentaries on the violence, death, sex and corruption he saw around him, and on the harshness of war. This is a triptych, a type of painting that is traditionally associated with religious altarpieces. Yet it deliberately and brutally contrasts with biblical stories, while deriding the Weimar society and highlighting the depravity that Dix saw all around him. Three night scenes are shown in a generic Weimar Republic city during the 1920s. Dressed in their finery, in the central panel, several wealthy people are dancing to a jazz band. The women are dressed expensively and fashionably, and their reflections can be seen on the polished parquet flooring. Enjoying themselves, they have no thought for anyone else, especially those less well off than they are. In the left-hand panel, several prostitutes strut in front of the entrance of the same bar. They look disdainfully at two men; one is lying on the floor and the other is a war invalid. A dog also barks at the men. In the right-hand panel, a group of high-class prostitutes dressed in furs are walking past another war invalid, also ignoring him. The contempt shown by these women for the war veterans is aggressive and shocking, but all are struggling; the men are starving and the women have turned to prostitution to support themselves.

Dix modelled several of the characters in this work on real personalities from Dresden, including the architect Wilhelm Kreis, the painter Gert Wollheim, the head of the Saxon State Chancellery, Alfred Schulze, and the artist's own wife, Martha Dix.

Otto Dix (1891–1969)
Grosstad (Urban Debauchery), mixed technique on wood, 1927–28

'Dix created **ruthless** satirical **visual commentaries** on the violence, death, sex and corruption he saw around him, and on the **harshness of war.**'

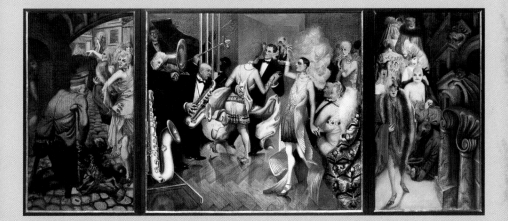

'The man and woman are portrayed as **survivors**, embodying the **strength and dependability** of the American Midwest.'

American Gothic
esteems the Midwest

Figurative painting enjoyed a revival around the world after World War I. The American realist art style known as Regionalism flourished in the 1930s, and Grant Wood became one of its best-known proponents. Born in Iowa, he studied in Europe before returning to teach at Iowa's School of Art in the early 1930s. His detailed, realistic painting style reflected the traditional values of small-town America.

The year after the stock-market crash of 1929, Wood passed through Eldon, Iowa. Looking for something to paint, he saw a white wooden house known as the Dibble House. It appealed to his idea of the American values of diligence, civic duty and rigour, and he sketched the house on the back of an envelope. Eldon was a small, sleepy country town with fewer than 1,000 inhabitants and the house, built in 1881, was in a modest architectural style known as Carpenter Gothic. Wood obtained permission from the owners to return the next day to draw the small house with its gable and pointed-arched window, and he made a more detailed sketch in oil on paperboard, exaggerating the angle of the roof and lengthening the window. At the time, the country was sinking deep into the Great Depression and there was a general sense of despair. Wood said he decided to paint the house with 'the kind of people I fancied should live in that house'.

Back at his studio, he painted the house and put two figures in front of it: his sister Nan and his dentist, Dr Byron McKeeby, to represent a farmer and his spinster daughter. He painted the house and the two figures individually, amalgamating them in the painting. Nan wears an old-fashioned pinafore and a cameo brooch, and has her hair pulled back; McKeeby wears a collarless shirt, jacket and overalls and holds a pitchfork pointing to the sky, echoing both the Gothic window behind him and the stitching on the pocket of his overalls. Bald-headed, dark-eyed and stern-looking, he stares directly at the viewer, while Nan looks rather anxiously into the distance.

Wood placed several repeating and rhythmic forms and lines to unify the composition. For instance, the curtains in the Gothic window echo the pattern of Nan's dress, and her brooch and the potted plants on the porch echo the shape of her head. The precise and detailed style reflects the Flemish Renaissance oil paintings Wood studied while in Europe between 1920 and 1928, and he intended the painting to be a positive statement about rural American values, presenting an image of reassurance at a time of such hardship. The man and woman are portrayed as survivors, embodying the strength and dependability of the American Midwest.

Grant Wood (1891–1942)
American Gothic, oil on beaverboard, 1930

The Persistence of Memory
expresses a hallucination

One of the most prolific artists of the twentieth century, Salvador Dalí was a skilled draughtsman and a relentless self-publicist. He worked as a painter, printmaker, sculptor, film-maker and fashion and advertising designer, and his personality was as famous as his artwork. Frequently featuring strange juxtapositions, his hyper-realistic painting style had wide appeal among the general public. He was fascinated by the idea of subconscious art, and he joined the Surrealist group officially in 1929. The following year he maintained that he had invented a way of painting in a self-induced hallucinatory state, which he called his 'paranoiac-critical method'. He claimed this enabled him to produce paintings with double meanings that evolved from his fascination with hallucination and delusion. He was ultimately expelled from the Surrealist group for his contradicting and controversial views, but he nonetheless became one of the most famous of them, recognized as much for his technically accurate illusions as for his flamboyant, extrovert personality and weird antics.

Dalí was born in Figueras, in the Spanish region of Catalonia, and the distant rock formations in this painting are a portrayal of the landscape that surrounded him as he grew up. With its emphasis on dreams, the subconscious and the theories of the Austrian neurologist Sigmund Freud, Surrealism suited him, and he painted this work while he was still a member of the group. The image appears to be a representation of one of his hallucinations, and was one of his first works to be produced using his 'paranoiac-critical method'. When asked about the soft-looking clocks shown here, he said they were inspired by a Camembert cheese he had watched melting in the sun. Soft and pliable, the clocks appear to melt and slide in the heat, suggesting that time is not functioning in its familiar, reliable way. Even stranger, in the centre is some sort of senseless-looking creature with a melting clock draped over its back. This fleshy organism is a loose depiction of Dalí's own face in profile, its nose, tongue and spider-like eyelashes appearing disturbingly both familiar and unrecognizable. In the left foreground, a closed red pocket watch is covered with ants. Ants were a common theme in the artist's work, usually symbolizing decay.

Dalí once explained the painting: 'This picture represented a landscape near Port Lligat, whose rocks were [lit] by a transparent and melancholy twilight; in the foreground an olive tree with its branches cut, and without leaves.' Frequently describing his paintings as 'hand-painted dream photographs', Dalí presented this scene from his dreams, imagination and subconscious 'to systematize confusion and thus to help discredit completely the world of reality.'

Salvador Dalí (1904–1989)
The Persistence of Memory, oil on canvas, 1931

'Dalí presented this scene from his **dreams, imagination** and **subconscious** "to **systematize confusion** and thus to help discredit completely the **world of reality**".'

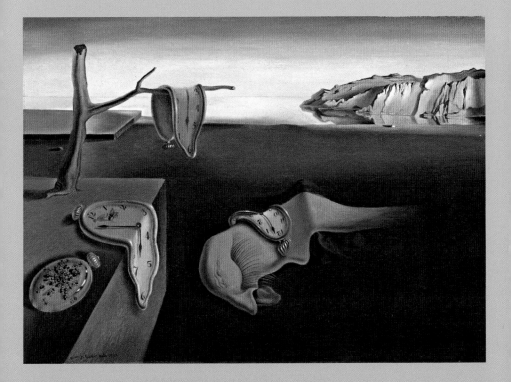

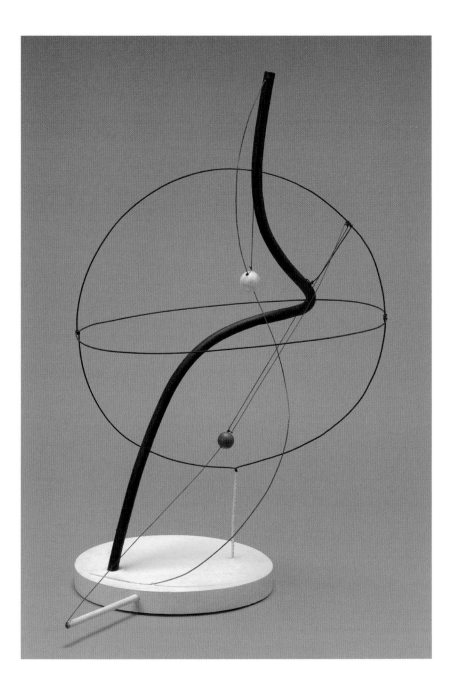

'The underlying **sense of form**
in my work has been **the system of the Universe**,
or part thereof.'

A Universe
simulates the cosmos

Best known for his innovative kinetic mobiles that move by air current or motors, the American artist Alexander Calder also created paintings, prints and miniatures, designed theatre sets and jewellery, and made tapestries, rugs and political posters. He studied first as a painter at the Art Students League of New York, and then, in 1926, went to Paris, where he worked as a sculptor, combining his intuitive engineering skill with a unique artistic vocabulary that burgeoned alongside Surrealism. He also befriended the avant-garde artists Marcel Duchamp and Piet Mondrian.

Calder was the first artist to formalize kineticism in art. Kinetic sculpture had been conceived by the Russian Constructivists in 1915. Calder was not aware of the Constructivists when he invented the mobile in the early 1930s, but his sculptures – whether motorized or suspended from wires attached to the ceiling or to free-standing tripods – resonate with a number of artists and movements, including Dada, the rhythm of Mondrian's work and some paintings by Joan Miró. Calder's moving sculptures revolutionized art. In 1931 Marcel Duchamp called them 'mobiles', and Jean Arp called his later free-standing metal sculptures, which did not move, 'stabiles'. Calder himself called them 'four-dimensional drawings'.

Most of Calder's delicately balanced constructions consist of abstract shapes. A few recall the real world, and in 1933, just before he created the work shown here, he said, 'Just as one can compose colours, or forms, so one can compose motions.' One of his first mechanized mobiles, this structure was inspired by a personal fascination with the dynamics of energy, or, as he once put it, 'the idea of detached bodies floating in space, of different sizes and densities, perhaps of different colours or temperatures'. The structure comprises a small red sphere and a larger white one, both attached to lengths of curving wire that twist and encircle each other. Propelled by a motor he made, the two orbs move, rotate and pass each other in different places and at different speeds, completing one full cycle in 40 minutes. As the objects rotate and pass each other, the sculpture conveys the flowing, continuous movement of an abstract vision of the cosmos, exploring it in a light-hearted, unspecific way.

Calder intended the unpredictability of pattern and movement to represent the fine balance and perpetual motion of a universe and the changing physical relationships within it. Reflecting on his work of this period, he commented: 'The underlying sense of form in my work has been the system of the Universe, or part thereof.' It is said that when the piece was exhibited in 1943 at the Museum of Modern Art in New York City, Albert Einstein stood spellbound in front of its slowly moving elements for the entire 40-minute cycle.

Alexander Calder (1898–1976)

A Universe, painted iron pipe, steel wire, motor and wood with string, 1934

Guernica
condemns Fascism

Created by Pablo Picasso, the most famous artist of the twentieth century, *Guernica* was an expression of the artist's revulsion at the Nazi bombing of a Basque town in northern Spain, ordered by the Fascist General Franco during the Spanish Civil War (1936–39). Conveying pain, violence and suffering, the monumental image is painted only in black, white and grey, and has become an international symbol of the horrors of war.

Picasso was a child prodigy and an innovator. Among other things, he co-founded Cubism, introduced collage and ceramics into fine art, and developed various styles throughout his career, often inspired by the women in his life. In early 1937, while living in Paris, he was commissioned by the republican government of Spain to produce a mural for the Spanish Pavilion at the Paris Exposition. He could not decide on a theme for the mural, when he read a newspaper article about the bombing in April that year of the small Spanish town of Guernica, in broad daylight, by German forces acting on General Franco's orders. Picasso determined to make the atrocity known to the world, and he decided that it would be his subject for the mural commission.

Various anti-war elements can be seen in this work. According to Picasso, the bull – usually a symbol of strength when related to Spain – is here as an emblem of brutality. In front of the bull, a woman throws her head back in grief and distress, holding her dead baby in her arms. A single light bulb blazes from the ceiling, the jagged light recalling an explosion, while next to the horse's head, another light in the form of a candle is held by a woman at a window. Beneath the horse is a dead soldier with a severed arm that still grasps a shattered sword, from which a small flower grows. This is a tiny symbol of hope. The lines in the palm of the soldier's other hand could be stigmata, a symbol of martyrdom from Christ's Crucifixion. When Picasso was asked what the horse denoted, he said it embodied all the innocent people who died in the massacre. On the far right-hand side, a figure with outstretched arms is consumed by flames. It is not clear whether this figure (male or female) is falling or trapped, but she or he shrieks up at the sky.

The mural was exhibited in Paris, where there was growing support for Fascist parties in France and other European countries, and it caused considerable controversy. After Paris, it travelled to America. It continued to tour extensively in North America and Europe, but Picasso refused to return it to his native Spain until democracy had been re-established there.

Pablo Picasso (1881–1973)

Guernica, oil on canvas, 1937

'This monumental image is painted only in black, white and grey, and has become an **international symbol** of the **horrors of war.'**

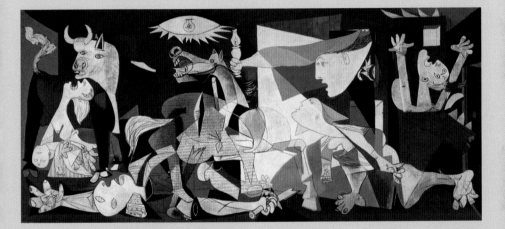

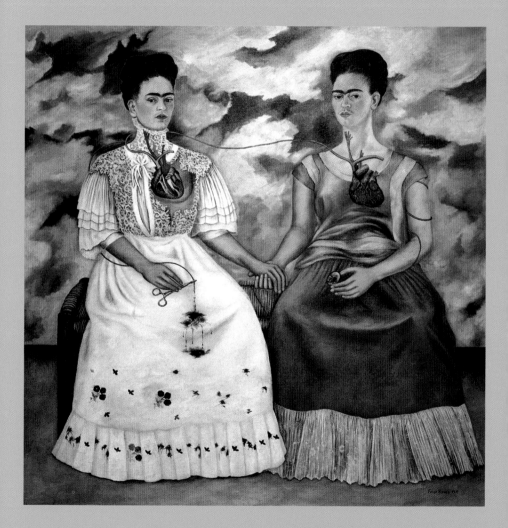

'Many of Kahlo's images are **deeply personal** commentaries and, in this way, her **traumatic life** cannot be separated from her **art**.'

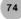

The Two Fridas
puts suffering on show

Two identical women are sitting together. Both are self-portraits of Frida Kahlo, the artist known for paintings that explored and expressed aspects of her troubled and painful life. Many of her images are deeply personal commentaries and, in this way, her traumatic life cannot be separated from her art.

Of German and Mexican heritage, Kahlo grew up in Mexico City. At the age of 6, she contracted polio and had to remain in bed for nine months. After her recovery, she walked with a permanent limp. Twelve years later she was travelling home from school when her bus collided with a tram and she was impaled on an iron handrail. She sustained several fractures and a crushed pelvis. Bound in a plaster corset, she spent months in hospital, and during her recovery she began painting from her bed. Three years later she joined the Mexican Communist party and met the artist Diego Rivera, 21 years her senior. After he divorced his second wife, he and Kahlo married, but their relationship was volatile. He was unfaithful and Kahlo continued to suffer with her health, undergoing many surgical procedures and operations. She too began to have affairs, but after Rivera had a liaison with her younger sister, the couple divorced in 1939; they remarried a year later.

This work was painted during the year of Kahlo and Rivera's divorce, and it conveys the physical and psychological pain and anguish she felt, and her inner turmoil. She later said it expressed her loneliness at being separated from Rivera. With no obvious expressions, sitting on a wooden bench, the two women hold hands. As usual, Kahlo has made her face, body and facial hair heavier than in real life.

The Frida on the left-hand side wears a white lace, European-style Victorian dress, and the Frida on the right-hand side wears a traditional Mexican costume. The white dress represents the type of clothes Frida wore before her marriage to Rivera, while its whiteness also highlights the dark red of her blood. This Frida is weakened by an exposed heart that is torn and bleeding as she pines for her lost love. Additionally, in several cultures, a bleeding heart is used as a symbol of true love and of compassion for the suffering of others. Meanwhile, blood spills on to her lap as she holds surgical pincers to cut a vein. The vein both connects the two Fridas and alludes to her constant pain and frequent medical procedures. The other Frida is independent and strong. Like European Frida, her heart is exposed, but unlike hers, it is whole. Attached to the vein that comes from European Frida, in Mexican Frida's left hand, is a portrait of Rivera.

Frida Kahlo (1907–1954)

The Two Fridas, oil on canvas, 1939

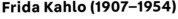

Nighthawks
epitomizes urban loneliness

Renowned for his contemplative depictions of East Coast America in the early to mid-twentieth century, Edward Hopper trained in illustration and painting and worked as a commercial illustrator for an advertising agency before becoming an artist. Born near the Hudson River, he made three trips to Europe between 1906 and 1910, visiting Paris, London, Berlin, Amsterdam and Brussels. However, rather than develop a contemporary abstract approach to painting that was in evidence all around him, he developed a realistic style modelled on the influence of his teacher William Merritt Chase, as well as that of Edgar Degas, Édouard Manet and Gustave Courbet. Back in the United States, he produced paintings of urban American life, and – after years of struggling to be recognized – in 1924, with his second solo exhibition, he achieved the success he yearned for. He left his job and travelled to New England with his wife, the painter Josephine Nivison, who became his only female model in all his paintings.

Introspective and melancholic, Hopper's depictions of feelings of isolation within the modern city influenced many artists and particularly film-makers of the 1960s and 1970s. *Nighthawks* is his best-known painting. With its solitary figures, long shadows and atmospheric light, the work embodies the sense of separation and remoteness that is so common in large towns and cities, and which Hopper saw

all around him. The brightly lit diner throws disquieting shadows into the deserted street outside. The fluorescent light inside comes from the ceiling and is quite harsh, shining down on to the four figures. Because of the lighting and the title, it can be assumed that this is night-time. Each figure seems to be alone and detached, absorbed in personal thoughts. No one converses.

With her illuminated hair and skin, the auburn-haired woman in the red dress is the focal point of the image, even though she is quite far to the right-hand side of the composition. She communicates with neither the man beside her nor the barman. Hopper painted this image after he and his wife had been to a restaurant in New York's Greenwich Avenue. Josephine made notes for him, including: 'Man night hawk (beak) in dark suit, steel grey hat, black band, blue shirt (clean), holding cigarette.' The scene is cleverly arranged, including such things as the angles of the light and the long, dark shadows, the highlighted areas – including those in the street outside – the brilliant green of the shelf inside the glass, and the bright lemon-yellow wall. Particularly enigmatic elements include the figure whose back is towards us, the man sitting with the woman, and the fact that no door can be seen. It is an evocative image that communicates an almost palpable sense of loneliness.

Edward Hopper (1882–1967)
Nighthawks, oil on canvas, 1942

'With its **solitary figures, long shadows** and **atmospheric light**, the work embodies the sense of **separation and remoteness** that is so common in large towns and cities.'

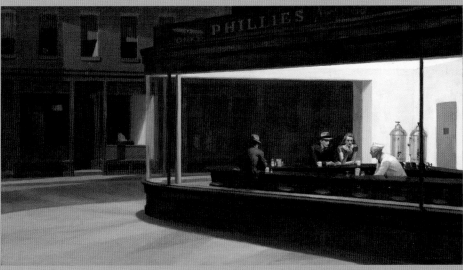

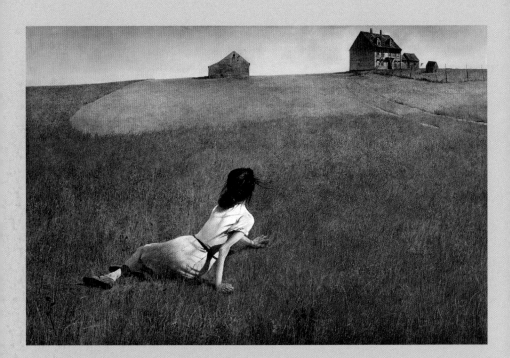

'Conveying the unacknowledged **suffering** and indomitable
will of the woman, this painting is more a
psychological landscape than a **portrait**.'

Christina's World
personifies inner strength

A young woman is sitting on the ground in a field, looking into the distance at a house with a barn and other small outbuildings. The tawny grass suggests that there has been no rain, but a gentle breeze plays with the woman's hair; dark strands escape from the loose knot at the back of her neck. At first glance, this painting seems to be a peaceful, pastoral scene. However, on closer inspection, it can be seen that the young woman is painfully thin and her position seems almost to be yearning.

The painter was Andrew Wyeth, the son of a celebrated illustrator, N.C. Wyeth, who had been killed at a railway crossing just three years earlier. After that loss, as an expression of his grief, Wyeth's painting style underwent a significant change. His palette became muted, his landscapes barren and his figures often sad or troubled in some way. Wyeth had a summer home in Maine, and this depicts the area surrounding that home. The woman in the painting was his neighbour there, Christina Olson, who lived with her brother Alvaro Olson. Suffering from the effects of polio, Christina was partially paralyzed. Either too modest or too proud to ask for help, she refused to use a wheelchair, and instead moved around independently. Here, with her thin, wasted limbs, she is trying to pull herself by her arms towards the house. Wyeth wrote: 'Christina was limited physically but by no means spiritually ... The challenge to me was to do justice to her extraordinary conquest of a life which most people would consider hopeless.' He had been inspired to create the painting when he saw, from a window of his own house, Christina determinedly crawling across the field. However, she was 55 at the time, and to create a more visually appealing image, he blended aspects of his wife, Betsy, who was then in her mid-twenties, with Christina. The wasted limbs and pink dress belong to Christina, and the youthful head and torso belong to Betsy.

The Olson farmhouse was built in the late eighteenth century and is imposing and grey. The overcast sky emphasizes the starkness of the scene. To create a balanced, asymmetrical composition, Wyeth altered the positions of the house, barn and outbuildings. He recorded the arid landscape, rural house and shacks meticulously, painting every blade of grass and individual strand of hair and every gradation of light and shade. Moving away from his usual watercolours, he used egg tempera, a paint that had been used in the early Renaissance. Conveying the unacknowledged suffering and indomitable will of the woman, this painting is more a psychological landscape than a portrait, a portrayal of a state of mind rather than a place.

Andrew Wyeth (1917–2009)

Christina's World, egg tempera on gessoed panel, 1948

Mountains and Sea
shapes an abstract climate

Always inspired by the landscape, Helen Frankenthaler began her career as an Abstract Expressionist, influenced by artists including Jackson Pollock, Franz Kline, Arshile Gorky, Willem de Kooning and Robert Motherwell. Abstract Expressionism began in New York City after World War II. While none of the artists involved had a coherent style, all created large-scale, abstract works that broke away from traditional processes and conveyed or influenced emotions. Frankenthaler developed her unique approach with this work in October 1952, after holidaying on Cape Breton Island in Nova Scotia, Canada. Fluid and free, her 'soak-stain' technique was created by pouring oil paint that had been heavily diluted with turpentine on to huge canvases. This resulted in clear washes of luminous colour that merge and blend and do not attempt to create three-dimensional illusion.

Even though it is created with oils, the painting has the effect of a watercolour. As well as diluting her paint, Frankenthaler used an unprimed canvas, so that the thin paint soaked in and spread uncontrollably. She was just 23 when she produced this work, but her method impressed more experienced artists, including Morris Louis and Kenneth Noland, who began using it. It initiated the second phase of Colour Field painting, a strand of Abstract Expressionism that featured flat, abstract, colour-saturated surfaces that encouraged

viewers to meditate and become engrossed with the colours. By pouring the paint, rather than spreading it with an implement, Frankenthaler avoided any suggestion of an artist's hand. The stained areas often bled into each other, changing shape and fusing. Unlike most Colour Field paintings, however, this work hints at elements from the real world, with suggestions of the Canadian landscape, also indicated by the title. Sky, water and trees can be recognized, and a summer's day in Canada can be sensed through the colours. The diluted blue at the top implies a mountain peak, the deeper blue conveys the sea, and the green and pink could be flowers. Frankenthaler said: 'My pictures are full of climates, abstract climates. They're not nature per se, but a feeling.'

To create this work, Frankenthaler placed her canvas on the floor, made a few sweeping marks with charcoal and then poured on her diluted paint. Although she was aware of a general aim and the overall appearance she was trying to achieve, she worked intuitively, believing that unplanned abstractions enabled viewers to respond more personally and individually than they did to figurative art. Years later, she explained: 'When you first saw a Cubist or Impressionist picture, there was a whole way of instructing the eye or the subconscious. Dabs of colour had to stand for real things; it was an abstraction of a guitar or a hillside. The opposite is going on now.'

Helen Frankenthaler (1928–2011)
Mountains and Sea, oil and charcoal on canvas, 1952

'By **pouring** the paint, rather than spreading it **with an implement**, Frankenthaler avoided any suggestion of **an artist's hand**.'

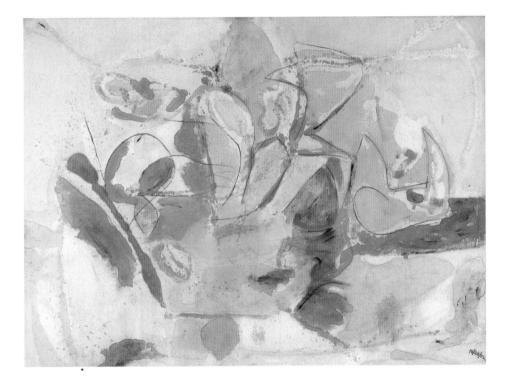

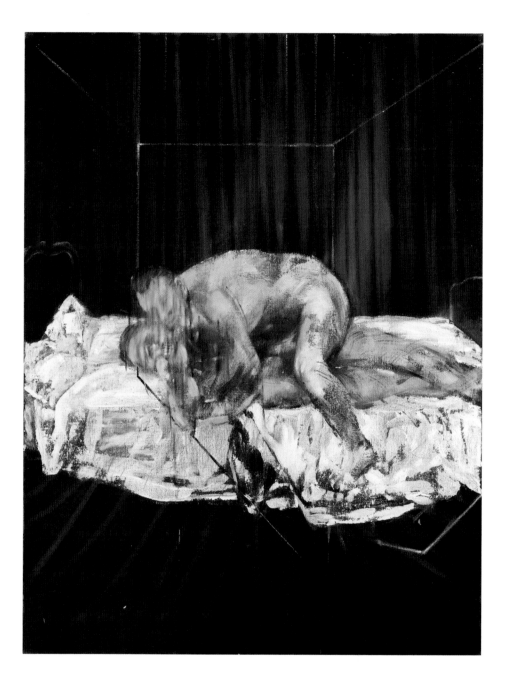

'Although not clear, their **forms** and **featureless faces** make them seem to be **two parts** of **one entity**; some of their **body parts** could **belong to either**.'

Two Figures
examines the male body

Inspired by Surrealism, film and photography, as well as Picasso, Van Gogh, Velázquez, Michelangelo, Rembrandt and Cimabue, the Dublin-born artist Francis Bacon developed a distinctive style of painting that often featured violent, tormented figures. Growing up between Ireland and England, he later travelled around Paris and Berlin. With no formal art training, he began his career as a furniture and interior designer, then started painting in a semi-Cubist, Surrealist style.

Bacon grew up surrounded by aggressive undercurrents, from childhood beatings to terrorism against the Anglo-Irish community, and all with the backdrop of two world wars. As an adult, his personal life with his lover, the ex-fighter pilot Peter Lacy, was also turbulent and brutal. Bacon once reflected: 'I have been accustomed to always living through forms of violence, which may or may not have an effect upon one, but I think probably does. But this violence of my life, the violence which I've lived amongst, I think it's different to the violence in painting. When talking about the violence of paint, it's nothing to do with the violence of war. It's to do with an attempt to remake the violence of reality itself.'

Bacon painted this work while living in Lacy's cottage. He said that the sadomasochistic pose of the two figures was inspired by wrestling magazines, but that was possibly his way of camouflaging the celebration of homosexuality when such acts were illegal. The bed, sheets and black box of the room suggest that the entangled figures are on a stage. As if interrupted, they stare back at the viewer. Bacon created the work following anatomical drawings, Eadweard Muybridge's motion photography, images of boxers in magazines and his own photographs. He said: 'I don't only look at Muybridge photographs of the figure. I look all the time at photographs in magazines of footballers and boxers and all that kind of thing – especially boxers.'

When first exhibited, this painting caused a furore because of its insinuations of homosexuality, and indeed it is as much a representation of homosexual love as it is an examination of the human body. The two distorted, disfigured bodies appear to be intertwined in a distressing, gruelling and persistent struggle. Although not clear, their forms and featureless faces make them seem to be two parts of one entity; some of their body parts could belong to either, and they are covered by the fine, stringy lines that Bacon painted over many of his images, adding to the sense of menace. The image conveys an eternal struggle, a fight and a less tangible sense of pain and violence. In all his work, Bacon aimed to create images that shook the viewer and created a sense of unease to convey the suffering felt so often through life's experiences.

Francis Bacon (1909–1992)
Two Figures, oil on canvas, 1953

Flag
questions familiarity

At the end of the 1950s, in America, artists began to move away from what they perceived as the self-importance of Abstract Expressionism and from abstract imagery to the depiction of real objects. Jasper Johns played an essential part in this, departing from what he called 'painterly deception' to create art that was a reality itself. His work is often described as Neo-Dadaist and anticipates aspects of Pop, Minimal and Conceptual art. He began producing representations of commonplace items, in which the works of art are also themselves objects, and things that everyone can recognize.

The 48 stars and red-and-white stripes depicted here represent the American flag from the year the work was made. Johns's choice of the US flag allowed him to explore a familiar two-dimensional object, with its simple internal geometric structure and complex symbolic meaning. He was attracted to painting 'things the mind already knows', and claimed that using a familiar object such as the flag freed him from the need to create a new design, allowing him to focus on the execution of the painting. Critics were not sure whether it was a painted flag or a painting of a flag; Johns later said it was both. Similar to a readymade, this work combines panels, paint and encaustic (a mixture of pigment and melted wax). Beneath the stars and stripes is a collage of pieces of newspaper, dated with the year the painting was made.

Johns created the work to combine his concern about the craft of painting and the relevance of subject matter. Simultaneously real and invented, simple and complex, the painting presents a paradox; it appears two-dimensional, but the brush marks and inflections in the encaustic resemble Paul Cézanne's approach. Johns was also detaching himself from any symbolic connotations; this is a painterly representation of a flag that questions our familiarity with an image.

Johns said that the idea for this work came to him in a dream. His use of the ancient medium of encaustic, in which wax rather than oil binds the pigment, enables him to keep his brushstrokes visible. So he applied his colours with great textural variation, allowing some of the underlying areas of collage to show through, inviting the viewer to look closely and question what he or she is looking at. Is this a flag or a copy of one? Is it a work of art? Does it matter? A smooth-looking, accurately reproduced flag would be familiar and therefore probably not studied by most people; they recognize it, so there is no need to spend time looking at it. By being painted in encaustic, with its heavily worked, encrusted surface, this image is both familiar and unfamiliar, and therefore draws attention.

Jasper Johns (b.1930)

Flag, encaustic, oil and collage on fabric mounted on plywood, 1954–55

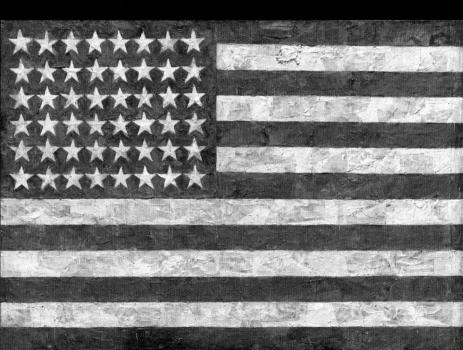

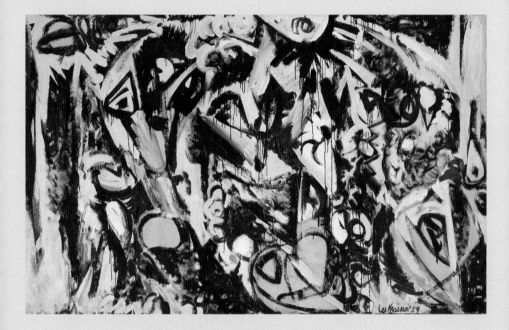

'Using **forceful and dramatic** marks and gestures,
Krasner worked across the vast canvas, applying paint
intuitively and spontaneously.'

Cool White
expresses heartbreak

Conveying great energy and vigour, *Cool White* was made during a period of the artist's spells of insomnia from 1959 to 1963, when she painted only at night. Lee Krasner was an American Abstract Expressionist painter, who was overshadowed for much of her career by her husband, Jackson Pollock. She is now recognized for her ideas and creativity and particularly for her sense of colour, which is why this sombre painting of just umber and white is particularly interesting.

In 1956 Pollock died. He was 44, drunk and driving with his mistress and an acquaintance when he crashed the car. He and his acquaintance were killed. When Krasner painted this, she was dealing with grief and heartbreak over his death and infidelity as well as the recent death of her mother, problems that had arisen with the Pollock Estate and the unexpected cancellation of an exhibition that she had been working towards for months. This was one of several paintings she produced at that time, at night and in monochromatic colours. She recalled: 'I painted a great many of them because I couldn't sleep nights. I got tired of fighting insomnia and tried to paint instead. And I realized that if I was going to work at night, I would have to knock out colour altogether, because I couldn't deal with colour except in daylight.'

The paintings of the series were Krasner's way of working through her emotions as she came to terms with her turbulent relationship with Pollock, and the grief and heartbreak she felt over the circumstances of his death, with the added pain of losing her mother. She felt anger, sadness, frustration and intense misery. For much of the time she painted, she was blinded by tears, and this work powerfully projects these conflicting emotions, which moved from deep unhappiness to intense rage.

Using forceful and dramatic marks and gestures, Krasner worked across the vast canvas, applying paint intuitively and spontaneously, so that in some areas the paint has been dragged across, and in others it has been spattered on. In places, the paint is thickly textured, and in others it is fairly thin. Her dynamic brushwork evolved and changed as she worked without thinking consciously or planning. With aggressive and assertive movements, she applied paint from a thickly loaded brush, dragging and pushing the pigment across the large canvas to create a spirited, animated image. After Pollock's death, she moved into his studio in a large barn on their property, which enabled her to work on this large scale and with greater, more sweeping gestures than had been possible in her own smaller studio in the house.

Lee Krasner (1908–1984)

Cool White, oil on canvas, 1959

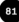

Spatial Concept 'Waiting' suggests infinity

After World War II, Lucio Fontana began developing his concept of *Spazialismo*, 'Spatialism'. He observed that in many other areas of life, things were changing and being sped up through machines and other technology, but that art had not changed for centuries; painters were still painting on flat canvases, for instance. He said that artists should create energetic, dynamic art that embraced the times. In an effort to create an extra dimension, he developed the idea of cutting into canvases, calling these cuts *Tagli*. In 1949 he devised the term *concetto spaziale*, 'spatial concept', to describe his work. By piercing the flat surfaces of his canvases, he was integrating real rather than imagined space and depth, and rather than creating illusions with paint, he was suggesting immeasurability, or infinity. When a critic commented that his work seemed aggressive, he said 'I have constructed, not destroyed.'

In some ways, this work resembles the slashing paint marks of some Abstract Expressionism of the 1940s and 1950s, but unlike the Abstract Expressionists' methods of 'action painting', which focused on the act of painting and surface marks, Fontana described this slash as 'an infinite dimension'. Calling his work 'art for the space age', he aimed to escape the conventions that had dominated art since before the Renaissance; his slashes were meant not to represent anything from the real world, but to transcend space and generate a feeling of infinity.

Born in Argentina to Italian parents, Fontana felt a strong alliance with the Futurist movement that began in Italy in 1909 and aimed to capture in art the dynamism and energy of the modern world. He first began puncturing the surface of his paper or canvas in the late 1940s, blurring the distinction between two and three dimensions. He made his first *Tagli* in the late summer of 1958, using a sharp blade and a single movement, creating small or large, often diagonal incisions, sometimes in groups, and he continued to experiment with this idea as a gesture that went beyond painting. Initially he painted some canvases in single bright colours; later he worked with plain, unprimed canvases.

During 1959, Fontana's cautious holes and slits evolved into single, more decisive slashes. He then backed each canvas with strong black gauze to give the appearance of a void behind the slash. On his first works, on the backs of canvases with one cut, he wrote the word *Attesa*, meaning 'expectation' or 'hope', and on the backs of those with several cuts, he wrote *Attese* (the plural version). In 1966 Fontana displayed a whole room of white *Tagli* at the Venice Biennale, stating that he had found a way of 'giving the spectator an impression of spatial calm, of cosmic rigour, of serenity in infinity'.

Lucio Fontana (1899–1968)

Spatial Concept 'Waiting', canvas, 1960

'Fontana's slashes were meant not to represent anything from the **real world,** but to **transcend space** and generate a feeling of **infinity.**'

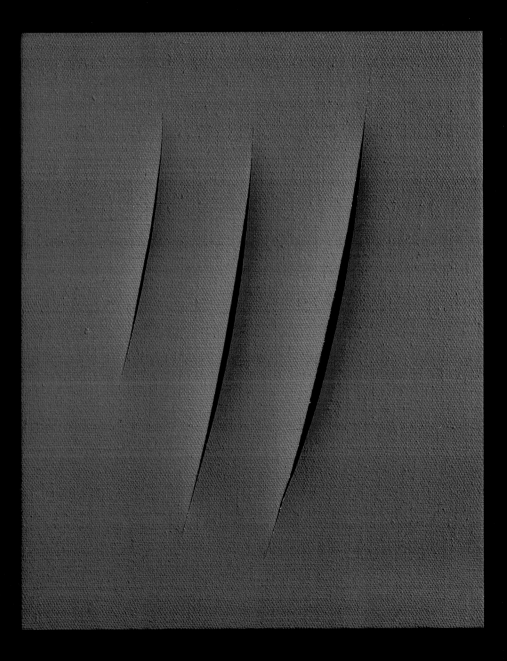

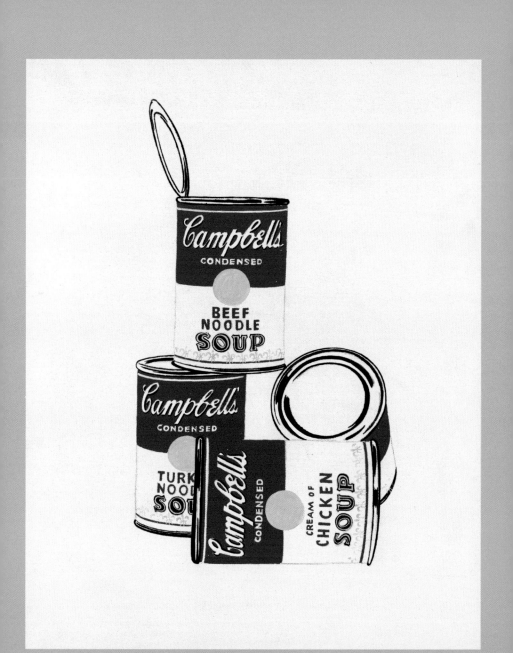

'This painting deliberately **challenged basic assumptions** about
the **function and perception** of **art and artists** in society.'

Four Campbell's Soup Cans
explores consumerism

This painting of four simple soup cans helped to change the history of art. It was one of the first images made by Andy Warhol of his favourite cans of soup. Later that year, he began creating further images of Campbell's soup cans and other familiar consumer items using the screenprinting process.

Born and raised in Pittsburgh, Warhol worked first in New York City, where he became a highly successful commercial illustrator. By the late 1950s he was receiving recognition for his controversial artwork. He became one of the best-known and most influential figures of the twentieth century, confronting the art world with his images of mass-produced goods, based on his understanding of marketing, promotion and consumerism. His New York studio, The Factory, became well known as a gathering place for celebrities, aristocrats and bohemians, and he wrote books, managed a rock band, started a magazine and made works of art that spurned artistic tradition, instead exploring the notions of consumerism and commercialism that had expanded enormously since the end of World War II.

This painting deliberately challenged basic assumptions about the function and perception of art and artists in society, and established beliefs about art, consumerism, stereotypes, individuality and familiarity within society, and the importance – or not – of originality in artists. Warhol created it to encourage viewers to consider what makes something 'art'. Until this point, artists had been seen as somewhat mysterious creators, and their art as almost sacred and certainly unattainable, but the object in this image was an ordinary, mundane item. Warhol once said that the benefit of the consumer society was the fact that the poor could buy or experience the same things as the rich. A can of Campbell's soup was the same for whoever bought it, whether they lived in a mansion or a tent.

This painting is one of a group of 17. The image of consumer products that anyone could buy contrasted with traditional works of art in which artists chose appealing subjects and used their own skill and interpretation to convey them. To create the work, Warhol projected photographs of the soup cans on to canvas and traced around the images carefully with pencil and paint. Each of the 17 paintings shows slight differences, such as torn labels, crushed or dented areas, or, as seen here, an opened can at the top. Details of the labels are sharp; they are almost exact copies of the real labels, rather than an attempt to represent curving labels on three-dimensional cans within a painting. Against the stark white background, the bright red and black give the impression of commercial packaging rather than a painting produced by an artist.

Andy Warhol (1928–1987)

Four Campbell's Soup Cans, casein and graphite on canvas, 1962

Rhythm 0
pushes to the limit

In a gallery, 72 objects were placed on a long table covered with a white tablecloth. They included a rose, a feather, perfume, honey, bread, grapes, wine, scissors, a scalpel, a metal bar, paint, a comb, a bell, a whip, lipstick, a pocket knife, a fork, olive oil, soap, matches, a candle, a hammer, a safety pin and a gun loaded with one bullet. Standing still next to the table for six hours at a time was the Serbian conceptual and performance artist Marina Abramović. Visitors entered the room and read the instructions:

There are 72 objects on the table that one can use on me as desired.
Performance.
I am the object.
During this period I take full responsibility.

Duration: 6 hours (8 pm – 2 am)

For six hours visitors to the gallery were invited to use any of the objects on the table on Abramović. She did not move or speak. She later wrote: 'The experience I drew from this work was that in your own performances you can go very far, but if you leave decisions to the public, you can be killed.' In Abramović's art, she especially focuses on the relationship between performer and audience, the limits of the body and the ways in which the mind works. She pioneered aspects of Performance art that she says focus on 'confronting pain, blood and physical limits of the body'. This work was one of her most challenging. To test parameters of the relationship between the performer and the audience, she gave herself a passive function and the visitors an active role. Some of the objects could give pleasure, but others had the potential to inflict pain or harm her.

To begin with, visitors were gentle, offering her a rose or a kiss, for instance, but as time passed and she remained passive, some members of the audience became aggressive. Using the razor blades, her clothes were cut from her; her throat was slashed and someone sucked her blood. Various minor sexual assaults were carried out on her body. However, as much as this faction of the audience became brutal and hostile, a protective group developed. When a loaded gun was thrust to her head and her own finger was being worked around the trigger, a fight broke out as someone tried to protect her. Abramović later reflected that it 'pushed my body to the limits ... I felt really violated: they cut up my clothes, stuck rose thorns in my stomach, one person aimed the gun at my head and another took it away. It created an aggressive atmosphere. After exactly six hours, as planned, I stood up and started walking towards the audience. Everyone ran away, to escape an actual confrontation.'

Marina Abramović (b.1946)
Rhythm 0, table with 72 objects and slide projector with slides of performance and text, 1974

'The experience I drew from this work was that in your **own performances** you can go **very far**, but if you leave **decisions** to the public, you can be **killed**.'

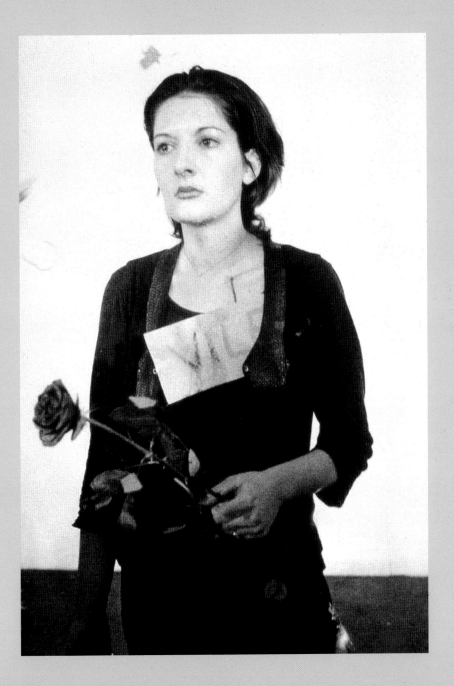

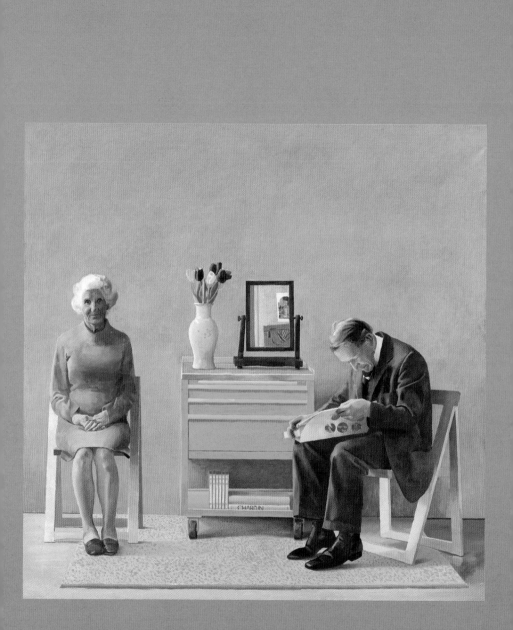

'**Full of symbols**, the image suggests aspects of Hockney's **life** and his parents' **dispositions**, while at the same time conveying his **affection** for his mother and father.'

My Parents
captures a son's love

Famous for his unique vision, his sense of colour and his experimentation, David Hockney was an international success by the time he was in his mid-twenties. Always fascinated by various art and artists, including Pablo Picasso, Jean-Baptiste-Siméon Chardin and Piero della Francesca, he adapts and incorporates many ideas in his work. In 1964 he moved from England to Los Angeles, where he produced a series of paintings of swimming pools, exploring the vivid colours and light using the comparatively new medium of acrylic paint. Since that time, he has travelled back and forth between Los Angeles, London and Paris.

Although at first glance this smoothly painted image of a sparsely furnished room may appear detached, it is in fact an affectionate portrait by a son of his parents. A devout Christian, Laura Hockney was a vegetarian, which was unusual at the time. Kenneth Hockney, who died a year after this double portrait was completed, was an anti-war and anti-smoking campaigner. Full of symbols, the image suggests aspects of Hockney's life and his parents' dispositions, while at the same time conveying his affection for his mother and father. In the mirror on the top of the trolley, rather than a reflection of himself, he painted a reflection of a postcard of *The Baptism of Christ* by Piero, an artist he admired – but it is probably here also to signify his parents' Christian beliefs. Next to the mirror is a vase of sleek yellow and pink tulips.

Sitting on plain, hard wooden chairs set apart from each other, Laura and Kenneth portray their personalities and their individual relationships with their son. Kenneth is absorbed, turned away and seemingly oblivious to his son, bent over the book *Art and Photography* by Aaron Scharf. On the trolley next to him are other books, including a collection of Marcel Proust's *Remembrance of Things Past* and a book about Chardin. By putting his parents in close proximity to his artistic influences, Hockney was acknowledging their influence on his career and his love of art. Unlike Kenneth, Laura faces Hockney, paying him complete attention and radiating pride as she poses for him. In a bright-blue dress, she sits up straight, her hands clasped in her lap, feet together. She wears no jewellery, but her styled white hair is highlighted by the illumination from the left-hand side. It also falls on the vase and Kenneth's hair, face, brown suit and shiny black shoes.

In particular, this painting evokes Hockney's nostalgia for his childhood. It is almost an analysis of his own past and his love of his parents. Later, speaking about Laura and Kenneth's reaction to the painting, Hockney's sister Margaret said, 'Mum and Dad were very proud of it, and felt all the sittings had been worthwhile.'

David Hockney (b.1937)

My Parents, oil on canvas, 1977

Untitled Film Still #13
exposes female stereotypes

One of 69 black-and-white photographs featuring various generic female film characters, including starlet, working girl and lonely housewife, and each staged to resemble scenes from films of the 1950s and 1960s, this image was created by Cindy Sherman. Not self-portraits, the photographs are an exploration of the stereotyping of women by men.

Dressing up and posing as every character in her *Untitled Film Stills*, Sherman took inspiration from several films and prominent directors and actresses from the 1950s to the 1970s. Drawing on many movies she had watched growing up and after moving to New York City in 1977, she reinvented each woman through carefully planned and arranged poses, expressions, costumes, staging and camera angles. She produced six of these photographs initially as an experiment, exploring the imaginary lives and roles of various actresses of that period. Later, she developed more characters in other roles, including this librarian. Making the photographs look like film or publicity stills, she ran out of clichés to illustrate after three years, and so ended the series.

Although every woman in the series is invented, all are based on particular types of female that were created mainly by men in post-war America. Fashioned purely to meet men's fantasies, these women appeared in films and on television. In this image, Sherman aimed to portray a blonde actress as if she has been caught in an unguarded moment, either at home or on a film set. Demonstrating an understanding of the imagery and psyche of both the females in such roles and the men who directed them, Sherman's stereotypes are instantly recognizable. Andy Warhol commented on her insight and abilities in portraying the women, saying: 'She's good enough to be a real actress.'

Although most of Sherman's females are almost completely invented, this particular image was based on Brigitte Bardot, one of the most famous sex symbols of the 1950s and 1960s. Her styling of the character is based on *Le Mepris* (*Contempt*), a film starring Bardot made in 1963 with the director Jean-Luc Godard. Shot from below, here, the young woman reaches for a book on a shelf. Typical of the male-dominated camera angles of the time, she stretches upwards and the camera catches her flimsy shirt tight across her bust. She looks to one side as if she has heard someone coming and should not be there. Whether she is an actress, a librarian or just a woman in a library does not matter. Sherman's criticism conveys not only the stereotypical visual styling of the woman, but also the notion – similarly dictated by men – that such women did not use their brains. Although she is an embodiment of male desire, she is illicitly demonstrating her intelligence and enquiring mind.

Cindy Sherman (b.1954)
Untitled Film Still #13, gelatin silver print, 1978

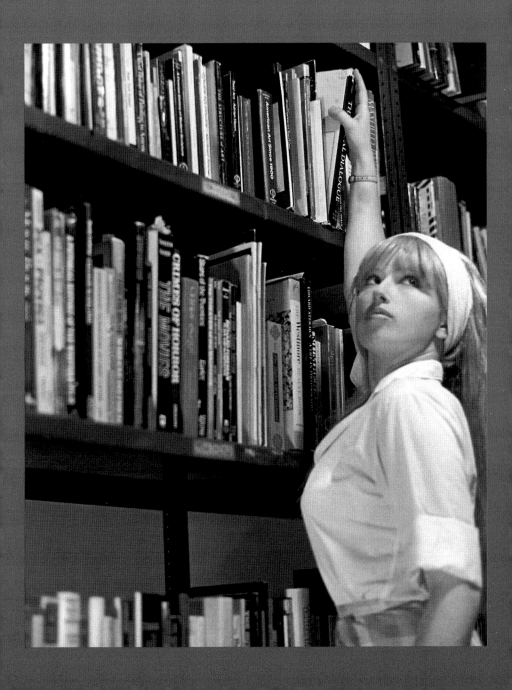

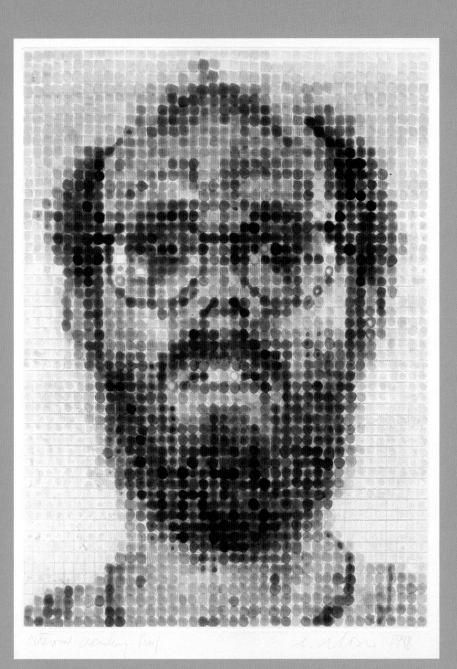

'Although the print itself is far **smaller** than most of his painted portraits, the image **fills the paper**, as Close investigates how his **facial domination** of that space **transmits to the viewer**.'

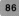

Self-Portrait
explores personal space

Breaking completely with tradition, the American artist Chuck Close explores personal space through portraits based on photographic imagery and using methodical processes. As a child, Close suffered with a neuromuscular condition that meant he found it difficult to lift his feet. He was also dyslexic, which was not diagnosed when he was at school, and he suffers from prosopagnosia (face blindness), meaning that he is unable to recognize faces. He began painting portraits partly because of the prosopagnosia and his feeling of detachment from his classmates that his conditions brought about. After studying art in Seattle, at Yale University and in Vienna, Close taught art at the University of Massachusetts, then moved to New York City in 1967. There he began painting huge portraits and self-portraits, making each face fill almost all of the available space on his canvases. Most of these larger-than-life works are detailed and extremely lifelike.

At the end of 1988 Close suffered a seizure that left him paralyzed from the neck down. He had sustained a spinal artery collapse, and he has since had to rely on a wheelchair to move around. However, he discovered that he could paint with a brush strapped to his wrist, and continued to create large portraits using photographic images and grids created by an assistant. He also began working on a smaller scale, producing printed portraits. In both forms, he uses grids to transfer his subjects square by square from a photograph to his canvas or paper. Early on, he made an effort to obscure his grids and create images that look lifelike and seamless, but in his later images, differentiation within the grids became an important element of the work.

This work was his first attempt at creating a portrait with spit-bite aquatint. Usually in aquatint prints, the entire plate is dipped in an acid bath, but in spit-bite aquatint, the artist dilutes the acid with gum arabic or water mixed with his or her own saliva, and brushes it on to particular areas of the plate. The acid bites wherever it touches the plate, resulting in a soft, watercolour-like appearance. Here, Close put a grid on the photograph and projected it on to his plate, copying the image cell by cell. Each cell resembles a dab of paint because he applied the acid with a brush, and he carefully controlled the length of time the acid was allowed to bite the plate, resulting in particular tonalities. Although the print itself is far smaller than most of his painted portraits, the image fills the paper, as Close investigates how his facial domination of that space transmits to the viewer.

Chuck Close (b.1940)
Self-portrait, spit-bite etching, 1988

Concert for Anarchy
creates anxiety

A grand piano is suspended upside down from a ceiling in a spacious gallery by heavy wires attached to its legs. It appears to dangle perilously in mid-air, high above the floor and over the heads of visitors. Every two or three minutes a mechanism inside it goes off, and when this happens, the keys in the keyboard suddenly fall out with a loud, discordant jolt. It seems that the keys will fall to the ground and hit visitors, or at least smash dangerously on the floor. At the same time, the lid of the piano falls open to reveal its interior and the strings resonate seemingly arbitrarily. Then everything stops for a moment and all is suspended in the air and in silence. This unexpected, somewhat violent act is followed a minute or two later by a retraction as the keys slide back into place and the lid closes, everything creaking loudly. The cycle is soon repeated, and to those who are waiting below, just before the keys and lid fall, rather like a giant cuckoo clock, the tension mounts, followed by the slow and noisy withdrawal back to immobility and silence when the piano is closed.

Known best for her installation art, film-directing and 'body modifications', the German visual artist Rebecca Horn was taught to draw by her Romanian governess. She spent most of her school years in boarding schools, and then went to several art schools until 1964, when she had to leave because she had contracted severe lung poisoning. She reflected:

'I was 20 years old and living in Barcelona, in one of those hotels where you rent rooms by the hour. I was working with glass fibre, without a mask, because nobody said it was dangerous, and I got very sick. For a year I was in a sanatorium. My parents died. I was totally isolated.' After she left the sanatorium, she began using soft materials, creating sculptures that explored her illness, long convalescence and loneliness.

Concert for Anarchy is one of several sculptures that Horn created incorporating mechanization. She had started producing this form of art in the late 1970s, and made this work more than a decade later to create a sense of tension and anxiety. Taking the piano away from its normal setting already creates a certain apprehension among any figures below. Then, when the instrument makes its jarring performance, the stress mounts. As well as visual and aural, this artwork is kinetic. Horn said that as well as creating a sense of unease, her intention with it was that it should 'trigger a new form of interaction with the visitors of an exhibition'.

Rebecca Horn (b.1944)
Concert for Anarchy, piano, hydraulic rams and compressor, 1990

'Taking the piano away from its **normal setting** already creates a certain **apprehension** among any figures below. Then, when the instrument makes its **jarring performance**, the **stress** mounts.'

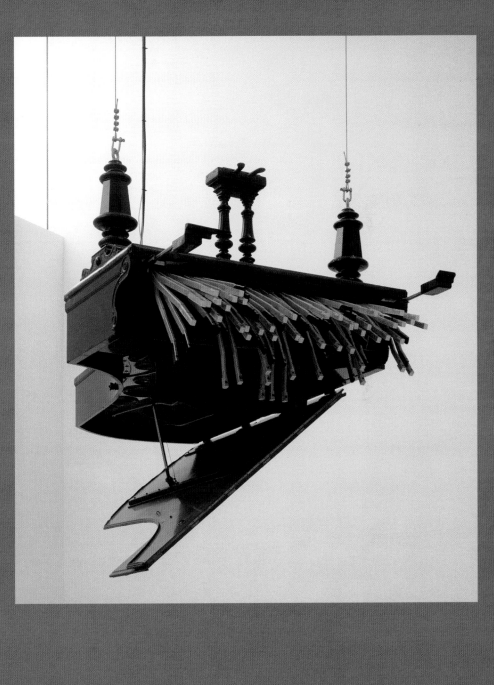

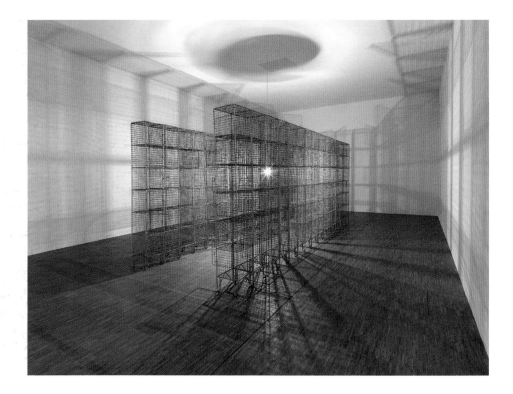

'This **intentionally ambiguous** work alludes to any experience of being **restricted**, including in a domestic setting, in a difficult relationship or through imprisonment during war.'

Light Sentence
studies confinement

Using wire mesh lockers and an electric light, Mona Hatoum (b.1952) created this installation to encourage viewers to consider what it means to be trapped. Known for her installations that often tackle discomforting aspects of conflict, restriction of movement and confinement, Hatoum explores and alludes to individual and general events and occurrences. Hatoum, who was born in Beirut to a Palestinian family, is often described as an artist who expresses purely personal feelings relating to her own experiences, but in fact, her work focuses on universal occurrences and events that could happen to anyone in any culture and at any age.

Intentionally ambiguous, this work alludes to any experience of being restricted, including in a domestic setting or governmental institutional structures, like prisons or barracks. Hatoum explores the conflicts and contradictions of our world, the dark side of human nature and situations in which individuals or groups find themselves as victims of state control. Since the late 1980s she has used a wide range of materials to make her installations and sculptures and often uses grids or geometric forms to convey barriers and borders.

Hatoum became a British exile by accident. After attending Beirut University College from 1970 to 1972, she visited London in 1975 but while she was there, civil war broke out in Lebanon, which made her return home impossible. She remained in London, studied at the Byam Shaw School of Art and the Slade School of Art, then held several artist's residencies in Europe and the United States. Often addressing vulnerability of the individual and sinister underlying systems of social control, her work engages viewers on different levels, frequently inspiring a range of emotions.

This work, for example, comprises wire mesh cages and a single naked light bulb that dangles and slowly moves up and down in the centre of the installation. In doing this, dramatic and dynamic shadows are cast from the light through the cages. The shadows rise and fall on the walls around the room and create large silhouettes of the viewers enmeshed in the grids of the cages surrounding them and creating the varying senses of confinement and disorientation. With no exits or entrances, the cages combine industrial materials with the reduced forms of the Minimalist art movement.

Exploring broad concepts including personal freedom and the human condition, Hatoum's work also inspires feelings of disorientation, internment, being watched, being questioned, loss of freedom, personal privacy, physical and emotional discomfort and tension. Encouraging the viewer to explore multiple ideas at once, she has said that she sees her role as an artist as being to pose questions rather than answer them.

Mona Hatoum (b.1952)

Light Sentence, 36 wire mesh lockers, electric motor, light bulb, 1992

Prop
challenges expectations

Throughout history, painters such as Rubens, Titian, de Kooning, Ingres, Matisse and Picasso have objectified the female body, creating images that appealed to them and to their predominantly male viewers. As a woman, Jenny Saville has a different perspective on the subject. Initially inspired to paint the female nude after watching obese women in American shopping malls when she was studying briefly at the University of Cincinnati in 1991, Saville says that fleshy women have always interested her. Recalling her piano teacher's body, she said: 'I was fascinated by the way her two breasts would become one, the way her fat moved, the way it hung on the back of her arms.'

With this early curiosity about flesh, skin and the manipulation of paint, Saville has painted female nudes since the start of her career. Going beyond the Realism of Gustave Courbet or Édouard Manet, for example, her bodies are always damaged, dimpled or altered in some way, and fleshier than contemporary society admires. This monumental nude with its foreshortened thigh, covered breasts and rounded belly looms towards the viewer. Depicted from a low viewpoint, she dominates the space, flouting preconceptions about the representation of women. Yet, even while contradicting convention, Saville re-interprets elements from previously established artists, such as Rubens's colour palette and de Kooning's gestural brush marks. Overall,

she challenges time-honoured portrayals of female beauty, instead conveying her figures as far from ideal and often looking vulnerable and exposed.

One of the artists classified as the YBAs, or Young British Artists, who showed in an extremely controversial exhibition in 1997, Saville crosses the boundaries that have been set by society's expectations of art. Applying her paint in heavy layers, she pushes and drags the pigment over her canvases, raising questions about society's perception of the body. She has said: 'There is a thing about beauty. Beauty is always associated with the male fantasy of what the female body is. I don't think there is anything wrong with beauty. It's just what women think is beautiful can be different. And there can be beauty in individualism. If there is a wart or a scar, this can be beautiful, in a sense, when you paint it.'

Saville is concerned with the presentation of femininity and the pressure placed on women to subscribe to notions of beauty in society: 'I'm interested in the power a large female body has – a body that occupies a lot of physical space, but also someone who is acutely aware that our contemporary culture encourages her to disguise her bulk and look as small as possible.' Along with questioning the notion of beauty, despite the size of this nude, Saville also conveys a sense of vulnerability and fragility.

Jenny Saville (b.1970)
Prop, oil on canvas, 1993

'Saville challenges **time-honoured portrayals** of **female beauty**, instead conveying her figures as far from ideal and often looking **vulnerable and exposed**.'

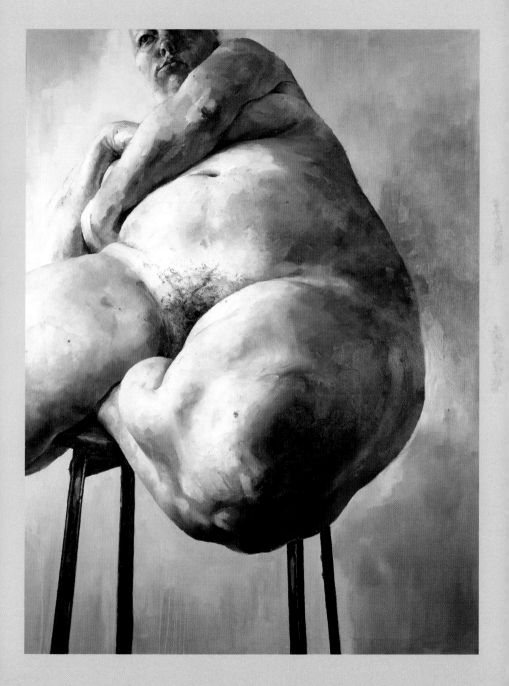

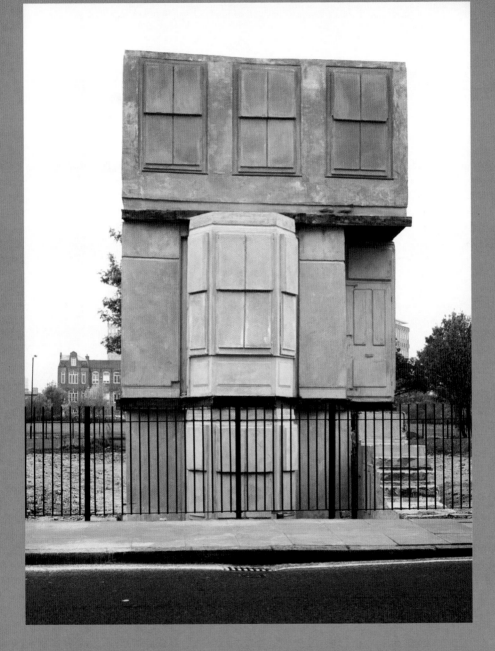

'The work celebrated **memories** – of years of life;
of families living and growing there –
revealing an intimate, private space to all.'

House
solidifies memories

In commemorating and preserving the memories of a dwelling that had stood for about a century, Rachel Whiteread received nominations as both the best and worst artist in Britain. She had made this concrete cast of the inside of a Victorian terraced house in London's East End, and for it, in November 1993, she won both the prestigious Turner Prize for best young British artist and the K Foundation art award for worst British artist.

Some of the buildings in Grove Road, Mile End, had been destroyed by bombing during World War II and replaced by prefabricated dwellings, and by the 1990s the area had a diverse social mix, with both Victorian terraces and high-rise blocks of flats from the 1960s. The new development of towers at Canary Wharf was visible in the distance, and the entire area was in the middle of an extensive redevelopment. The local authorities had decided to demolish a row of houses to create a park, but Sydney Gale, the last resident of one of them, opposed its demolition and continued to live in the house while the others were demolished. After a long battle with the authorities to remain in his home, Gale was evicted and rehoused nearby.

Determined to commemorate a dwelling that had stood for more than a century, Whiteread obtained the approval of both Gale and the local council, and, knowing that it would be able to stand only temporarily, made a concrete cast of the property. Three years earlier Whiteread had exhibited her sculpture *Ghost*, a plaster cast of four living-room walls inside an abandoned Victorian house. Although this was on a larger scale – an entire house rather than just a single room – *House* was on a similar theme. It was commissioned by Artangel and sponsored by Beck's and Tarmac Structural Repairs, and one specification was that the structure must be free-standing and visible from all sides.

Whiteread and a team worked inside the house, removing everything but the walls. Fittings such as sinks and cupboards were removed, holes in walls filled and windows covered. All was then cast in concrete supported by an interior metal armature, and builders removed the exterior of the house, leaving only the hardened concrete visible. The work celebrated memories – of years of life; of families living and growing there – revealing an intimate, private space to all. For the 11 weeks the sculpture stood (25 October 1993–11 January 1994) people flocked to see it, but it received a mixed reception and was demolished earlier than had originally been agreed.

Rachel Whiteread (b.1963)

House, concrete, 193 Grove Road, London E3, 1993 (destroyed 1994)

East West Circle
brings the outside in

Composed of rocks, some with flat bottoms and some rougher, a large circle is laid out on a gallery floor. The chunks of flint and black river stones create a jagged, natural-looking texture. The English Land artist Richard Long has reflected on the universality of the circle: 'I can make a circle of words, I can make a circle of stones, I can make a circle of mud ... I can walk in a circle for 100 miles. It is a completely adaptable image and form and system.'

Several of Long's works are based on walks he has made and natural structures he has seen. Since the mid-1960s he has walked in the Sahara Desert, Australia, Iceland and Britain, among other places. His resulting artworks have influenced the boundaries of sculpture, showing that it does not have to be limited to 'traditional' materials. In this way, he has changed the perception of art. Indirectly referencing ancient symbols, beliefs and superstitions surrounding sacred sites and stone circles, as well as reflecting on natural shapes and forms within the environment, Long integrates his sculpture with performance and conceptual art.

Since Long's first walks, he has used materials including earth, rock, mud, stone and other naturally found substances. Here he has used rocks, because they are the most fundamental materials from which the Earth is made and the earliest means of human creativity and survival. As this most basic, elemental shape, the circle here connects the essence of the Earth with rudimentary expression, as he has explained: 'You could say that my work is ... a balance between the patterns of nature and the formalism of human, abstract ideas like lines and circles. It is where my human characteristics meet the natural forces and patterns of the world.'

Most of Long's art is made either in or about the outside world, but much of it, as here, is brought inside, where it is more accessible to most viewers. 'Nature, the landscape, the walking, is at the heart of my work and informs the indoor works,' he says. 'But the art world is usually received indoors and I do have a desire to present real work in public time and space, as opposed to photos, maps and texts, which are by definition second-hand works. A sculpture feeds the senses at a place, whereas a photograph or text work (from another place) feeds the imagination. For me, these different forms of my work represent freedom and richness – it's not possible to say everything in one way.' In *East West Circle*, each piece of stone touches others, and together the pieces form a circle. As well as bringing the outside in, this invites contemplation about the relationship between humans and nature.

Richard Long (b.1945)
East West Circle, English flint and black river stones, 1996

'Rocks are the most **fundamental materials** from which the **Earth** is made and the earliest means of **human creativity and survival**.'

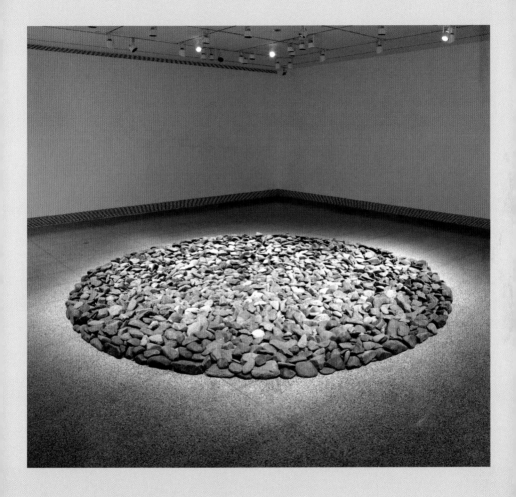

'In a scarred terrain, Kiefer confronts **dark aspects** of his country's past and connects it with Jerusalem's complex and turbulent **religious, political and cultural history** over millennia.'

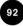

Heavenly Jerusalem
mixes darkness and light

Focusing on German history and myth, and using both Jewish and Christian symbolism, this painting by the German artist Anselm Kiefer confronts some uncomfortable aspects of history and explores human struggle and spirituality in a world disfigured by war and destruction. Incorporating thick impasto paint as well as lead, salt and silver leaf, this highly textured painting uses the city of Jerusalem as a powerful example of a place with a history of conflict, endeavour and spirituality. There are no concrete elements of the city itself, but Kiefer uses his own distinctive visual symbols.

Kiefer trained as a painter after studying law and languages at Freiburg University. His horror of the Holocaust and shame at the part played by Germany in two world wars has been a constant theme in his work, and he uses a range of unusual media, saying that these materials extract 'the spirit that already lives within [them]'. This is why many of his materials have their own histories, such as lead, which changes its appearance during heating and melting, and is associated with alchemy. In the medieval period, some alchemists believed they could turn lead into gold. Kiefer uses it in this work to convey the futility of the alchemist's quest and the difficulty of turning one thing into another, comparing such a struggle to the process of making art.

In a scarred terrain, Kiefer confronts dark aspects of his country's past and connects it with Jerusalem's complex and turbulent religious, political and cultural history over millennia. The damaged land is a metaphor for human suffering, and the railway tracks leading through that scorched and barren earth to a vanishing point in the middle of the horizon recall the trains commandeered by the Third Reich to deport millions of Jewish people to the death camps. Relating to his layered materials, Kiefer considers layers of history, both ancient and that of the world since 1945. Jerusalem is both a historical and a spiritual location, a place where settlers have lived for thousands of years, where strife has occurred since biblical times and where a modern identity has been established that is frequently challenged. Kiefer's painting therefore conveys the notions of darkness and light, horror and hope, anger and happiness, danger and safety, Germany and Jerusalem, ideas and facts.

Kiefer frequently uses train tracks and ladders in his work. While the former symbolize the transportation of Jews across the war-torn landscape to concentration camps, the latter recall the biblical story of Jacob envisioning a crossing place between heaven and Earth. In his use of these motifs, therefore, Kiefer is suggesting that Jerusalem is both a heavenly realm and a gruesome reminder of the Holocaust.

Anselm Kiefer (b.1945)

Heavenly Jerusalem, emulsion and shellac with lead, salt and silver leaf on canvas, 1997

Fireflies on the Water
investigates space

This small, darkened room lined with mirrors is meant to be viewed in isolation; only one person at a time can enter and experience the installation. Inside, 150 small lights dangle from the ceiling, and in the centre of the floor is a pool of water with a viewing platform extending over it. Collectively, these elements are seen through the shifting effects of light, both direct and reflected, sometimes sparkling and bright, sometimes subdued and shadowy, since some of it emanates from the electric lights, some bounces off the mirrors and some glitters and dances on the surface of the water. Because the light is not strong – coming from different small sources and being scattered by the reflective surfaces – the space itself is ambiguous. Standing in it, the viewer feels unsettled, as the dark corners and other shadowy areas make it impossible to judge the size of the room.

Since the 1950s, the Japanese artist Yayoi Kusama has been creating repeating patterns and installations that disorientate through the use of mirrors and effects of light. Born in Matsumoto City, Kusama started painting at a young age, at the same time as she began experiencing the visual and aural hallucinations that have continued ever since. She has said that her art 'is an expression of my life, particularly of my mental disease', and, working intuitively, she uses these hallucinations, inner feelings and visions to inform her work.

Although her family disapproved of a career in art, Kusama studied the traditional style of Nihonga (literally 'Japanese') painting in Kyoto before moving to New York City in 1958. There she mixed with significant Pop artists, including Andy Warhol and Claes Oldenburg, and she came to public attention when she organized a series of happenings in which naked participants were painted with brightly coloured polka dots. She experimented with sculpture and installation and, since returning to Japan in 1973, has been involved with printmaking, film-making, fashion and product design as well as poetry, performance, painting and installation art.

Kusama frequently investigates the idea of infinity in her work, and in the subdued and uncertain light of this installation, it could be that the space is limitless. It is unclear where the work begins or ends, and this encourages in the viewer feelings that resemble hallucination. While the arrangement of lights, mirrors, water and viewing platform might seem haphazard, Kusama paid careful attention to the construction of the space through its light, shadows and reflections. The play of light and sense of perspective have been meticulously planned, and the mirrors and lights strategically placed to create disorientating illusion and the impression of infinity.

Yayoi Kusama (b.1929)
Fireflies on the Water, mirrors, Plexiglas, lights and water, 2002

'In the subdued and uncertain light of this installation, it could be that **the space is limitless**. It is unclear where the work **begins or ends**, and this encourages in the viewer feelings that resemble **hallucination**.'

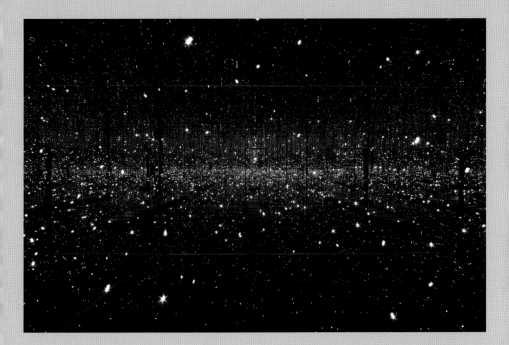

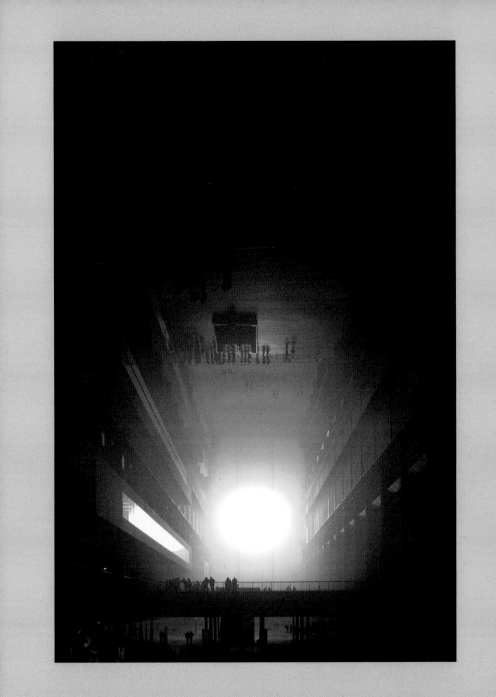

'Eliasson explored ideas of **experience**, **intercession**, **representation**, **self-perception** and, of course, the weather and how we **experience** it.'

The weather project
reproduces climate

The Danish-Icelandic artist Olafur Eliasson frequently uses elements of the weather such as water, light and heat in his installations in order to replicate nature. In re-creating rain, fog, sunshine or mist for instance, in open spaces and art galleries, he inspires viewers to reconsider the environments around them.

The weather is a topic that is always readily discussed, especially in Britain where it is so changeable. As well as exploring the weather in *The weather project*, Eliasson was also investigating ways in which museums and galleries introduce and explain the art they exhibit, and how these interpretations influence the visitors' understanding of the art being shown. With this work, Eliasson determined to allow visitors to make up their own minds, so that each viewer's experience of the art was unadulterated and personal.

First, he conducted a survey of the gallery staff, asking about different ways they discussed the weather, and then he created a unique environment inside Tate Modern's huge Turbine Hall. Reflecting that the weather is one of the few encounters with nature that can still be experienced in a city, he explained: 'As inhabitants, we have grown accustomed to the weather as mediated by the city. This takes place in numerous ways, on various collective levels, ranging from hyper-mediated (or representational) experiences, such as the television weather forecast, to more direct and tangible experiences, like simply getting wet while walking down the street on a rainy day. A level between the two extremes would be sitting inside, looking out of a window on to a sunny or rainy street. The window, as the boundary of one's tactile engagement with the outside, mediates one's experience of the exterior weather accordingly.'

Using lights, humidifiers, haze machines, mirror foil, aluminium and scaffolding, Eliasson created a huge installation in the Turbine Hall. Visitors were able to walk around the space filled with a mist of sugar and water and lit by a huge yellow-orange disc high up near the ceiling. Visitors could see themselves through the mist, upside down as tiny dark figures reflected on the vast ceiling-mirror. They also experienced the illusion that they were close to the sun as this was made out of a huge semicircle of yellow-orange lights suspended just below the mirrored ceiling. This was all part of Eliasson's plan for the work as he explored ideas of experience, intercession, representation, self-perception and, of course, the weather and how we experience it, especially in a city and in unexpected places.

Olafur Eliasson (b.1967)
The weather project, mono-frequency lights, projection foil, haze machines, mirror foil, aluminium and scaffolding, 2003

Cloud Gate
reflects a city

In a plaza in Millennium Park, Chicago, a huge, shiny sculpture reflects, distorts, twists and shrinks the city's skyline. Nicknamed 'The Bean' because of its shape, *Cloud Gate* is a public sculpture created by the India-born British artist Anish Kapoor. It comprises 168 stainless-steel plates welded together, but its highly polished, elliptical exterior has no visible seams, so it looks like liquid mercury.

Cloud Gate was created using computer technology to cut the massive steel plates into precise shapes, which were then pieced together and welded. Visitors can walk around it, watching their own reflections move, change and distort on the undulating surface. They can also pass or stand under its 3.7 m-high (12 ft) arch and, from underneath, look up to the concave chamber that has been called by the press *omphalos* (Greek for 'navel'). Because of its indented shape, the *omphalos* warps and multiplies reflections in a different way from the convex exterior. Although various technological concerns about its construction and maintenance arose before the piece was created, they were overcome, and now, as visitors are drawn to watch their own contorted images from a multiplicity of perspectives, the work entices many into moments of self-reflection, introspection and contemplation.

Born in Mumbai, Kapoor moved to London in the late 1970s to study at Hornsey College of Art and then Chelsea College of Art. In 1990 he represented Britain at the Venice Biennale, where he received the award for best young artist. The following year he won the highly respected Turner Prize. His art often conveys a sensuous interiority that alludes to the human body, iterated in diverse materials and frequently on a monumental scale. A central theme in Kapoor's work is the condition of positive and negative space, of emptiness and fullness, and the viewer's active experience with the sculpture. The convex exterior form of *Cloud Gate* provides a 'gate' to the concavity beneath, while the mirrored surface pulls the sky and surrounding architecture into the sculpture. Kapoor observed: 'The work is clearly reflecting what's around it, picking up the Chicago horizon, the Chicago skyline – bringing it into itself, in a way. And it is a gate – a gate to Chicago, a poetic idea about the city it reflects.'

Anish Kapoor (b.1954)
Cloud Gate, stainless steel, 2004–6

'A central theme in Kapoor's work is the condition of **positive and negative space**, of **emptiness and fullness**, and the **viewer's active experience** with the sculpture.'

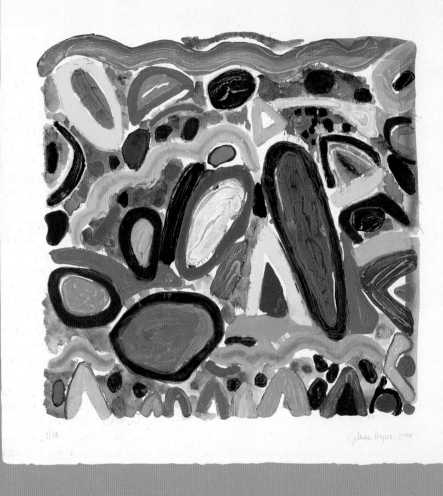

'This **vigorous** print is filled with **colours** and **organic shapes** that evoke
music and rippling water in the darkness, the sound and smell of the sea,
rocks, sand, **paint** itself and **aeons of history**.'

Fingal
responds to colour

Art-making for Gillian Ayres was all about colour, shape and energy. Known for her vibrant, uplifting paintings, she was also a prolific printmaker, producing etchings, woodcuts and monoprints, developing her own original methods, including working with carborundum etching and hand-painting both under and over her prints. Despite their often emotive titles, all her works are abstract. 'Shapes. Spaces. It's the way I see the world,' she explained.

This is a carborundum etching with underpainting. Comprising watery washes and loose brushwork beneath the print, with both soft- and firm-edged organic printed shapes, it features bright single colours and layers of darker, more muted hues that result in a lyrical, animated and fluid image. Carborundum is a relatively new process, invented in the United States in the 1930s, and Ayres loved it for the textures and tonal qualities she could obtain. However, colour was always paramount to her: 'All the painting I've liked has always been colour painting. I've found that I respond to colour more than anything.'

In 1989 Ayres was shortlisted for the Turner Prize, in 1991 she was elected to the Royal Academy of Arts, and in 2011 she was appointed CBE (Commander of the Order of the British Empire). Her exuberant abstract works reveal her love of rich, juicy paint and sumptuous colours and her close knowledge of the work of other artists, including Turner, Van Gogh, Gauguin, Matisse and Miró. Although her works are rarely a direct response to any particular artist, movement or subject, Miró was her greatest influence with what she described as his 'internal vision of eternity'. He was also one of the few artists to print with carborundum.

Rather than depicting any actual motif, Ayres said that she worked with 'no composition', describing her art in terms of a 'visual language', and that her titles give the viewer a direct reference point. So, without directly referring to any particular aspect of the world, this expressive image draws on recollections of the atmospheric works by Turner of Fingal's Cave. Remote, isolated and extremely dramatic, this rock formation on the uninhabited island of Staffa in western Scotland towers over the sea, featuring astonishingly geometric basalt columns, a large, arched entrance that is frequently filled by the ocean, and remarkable natural acoustics. The cave has inspired countless artists, poets, musicians and naturalists, and this vigorous print is filled with colours and organic shapes that evoke music and rippling water in the darkness, the sound and smell of the sea, rocks, sand, paint itself and aeons of history. Considering the energy and colour she always worked with, Ayres once said: 'I want an art that's going to make me feel heady, in a high-flown way. I love the idea of that.'

Gillian Ayres (1930–2018)

Fingal, carborundum etching from one plate with hand-painting on BFK Rives 300gsm paper, 2005

Blow Up 03
explodes a moment

Throughout his career, Ori Gersht has often been concerned with the relationship between history, memory, life, death and perception. Known best for his work with slow-motion capture, here he portrays a traditional subject of flowers, but has exploded them and presented them as photographs in the moment of destruction. Set against their black backgrounds, these powerful images recall the elaborately arranged and painstakingly painted seventeenth-century Dutch flower paintings by artists such as Ambrosius Bosschaert the Elder, Paulus Theodorus van Brussel, Osias Beert the Elder, Jan van Huysum, Jacob van Walscapelle, Willem van Aelst and Rachel Ruysch, but they also suggest themes of political conflict, disturbance and violence.

Israeli-born Gersht studied photography in England, and lives and works there. In this work, using cutting-edge technology, he investigates relationships between photography and technology, visual perception, the concept of time, relationships between photographic images and real life, associations with the art of the past, and how we perceive and process what we see before us. The series depicts the destruction of a floral arrangement captured by Gersht's lens at a rate of 1,600 frames a second, and each photograph explores both his interest in and mastery of the technical and philosophical aspects of photography. In his writing, he also makes frequent reference to the 'optical unconscious', a term the philosopher Walter Benjamin first used to describe the camera's unique ability to capture in a single frame more than the human eye is capable of seeing. In revealing instances that would otherwise be unseen, Gersht optically articulates the exact moment of explosion while also raising philosophical questions relating to time and space. Flowers, which often convey peace, become victims of brutality and destruction.

The somewhat shocking images are presented for contemplation, created to remind viewers of the past and present, of struggles, discord and, above all, of the fragility of life. Captured in freeze-frame, the arrangement is literally frozen in motion, a procedure that is possible only through technological advances in photography. In some ways, the images suggest the brevity of life, echoing the memento mori and vanitas paintings of the past – which many of the Dutch still-life paintings were.

As well as evoking imagery from the Dutch Golden Age, the light and the arresting of the moment echo some of the Impressionists' main ambitions, and the rapid movements of the subject recall Futurist art. By basing his photographs on time-honoured art-historical traditions, Gersht draws attention to the painterly nature of his photographs, while contrasting them with the digital processes required to capture details of each rapid movement.

Ori Gersht (b.1967)
Blow Up 03, Light Jet, 2007

‘The somewhat shocking images are presented for **contemplation**, created to remind viewers of the **past and present**, of **struggles**, **discord** and, above all, of the **fragility of life**.’

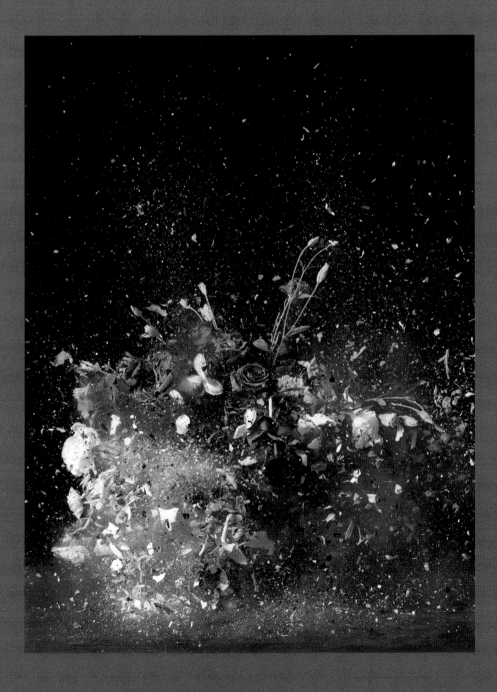

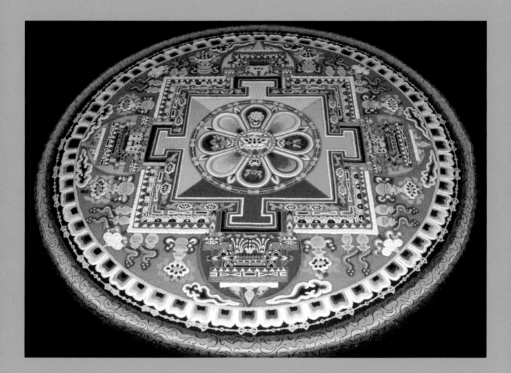

'Nothing is **arbitrary** or **unnecessary**, and the precise measurements, design and colour placements are created to attract the **positive energy** of **compassion and kindness**.'

Chenrezig Sand Mandala
helps meditation

Originating in the tantric teachings of Lord Buddha Shakyamuni, sand mandalas are symbolic images of the universe, representing specific deities and made with coloured sand, to enable meditation. Once certain ceremonies have been completed and meditation is ended, the mandala is ritualistically dismantled to symbolize the Buddhist belief in the transitory nature of material life. All the major Buddhist deities have their own individual mandalas.

Created with dense, heavy coloured sand by Buddhist monks, this mandala was planned with exact measurements, and the intricate design marked out precisely with chalk on a wooden platform. Then the sand was applied, one section at a time, by a group of monks using small tubes, scrapers and funnels called *chak-pur*. Although it is two-dimensional, the mandala represents the three-dimensional environment of the divine palace of Avalokiteshvara (Chenrezig in Tibetan), a deity who personifies the ideal of compassion, and his entourage. He is portrayed in several different forms, the most common being a white figure with either four or a thousand arms. The many arms signify his ability to help many beings concurrently.

In May 2008 the Dalai Lama visited England to give five days of teaching. For his visit, a group of monks from Tashi Lhunpo Monastery in Tibet created this sand mandala for public display, its brilliant colours symbolizing precious materials. Every aspect refers to something important; nothing is arbitrary or unnecessary, and the precise measurements, design and colour placements are created to attract the positive energy of compassion and kindness.

The work is set on a great square plinth that denotes the stability of the Earth, and the inner square represents the ground plan of Chenrezig's palace, which is divided into four coloured quadrants: the blue eastern quadrant, the yellow southern quadrant, the white western quadrant and the green northern quadrant. With the red of the central circle, these colours represent the attributes of the Five Buddha Families. The four walls of the palace represent faith, effort, memory, meditation and wisdom. Also represented are the five *dakinis*, or female spirits. The four doorways, centred in each wall, are decorated with jewels and stand for the four immeasurable thoughts: love, compassion, joy and equanimity. The lotus flowers in the centre are there to cleanse tainted states of mind.

The meditation and rituals connected to the mandala are believed by Buddhists to generate positive transformation, including bringing peace and harmony to the world. This example was created specifically to help those who meditate with it to develop wisdom and compassion.

Monks from the Tashi Lhunpo Monastery

Chenrezig Sand Mandala, coloured sand, 2008

A Subtlety
confronts the slave trade

Known for her cut-paper silhouettes and images that highlight and expose a history of repression and cruelty, the New York-based artist Kara Walker also works with collage, drawing, painting, performance, film, sculpture and light projection. In its exploration of slavery, violence, sex and stereotyping, much of her work is deliberately disconcerting and confrontational.

In May to July 2014, in the Syrup Shed of Brooklyn's disused Domino Sugar Refinery, Walker exhibited a massive sugar-coated sculpture of a woman with African features in the shape of a sphinx, plus 15 other sculptures representing black boys as her 'attendants'. The sculptures reflected the building and its history, and Walker gave the work the full title *A Subtlety, or the Marvelous Sugar Baby, an Homage to the unpaid and overworked Artisans who have refined our Sweet tastes from the cane fields to the Kitchens of the New World on the Occasion of the demolition of the Domino Sugar Refining Plant*. The installation was intended to instigate conversations about the slave trade and related themes of racism, sexuality, oppression, power, control and hard work.

The Domino Sugar Refinery was built in 1882, and by the 1890s it was producing half of the sugar being consumed in the whole of the United States. By 2014, however, it was scheduled to be demolished and the site redeveloped.

Walker decided to create a work of art that conveyed its questionable history and heritage. She had read in the anthropologist Sidney Wilfred Mintz's book *Sweetness and Power: The Place of Sugar in Modern History* (1985) that in the Middle Ages, in northern Europe, royal chefs made sugar sculptures called subtleties. Walker began thinking about the slaves who had actually worked in the refinery, cutting and preparing the sugar for the privileged markets in America. Reflecting on the slave trade in general, she considered the slave in Édouard Manet's painting *Olympia* (1863) and later works by similarly revered European artists, including Paul Gauguin and Pablo Picasso, who often depicted what they and viewers perceived as the 'exoticism' and 'primitivism' of African and Oceanic art.

With a kerchief around her hair, Walker's huge 'sphinx' is dressed in the typical garb of the Domino worker and has the stereotypical physical features of a female black slave. Her whiteness contrasts dramatically with the actual colour of her skin, as well as the whitening of originally brown molasses. Constructed from 330 polystyrene blocks, and 80 tonnes of sugar, Walker's figure intentionally created discomfort among viewers by emphasizing physical stereotypes, bluntly reminding them of inequality and exploitation.

Kara Walker (b.1969)

A Subtlety, or the Marvelous Sugar Baby, an Homage to the unpaid and overworked Artisans who have refined our Sweet tastes from the cane fields to the Kitchens of the New World on the Occasion of the demolition of the Domino Sugar Refining Plant, polystyrene foam, sugar, 2014

'Walker's figure intentionally created **discomfort** among viewers by emphasizing **physical stereotypes**, bluntly reminding them of **inequality** and **exploitation**.'

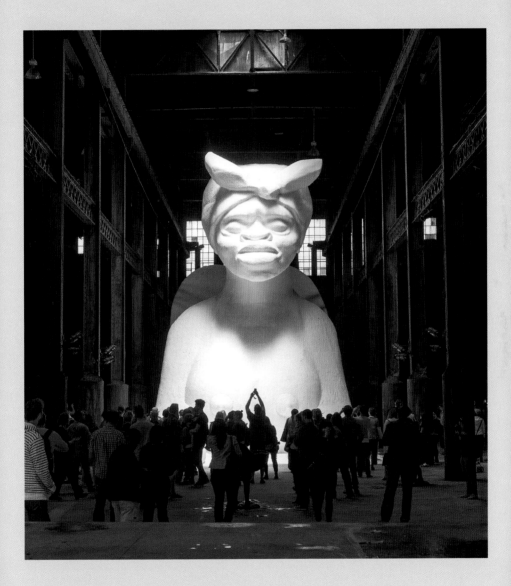

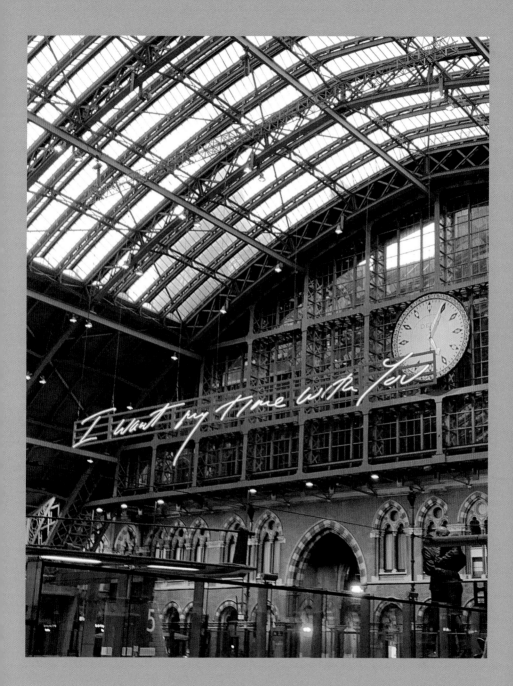

'It's really a great **subliminal message** sent out
to the rest of Europe. It will make people **happy**, I promise you,
it will make people **smile**.'

I Want my Time with You
beckons emphatically

'It's really a great subliminal message sent out to the rest of Europe,' explained Tracey Emin at the unveiling of this installation in a soaring nineteenth-century railway station in London. Emin created the work just after the United Kingdom had voted to leave the European Union. Her aim for the work, which was commissioned by the Royal Academy and St Pancras International station, was to send a message to the thousands of travellers who arrived every day by Eurostar from mainland Europe – that Britain still welcomes them and that almost half the UK population voted to remain. The work also aims to evoke the more personal romance of station reunions, of being met by someone after getting off a train. Emin reflected: 'I desperately hope to be met at the train station in a really romantic way – one day.'

Emin was born in London and studied fashion at Medway College of Design (now the University for the Creative Arts), at Maidstone College of Art and at the Royal College of Art, London, where she obtained an MA in painting in 1989. For a time she also studied philosophy at Birkbeck, University of London. For some years she remained unknown, but in 1997 she catapulted to fame after appearing on a live television programme discussing the question 'Is Painting Dead?' Two years later she was shortlisted for the prestigious Turner Prize and exhibited her work *My Bed* (1998) at London's Tate Britain. The installation garnered considerable media attention because, among other things, the bedclothes were stained with bodily fluids and detritus surrounded the bed, including condoms, empty cigarette packets and underwear with menstrual stains. The bed was presented as it had been when Emin had stayed in it for days, suffering with acute depression after the break-up of a relationship. Overall, it was a self-portrait. Much of her work is autobiographical and ignites intense disagreements, while blurring the boundaries between personal and public, and art and life.

I Want My Time with You is the largest text installation Emin has ever made, featuring her distinctive handwriting and suspended on chains from a specially constructed arch 30.5 m (100 ft) high in the large, curving Victorian roof. For the work, Emin had to comply with various health-and-safety measures, including ensuring that the drivers of trains coming in to the station were not shocked or confused by the lights. For this reason certain colours were prohibited, for example red, green and yellow, and she had to use LEDs, rather than her usual neon. '[The lights] were always going to be pink,' she said. 'At night, the whole station will be bathed in a pink light, and it will make people happy, I promise you, it will make people smile, because pink will make them feel good.'

Tracey Emin (b.1963)
I Want my Time with You, LED lights and wire, 2018

List of Works: dimensions and locations

1. *Venus of Willendorf*, H: 11 cm (4¼ in), Naturhistorisches Museum, Vienna, Austria

2. *Hall of Bulls*, 19 × 5.5–7.5 m (62 × 18–25 ft), Lascaux, France

3. *Nebamun Hunting in the Marshes*, 83 × 98 cm (36¾ × 38½ in), British Museum, London, UK

4. *Terracotta Army of Emperor Qin Shi Huangdi*, Guanzhong area, Shaanxi Province, Northwest China

5. Ellora Caves, Aurangabad, Maharashtra, India

6. *The Aldobrandini Wedding*, 92 × 242 cm (36¼ × 95¼ in), Vatican Museums, Rome, Italy

7. *Trajan's Column*, H: 35 m (115 ft), Rome, Italy

8. *Deësis*, Hagia Sophia, Istanbul, Turkey

9. *Wang Xizhi Watching Geese*, Qian Xuan, 23.2 × 92.7 cm (9⅛ × 36½ in), Metropolitan Museum of Art, New York, USA

10. *The Legend of St Francis*, Giotto di Bondone, Upper Church, San Francesco, Assisi, Italy

11. *The Wilton Diptych*, 53 × 37 cm (20¾ × 14½ in), National Gallery, London, UK

12. *Les Très Riches Heures*, Limbourg Brothers, 30 × 21 cm (12 × 8¼ in), Musée Condé, Chantilly, France

13. *The Holy Trinity with the Virgin, Saint John and Two Donors*, 667 × 317 cm (263 × 125 in), Santa Maria Novella, Florence, Italy

14. *The Arnolfini Portrait*, Jan van Eyck, 82 × 60 cm (32¼ × 23½ in), National Gallery, London, UK

15. *The Descent from the Cross*, Rogier van der Weyden, (86⅔ × 103 in), Museo del Prado, Madrid, Spain

16. *Penitent Magdalene*, Donatello, H: 188 cm (74 in), Museo dell'Opera del Duomo, Florence, Italy

17. *Madonna and Child*, Filippo Lippi, 95 × 62 cm (37½ × 24½ in), Uffizi Gallery, Florence, Italy

18. *La Primavera*, Sandro Botticelli, 207 × 319 cm (81½ × 125½ in), Uffizi Gallery, Florence, Italy

19. *The Garden of Earthly Delights*, Hieronymus Bosch, central panel 220 × 196 cm (86½ × 77 in), side panels, each 220 × 96.5 cm (86½ × 38 in), Museo del Prado, Madrid, Spain

20. *The Great Piece of Turf*, Albrecht Dürer, 40.8 × 31.5 cm (15⅞ × 12¼ in), Albertina Museum, Vienna, Austria

21. *The Virgin and Child with St Anne,* Leonardo da Vinci, 168 × 130 cm (66 × 54 in), Musée du Louvre, Paris, France

22. *The Creation of Adam*, Michelangelo, 280 × 570 cm (110¼ × 224½ in), Sistine Chapel, Rome, Italy

23. *The School of Athens*, Raphael, 500 × 770 cm (200 × 300 in), Apostolic Palace, Rome, Italy

24. *Deposition from the Cross*, Jacopo da Pontormo, 313 × 192 cm (123 × 76 in), Church of Santa Felicità, Florence, Italy

25. *Madonna of St Jerome*, Correggio, 235 × 141 cm (92½ × 55½ in), Galleria Nazionale, Parma, Italy

26. *The Emperor Guangwu Fording a River*, Qiu Ying, 170.8 × 65.4 cm (67¼ × 25¾ in), National Gallery of Canada, Ottawa, Canada

27. *The Ambassadors*, Hans Holbein the Younger, 207 × 209.5 cm (81 × 82½ in), National Gallery, London, UK

28. *Pope Paul III and his Grandsons*, Titian, 210 × 176 cm (82⅔ × 69¼ in), Museo di Capodimonte, Naples, Italy

29. *Children's Games*, Pieter Bruegel the Elder, 118 × 161 cm (46 × 63 in), Kunsthistorisches Museum, Vienna, Austria

30. *Arrival of the Portuguese*, Kanō Naizen, 178 × 366.4 cm (70 × 144¼ in), MNAA National Museum of Ancient Art, Lisbon, Portugal

31. *View of Toledo*, El Greco, 121.3 × 108.6 cm (47¾ × 42¾ in), Metropolitan Museum of Art, New York, USA

32. *Supper at Emmaus*, Caravaggio, 141 × 196.2 cm (56 × 77¼ in), National Gallery, London, UK

33. *Samson and Delilah*, Peter Paul Rubens, 185 × 205 cm (73 × 81 in), National Gallery, London, UK

34. *Judith Slaying Holofernes*, Artemisia Gentileschi, 199 × 162.5 cm (78⅜ × 64 in), Uffizi Gallery, Florence, Italy

35. *Cheat with the Ace of Clubs*, Georges de La Tour, 97.8 × 156.2 cm (38½ × 61½ in), Kimbell Art Museum, Fort Worth, USA

36. *The Proposition*, Judith Leyster, 31 × 24 cm, (11⅜ × 9½ in), Mauritshuis, The Hague, the Netherlands

37. *Equestrian Portrait of Thomas of Savoy, Prince of Carignano*, Anthony van Dyck, 315 × 236 cm (123 × 93 in), Galleria Sabauda, Turin, Italy

38. *Portrait of Innocent X*, Diego Velázquez, 141 × 119 cm (56 × 47 in), Galleria Doria Pamphilj, Rome, Italy

39. *Courtyard of a House in Delft*, Pieter de Hooch, 73.5 × 60 cm (29 × 24 in), National Gallery, London, UK

40. *Self-portrait with Beret and Turned-Up Collar*, Rembrandt van Rijn , 84.5 × 66 cm (33¼ × 26 in), National Gallery of Art, Washington DC, USA

41. *Girl with a Pearl Earring*, Johannes Vermeer, 44.5 × 39 cm (17½ × 15⅓ in), Mauritshuis, The Hague, the Netherlands

42. *Piazza San Marco*, Canaletto, 68.6 × 112.4 cm (27 × 44¼ in), Metropolitan Museum of Art, New York, USA

43. *Mr and Mrs Andrews*, Thomas Gainsborough, 69.8 × 119.4 cm (27 × 47 in), National Gallery, London, UK

44. *Whistlejacket*, George Stubbs, 296 × 248 cm (116½ × 97½ in), National Gallery, London, UK

45. *The Swing*, Jean-Honoré Fragonard, 81 × 64.2 cm (31⅞ × 25¼ in), Wallace Collection, London, UK

46. *Self-Portrait in a Straw Hat*, Élisabeth Vigée-Lebrun, 97.8 × 70.5 cm (38½ × 27¾ in), National Gallery, London, UK

47. *The Oath of the Horatii*, Jacques-Louis David, 330 × 425 cm (130 × 167¼ in), Musée du Louvre, Paris, France

48. *Self-portrait Hesitating Between the Arts of Music and Painting*, Angelica Kauffman, 147 × 216 cm (57⅞ × 85 in), Nostell Priory, West Yorkshire, UK

Index

Picture Credits